NOW WHAT?

Now What?

**QUANDARIES OF ART
AND THE RADICAL PAST**

Rachel Weiss

FORDHAM UNIVERSITY PRESS NEW YORK 2021

for the unconsoled

Contents

Introduction: Being Afterward

This began for me some years ago, during a few days in Lima. I was there to work with the Red Conceptualismos del Sur (Network of Southern Conceptualisms) on an exhibition they were preparing about the disappeared histories of artistic militancy in opposition to the dictatorships and state violence of 1980s Latin America.[1] The group of mostly young researchers had convened to share their findings with one another and to fit those pieces together into a whole. The intensity of that meeting rendered me, literally, speechless: It was clear that the project was not merely an act of historical vindication, since these were histories that cut to the anguished core of a legacy that was felt on the most intimate terms.

After that, I began to notice more and more of these acts of return to the radical past, and it seemed to me that they had a few things in mind, and in common. There was a sense of confrontation, in the form of a commitment to undo the cynical erasure of histories that had been deemed inconvenient but that held—maybe—importance in the present; such

confrontations moved amid the uses and shadows of those traumatic, insurrectionary legacies, tracing their presence through absence. There was often a sense of participation, rather than merely a recounting or recapturing of the past; a gesture of insertion into thwarted and unrequited historical projects in order to heal them or bring them to a close. This, it seemed to me, extended the meridian of doubt opened in any historical return, variously caressing or brutalizing the moments to which the redeemers went back. There was radicalization: Radical histories demanded a radical response, their unrequitedness pushing the question of what to do now.[2] And, sometimes, there was reparation, conciliation—a recuperative register, springing from the license of a dream. Vectors, conferring on memory the power to unlock the past and return it to the present as a force field of utopian imagining; whirlpools, returns drawn back in, then spinning out from that; legends, taunting companions with whom we still walk. All this arises out of the acuity with which we desire and need to know the past—all the more so, perhaps, when it has been withheld from us.

All those histories that have been lost or cancelled out—whether of revolution, violence, resistance, or defiance—we go back in order to reclaim, declaim, or learn from them. This continual process of return is at the heart of some of the most disconcerting, difficult, and compelling artworks I've seen in recent years: There's a pervasive sense of many scores still remaining unsettled and of a need to return that is fueled, in large measure, by the painfully asymptotic footing of our time. Current aspirations for meaningful participation in the urgent struggles of the present resonate powerfully against earlier experiments along those lines that are lost and then brought, later on, to light. These are projects that come out of powerful emotional attachments

and that, in turn, often arouse painful and conflictive feelings in their viewers.

We Are Afterward

Looking back like this now could be fraught. Self-validating victimization narratives abound in American popular culture (think Trump): Trauma is sacralized, steeped in what Michael Roth has called "the awesome stimulation of the negative sublime,"[3] and claims to victimhood flourish. Ours is a society bound to its traumatic experiences, contends Patrick Duggan, a "wound culture" in which "trauma has become a cultural trope."[4] Even if we don't do it outright, this ubiquitization often verges on the trivialization of "trauma": We've come to give a lot of psychic space to our wounds. Nevertheless, our world is haunted and besieged by its lingering pasts: The global proliferation of truth and reconciliation commissions since the 1990s is testament enough to this festering condition. A post-traumatic condition, as Geoffrey Hartman noted in 2004, "begins to resemble the human condition as a whole."[5]

But some of those wounding pasts cut deeper than others. The works I look at here are tellings in the wake of historical watersheds— foundational and precipitate moments in the history of twentieth-century radical politics. The Cuban Revolution is an existential question at the heart of "Lupe at the Mic," an account of Tania Bruguera's 2009 performance *Tatlin's Whisper*. Patricio Guzmán's decades-long cycle of returns to Allende's Chile, to its destruction, and to the structures of its forgetting is the subject of "The Tenuous Moonlight of an Unrequited Past." Herta Müller's aching denominator—"Something That Opens a Wish and Closes a Door"—provides the starting point for a journey through

the recountings of the thwarted 1989 revolution in Romania in Harun Farocki and Andrei Ujica's *Videograms of a Revolution* and Corneliu Porumboiu's *12:08 East of Bucharest*. And the cascading reactions in postwar West Germany—the denial of the Nazi past and the ways that came to shape and deform ideas of justice in the succeeding generation—are the infernal tangle at the heart of "Whoever Knows the Truth Lies," considered here through the film *Germany in Autumn* and Gerhard Richter's *October 18, 1977* suite of paintings.

The fallout from the denial of the past, the betrayed promise of popular revolution, the normalization of modern state-sponsored terror, the miasmatic death throes of ideological collapse. Four forms of extreme political and psychological violence, each one upping the ante of what the state would justify in its own name—of the "superposition of life and death," in Hito Steyerl's chilling diagnosis, as a "standard feature of . . . [twentieth-century] government."[6] Four challenges to the very idea of an emancipatory movement. Four forms of damage, of disbelief, that have by now hardened into routine, no longer felt in their awful rawness. Parts of a process, steps along the way, that lead to what we can now find ourselves accepting as the grain against which we live our lives.

Four manners of denying the past, leaving people isolated, afraid, angry, silenced, desiring. Four moments in which a state of being "missing" became paramount: missing through denial, erasure, and institutionalized forgetting. But why does that matter so much? That's a central question for this book, along with its pendant query about what exactly it is that we want from the past—the radical past, in particular, especially in the wake of its failures. These tellings deal with legacies of political struggle and transcendent hope, of risk, cravenness, of societies that have done horrific, immoral things on

a drastic scale. Their relation to the past hurts, it heals; the past hides and is hidden, insists and refuses our entreaties for connection. The tellings broach affective recognition, identification; they flinch, alienate, and explode; they live in a state of doubt. They ask the age-old question of how we are to live with—or without—the past. What we see in these tellings, and in the whole genre of such works, is a complicated effort to discern what those pasts might mean to us now and, no less, why the fact of their being missing is such a problem. The missing leads us contradictorily, to want and dread the truth: The missing stays with us through its absence, like a foreign body unrelenting in our unconscious.

These are tellings about and from societies that have much to fear from the past and, for that matter, from themselves and their capacity to inflict such tremendous harm. They raise questions about remembering, representing, repeating, returning, and relating; about generational succession and inheriting pasts; about the half-life of messianic hope: They open up questions about the possibilities of telling.

Horizon

These works are intent on the past. They tell and retell those pasts in the interests of the radical energies that they embodied and unleashed, and they tell and retell them in the face of the retributions they engendered. Much of the writing about recovering the radical past points toward a project of rediscovery and redemption, a reworking in order to release their emancipatory potential: They're in the business of verifying, affirming, cementing.[7] But these works handle the matter of legacy differently. Martha Minow reminds us that, while "responses to collective violence lurch among rhetorics of history (truth), theology (forgiveness), justice (punishment, compensation and deterrence), therapy (healing), art

(commemoration and disturbance), and education (learning lessons)," the fact remains that "None is adequate."[8] What we'll find here, then, is not so straightforward and not so resolute: These returns trace uncertain horizons and sketch a condition of shared precariousness among the ordeal, its wake, and its telling. That condition of precariousness comes into view not as a crisis to be overcome but as something that is constitutive of our lives and with which we need to come to terms. The works evince the psychic afterlives of these histories, which extend beyond the terminable and remediable affairs of politics, speaking of the interminable project that parses justice in terms other than those of vengeance or conciliation. They reformulate history-work into a meter that persists, insists, pulses, and activates an emotion of recognition. The past as gnarled parentage, space of residues, "glimmer of an intimation that could animate a different future."[9] Our indecisive markers, sites of return: These are histories that need untangling, in no small measure because in them the loss itself has been lost.

We're faced with the quandary of how it might be possible to tell these pasts, given that trauma resists telling by its very nature, and so these works straddle the dialectic between the impossibility and the urgency of really knowing the ordeals that they tell: They're frames that make telling possible. Their consistency is in their fragility, told in languages made of pauses and fragments, told in a confusion of past and present, a time of nonhistorical form in which Then and Now punctuate each other. Told in minor voicings, they live in the time of consequences. They are deeply personal, but not in the business of revelation: Truth, History, Knowing, all shorn of their claims to certainty. Their claim is not of pure seeing but of a kind that is born of the lived interplay and tension between hope and fear. They tell of that dynamic with the im-

mediacy and urgency that their condition of being afterward demands. Or, to put it another way, they accept that being afterward, as we are, is a boundless process: Boundlessness is a condition perhaps more readily associated with love, but it's deeply affiliated, too, with the condition of attachment to an unrequited past.

The works share a condition of being afterward; they're tellings in the wake. They tell the undersong of these histories, of the wreckage of emancipatory hopes and energies and the consequences of that, and they tell in these kinds of languages so they might offer a different way to live afterward. Quarrels flicker throughout these incursions from the destroying past, but they hold fast to their relation to those difficult and suspended projects, respecting the ways that they've touched the world.

This book began as an effort to understand why we return to the radical pasts that have been lost to us and to learn what it might be that we want from them: to understand what work they can, or cannot, actually do. But if, at first, I was focused on those processes of reclamation, over time the center has shifted to the experience of the loss itself—that which forms the desire to go back. From reclamation to trauma's tailwind. We are, Judith Butler says, marked for life by trauma, "and that mark is insuperable, irrecoverable. It becomes the condition by which life is risked, by which the questions of whether one can move, and with whom, and in what way are framed and incited by the irreversibility of loss itself."[10] The condition by which life is risked.

These are works that hit a nerve and can't be easily dismissed, works that raise, and don't put down, a question that matters: From what perspective might we best understand the historical condition we live in now, our own broken time

of fearsome shadow and echo? The world I'm writing into today is volatile and ominous. We're full of fear: This is what it feels like to stand on the brink of the maelstrom, to be aware of impending calamities, but also to live with them. The bewilderment of loss, the indescribable anguish of living in a condition of aftermath, the gradual narrowing of hope, shot into a future that is radically unknown. We want to be moved by the untamed world of the past, and not only metaphorically. Our fear is that its meanings will be lost.

These tellings tell their stories in ways that allow them to belong to people other than those who had laid claim to them; they tell their pasts differently. They tell their pasts against simple repetition, and they tell them as a claim for their importance, their continued traction. They tell them toward a different kind of thinking about radicalism, utopianism, and to do that they break narrative form open: forsaking the typical modalities for narrating such pasts (progress, loss, return)[11] and for leaving them (truth and reconciliation commissions, above all), sounding those pasts in idioms that hit home otherwise. They don't rescue; they don't champion; they don't campaign. They refuse to leave their pasts behind, and they propose other ways to think about these legacies that haunt us.

This is a book about the stories we tell ourselves about the past and about some pasts in particular—radical ones, ones we loved or despised and ones ascribed to the ranks of failure, for the most part. Ones, however, that still matter, that we look to and ask for meaning, ones we hope into or harken to. Ones that, we suspect, can tell us something we need to know in light of present urgencies. Ones that can tell us things about how we might live in the present, if we learn how to ask about these pasts. This present, with its capacity to disgust and enrage; this present, which has

taken shape in parallel to my writing, is the setting against which I read these painful but optimistic tellings (all attachments, says Lauren Berlant, are optimistic, since they pull us outside of ourselves). It matters how we tell these pasts, and this will be an effort to read some of these retold pasts toward that end.

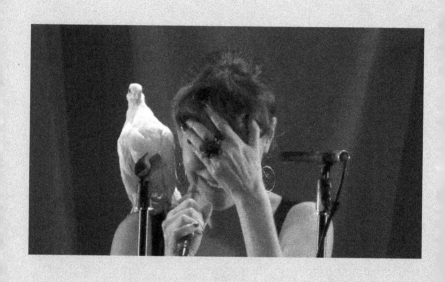

1

Lupe at the Mic

After January 1959, Havana, Cuba,
in Tatlin's Whisper #6

There was the usual milling around, on the basis of sketchy information. A stage was set up in the patio of a cultural center in the old part of the city—the restored, charming part full of restaurants and shops, the part where power blackouts and water shortages are rare and where crime is minimal because of all the police. Strong lights hit a podium on the stage in the darkening patio; a huge golden curtain hung behind it. A phalanx of big TV cameras, national and international press amid the noisy crowd—by now hundreds of people.

The crowd is pretty mixed. Since the performance is part of the Havana biennial, pretty much all the foreigners are somehow connected to the arts (collectors, curators, artists, etc.), but the Cubans come from a broader slice of the population. After a long while there's a little flurry of excitement: A cardboard box of something is brought out, and an announcement is made about people taking something from it. The box is filled with several hundred disposable cameras, and people push over to grab them, passing them along from

hand to hand. The space has gotten even more crowded and noisy and expectant.

I don't remember exactly how it started, but someone must have explained that anyone was welcome to take the stage and speak into the microphone for a minute. Maybe they had been there before, but it was then that I noticed a couple of kids in army fatigues holding a dove. After not too long things got going, and in a ragged and stop-start kind of way people went up and spoke: some of them shouting; a few fists raised in the air; some cries and cheers from the crowd; some confusion about what had been said, since the sound quality was bad; some defiance; some awkward declarations; some dead air; some confessions ("I've never felt more free"; "I am afraid"). Each time, the dove was put on the speaker's shoulder.[1] Usually it flapped around in the speaker's hair or flew off; each time, the guards would catch it and put it back. The performance had started late but ended punctually after exactly an hour, when the artist, the last to speak, said, "Thanks to the Cubans."

I was standing with a few friends, and over the course of the hour our disagreement about what was happening got stronger, to the point that one of us was furious, one exhilarated, and the other two of us deeply conflicted (of course). The performance was aimed at both romantics and cynics, and it had caught each of us at that edge.

What Happened (First Pass)

Right at the beginning a woman takes the mic and starts to cry. It takes most of the minute she's up there for people to quiet down, and even then there's still a lot of hubbub. She leaves without saying a word, still shaking with sobs. Some people recognize her because she had been an important

teacher and mentor until she left the country years ago, along with a lot of others.

Yoani Sánchez is next. She goes up right after Lupe leaves, and the shift in tone is almost violent: There's no interval for the emotion to settle. Now it's a protest rally, and the atmosphere is emphatic. Yoani reads a short speech: "Cuba is an island surrounded by the sea, and it is also an island surrounded by censorship," she begins. "Some cracks are opening in the wall of control. . . . We are still only a few bloggers, our sites highlight the awakening of public opinion." The sound system is not great, and there's a lot of reverb, which not only makes it hard to understand but also creates the sense of being in a giant space, an arena instead of a relatively intimate patio. That discrepancy piles onto the latent one—the sense of things just generally being askew, not adding up right. What does register succinctly is that this is a big deal, partly because Yoani is probably the most visible and celebrated dissident on the island, but mostly because this just doesn't happen in Cuba.

The next statement is also prepared, as is the next: All three of them speak in the same fluent cadence of declaiming, of oracular truths, of nailing lies. All three (all bloggers) are intent on their text, oblivious to the flapping of the bird's wings, which is amusing to everyone else because it adds an element of the ridiculous.

Another woman takes the mic and speaks "*en contra*," the anger rising in her voice. People finally settle down, and in the quiet the reverb completely fills the space. A smattering of whoops and applause, as with the others, and then the din starts right back up.

With the exception of the bloggers and a couple of others, the people who are speaking seem unsure of themselves up onstage. Sometimes the awkwardness lands lightly, and

sometimes not. There are a few flashes of the operatic oratory that's been a staple of the island's public space since that day in 1959 when another dove had landed on another speaker's shoulder. A young guy bounds onto the stage after the longest of several uneasy pauses, and as he exhorts people to speak up he gestures in a classic Fidel-esque kind of way, his hand slicing up and down with a pointed finger. It's not evidently a parody. After him a skinny teenager blabs on about doves, and their meat, and feathers—this time an unmistakable send-up of the *Commandante*. Rumor had it that he was trying to impress a girl.

The politics are all over the place. Someone talks about hunger strikers in Cuban prisons. Someone with bad Spanish pumps his fist in the air and shouts old slogans to the slightly embarrassed crowd. A woman declares that "millions of children are starving. None of them Cuban!" One guy pleads—addressing the authorities this time, not the assembled crowd—that the performance not be banished from the national media (it was). Eugenio Valdés, a respected curator and critic (also living abroad) goes up and refers to an infamous meeting in the early years between Fidel and intellectuals. "I only know that I am afraid," the great writer Virgilio Piñera is said to have remarked on that occasion. "Me too," says Eugenio, and there's a small grace note as he walks away. There are some soapboxers, denouncing everything from a recent home raid by State Security, to the unavailability of biennial catalogues for Cubans (there are plenty for foreigners), to violence against women in Ciudad Juárez. The level of polemic rises and falls. A woman screams into the mic. When someone asks for a minute of silence, "for ourselves," it's the first and only time that the room's energy focuses.

People are constantly gabbing and joking, and sometimes they look amused by what's being said or done onstage—even

if it's very self-serious. They're behaving like an audience, in other words, rather than a multitude, enjoying the performance as performance more than getting whipped up by it. It's only when there's a rallying shout from someone near the end that you realize the absence of things like that—no chanting in unison, no sense of the crowd organizing itself into a voice. There's no big catharsis, no major poetic moment, just a lot of stabs in various directions.

It's a strange kind of narrative space, never accumulating energy or building in some dialectical kind of way. The long stretches of dead air never find a rhythm, and the reactions to each speaker pass quickly. The waiting puts pressure on whatever happens next. Time tends to draw out. It's a meandering and unsettling kind of thing, impossible to discern a shape from within it, so whatever is around the edges takes on weight: the jostling and chatting, the constant flashes (meant to make people feel more important), the booming sound and difficulty of hearing, the flapping bird. At times it feels like the whole thing might just drag to a halt, nobody doing anything and nobody knowing if that would be the end of it or if it was a waiting game, where as long as people stuck around it would keep going. So Tania at least gave it a shape by giving it an end. It did seem odd that she thanked the Cubans specifically.

What happened that evening read differently to different people. An open mic and people demanding freedom was just extraordinary in the Cuban context, even though it was also something closer to political kitsch. It's possible that the discrepancy owed a lot to the incompatibility of the various historical memories in the crowd. Judging from reactions at the time, the awkward and self-conscious declarations were moving for some but depressing evidence for others: "nothing more than the reflection, and maybe the least of

the consequences, of the constant 'nobodyizing' [*ninguneo*] that we've been subjected to for so many years," as one guy put it. "Fleeting phrases, choked verbs in which, with some exceptions, you could see the thick and viscous patina of fear."[2] Depending on whom you asked, what happened was the germ of awakening defiance, the cynical maneuvering of regime strategists, evidence that "freedom" means the same thing everywhere, and, equally, evidence that a concept of freedom transported from one place to another will turn into a performance rather than a realization of itself. The performance did once again ratify Cuba as an incubator of radical contemporary art, and it convinced some reporters that change was definitely coming on the island. It was proof, for others, that the regime always gets the last laugh.

The huge curtain made everything look important. The incandescent yardage stretching up over the speakers' heads, the symmetrical tableau, the cameras, the lights facing one way at the stage and the other to catch the crowd, all lifted the patio and the hour into an iconic frame. The people were dwarfed by history and larger than life. Still, it all unfolded in a real time full of stutters, gaps, and miscues: The instantly recognizable image was dragged to the brink of itself by that buzzing, distracting mirror. There was tension between the naturalism suggested by the artist yielding control and the performance's extreme artifice—what was offered was not in any sense normal. All this made it charged and unsettling, and the obvious, looming question—would the police come?—made it jittery too.

There was wonderment that such a thing was allowed, and the first part of the answer why is that there were just too many foreigners for anything serious to go down. Anyhow, in Cuba, art—as the event made absolutely plain—is given a lot more latitude than other kinds of expression, at least as long as it's somehow useful to the government's overall objectives

(an "aesthetics of foreign policy," Laura Kipnis called it).[3] There are probably other reasons, like that it could provide catharsis in the paralyzing, Brechtian sense, and some even speculated that the performance gave the regime an excellent opportunity to take the temperature of general discontent, "recalculate their methods, and more."[4]

Another part of the answer has to do with the artist's status: She had to be firmly inside and outside at the same time, or she could never have pulled it off. Without her international reputation built around confrontational "political" work she'd be just another troublemaker, and the performance at the mic would have had to be read strictly within the Cuban context. But if the art world calls her "daring" and "important," then that makes it inconvenient for the Cuban authorities to call her counterrevolutionary. A couple of things are going on here. First, the relatively level playing field puts us more in the realm of constraint than brute force, and, second, they were playing from different sources of strength. Yoani's fatal flaw was to operate from the same system, and with the same language, as the regime, but the artist brought in an external source of leverage and deployed a compensatory form of power. She changed the price of responding to the provocation.

But anyhow, the piece took place as much offstage as on. As usual in Cuba, it had to be approved before it could be allowed and described and explained in detail in order to be considered. Though they're the work's hidden aspect, those negotiations were quite possibly the most artfully elaborated elements of the whole piece. By her own account, the artist confessed her worries in the course of those exchanges, but she gave them such an anodyne face that the image of what might go wrong—either total silence or joking around—didn't sound all that bad. The ostensible framework for the performance was a series called Tatlin's Whisper, which con-

sists of restaging media images that have gone stale from over-familiarity. (Earlier pieces included herding people around a museum lobby with mounted police and a bomb-making workshop.) It's hard to believe that officials could have been ingenuous enough to buy the idea that, in restaging Fidel's early triumph—sort of—the artist was intent on giving the audience a "direct experience" of that historic moment, one that they'd "understand and that [would] belong to them because they have lived it."[5] It's hard to believe that they might have fallen for her misdirections, but trying to divine what any of the players may have really had in mind is a fool's errand, and the main point is probably just that the various parties saw strategic convergences in the scenario, if not converging interests.

What We Were Arguing About

By splitting off an hour from the usual state of things, the performance made the lack of free speech in Cuba palpable: It made truth distinguishable from power. This didn't really resolve anything in a large or empirical sense, because it did nothing to alter the base condition of an entire society being silenced. It's a good (and painful) question whether we can expect art really to do anything about that, and the discrepant reactions to the performance had mostly to do with how actively and directly anyone thought that art can or should try to change the world.

In any case, the hour was extraordinary and historic, and it happened because it was art; that is, it made a space that would only be allowed to exist in art. It unsealed art's relatively permissive space and made it accessible to people who were normally at the bottom rungs of privilege. (From the bloggers' perspective, I suspect that the "artness" of the

occasion was secondary at best, hence Yoani's statement the next day that "it was an artistic action, but there was no game in the declarations we made. Everyone was very serious.")[6] It was a masterful deployment of art's privileged status, but nonetheless it was definitively art, and that's why, even afterward, official retaliations were minimal. Bruguera's ending the piece after an hour was the final feint: It really was (just) art, that seemed to say. It would not be allowed to become something outside the boundaries that had been announced; it would not be allowed to continue until it found its own natural end.

Part of the work's punch came from the fact that, beyond sharing her leverage, Bruguera flaunted it. It was a tricky balancing act: Without identifying with either of two irreconcilable parties, she acted as both. This flew in the face of all those ideas about artistic ethics that insist on rejecting and opposing the apparatus in order to remain outside, uncoopted, and uncorrupted. It also played against the rules of the game of revolutionary compliance, for obvious reasons. Bruguera's personal capital has both cultural and political valence, it works in both the art world and in Cuban circles of power, and each part has been built up by virtue of the other. The toughness of that double origin kept the work from lapsing into the romantic melancholy of so much political art and steered it clear of romantic protagonism. But the failure of the performance in rhetorical terms (the bulk of what was said was just too null, in either political or poetic terms) was the orphan space where it landed—not exactly art, not exactly insurrection. Although the set had pointed in a more imperial direction, what played out on it was something more like a real—as opposed to ideal—political subject: impeded and constrained, implicated in all kinds of ways, struggling for words and struggling with the fact of

being made public. Rancière has been unsympathetic on the question: "Those who want to isolate [art] from politics," he says, "are somewhat beside the point, but those who want it to fulfill its political promise are condemned to a certain melancholy."[7]

Another thing we were disagreeing about was spectacle. There have been all kinds of fantastic capacities imputed to theater: It's "an assembly where the people become aware of their situation and discuss their own interests," as per Brecht, or "the ceremony where the community is given possession of its own energies" (Artaud).[8] Although those two doctrines differ in important ways, they agree on the problem of spectacle, and while the argument I've been sketching about Bruguera's piece fits pretty well with those doctrines in terms of what happens to those who are assembled in a work, it's undeniable that her performance was intentionally and unapologetically spectacular.

Spectacle is bad because it's externality and separation (Debord), which is apparently antithetical to the connection and agency (the "infused spectator")[9] that's at the heart of this whole argument. But Bruguera put it at the center of the work and depended on it for fuel. (In fact, she built a spectacle around the spectacle of Yoani—lionized around the world, read by millions every month and denounced by others for her darling, superstar status.)[10] If spectacle is deception, then it's worth remembering that performance and deceit are basic to Cuban life. The artist embraced spectacle as an inevitable part of the scenario and let the full range of contradiction be visible and operative: the choral and riven social body, the trace elements of utopianism and the "choked verbs" of stunted discourse, the farce of historical iconicity and the continuing force of it, the vainglorious impulse to get up on stage, and so forth. In other words, rejecting the equivalence of externality and separation, playing on the very fact of ex-

ternality—the alienating rank of He at the podium—and owning it. Spectacle condones distance, but distance is the normal condition of communication. People know how to negotiate it, especially when they're subjected to it in the extreme form that is the Cuban political arena, and that night in the patio they took it up with a vengeance. Spectacle gave the performance a heavier charge than a more earnest staging would have managed.

The spectacle was theatrical and a little silly and pompous, too, but it was astonishing, and all of that emboldened a couple dozen neophytes. Strangely, it had a less serendipitous effect on the bloggers who were, indeed, "very serious" and came off as strident. This was ironic, since the voice of their blogs is sarcastic, witty, and most of all plain, and that's why Yoani is called the voice of her generation. That voice, which has been so wildly influential exactly for its lack of cant, turned fulsome on the podium: Others "found" a voice, but she lost one.

For her part, Bruguera has a particular relation to the question since her career, synchronous with the rise of biennials and megashows, has been mostly staged within those premier showcases. There has likely been a complicated back and forth between their demands of splashiness and her tendency to create conflicts that read clearly at a distance. It is easier to argue, at that focal length, on behalf of the sudden and the surprise and less necessary to quibble over what actually gets said or how well the anger gets husbanded into force. Maybe that's what to make of the melodramatic scenarios, of how close the dead-seriousness comes to farce—maybe the best political weapon that an artist has. The problem with all this might just be that farce, unlike more supple or forgiving narrative forms, depends on momentum—something that couldn't develop that night in the patio because none of us (and here I'm projecting) could quite figure out what the stakes really were.

A Hypothesis about Why Work
Like This Feels So Uncomfortable

Recent works—the mic, the horses, taunting an audience in Bogotá with lines of cocaine—come at a time when Bruguera has built up enough leverage to be strategic, to exercise strategic maneuvers. Maybe this is one reason they can feel so iffy, because they're her building power and testing it, while arts discourse in general is bending over backward in favor of a tactical approach.

These days in art it's all about tactics. Tactics are how guerrillas fight; they're intrinsically inventive and unorthodox. Tactics are for people unencumbered by a home base they have to protect, and art likes them because they're associated with wit: Tactical trickery is a witty handling of weakness. Being tactical is a way to live in ripple effects of refusal. It's agile and observant and bold; it hands you surprises, "cracks and lucky hits in the framework of a system."[11] Power, meanwhile, plans, and the strategic plods along with its force in heavy tow. It seems like a pretty risky artistic strategy to take on the role of power, to be willing to be associated with it in political and moral terms. Maybe it's just because Bruguera grew up with the experience of an absolute form of power, but it seems to me that she's not very romantic in her view about the struggle against it. At least, not romantic in the ways that contemporary art has tended to be, with its resort to micropolitics and convivial relations. Artists rarely align with power, and when they do it's generally in the form of money, but Bruguera designs situations where she wields control, even manipulation, and she does that unapologetically and, apparently, unreservedly. Tactics are opportunistic, non- or extrainstitutional, but Bruguera's performance at the mic waded deep into the negotiated, compromised territory of the most intransigent

institution, the place where the state's performance is most artfully choreographed.

Strategies privilege spatial relationships. This has to do with their function of claiming their "own" place and having the power to defend it. This tends to reduce temporal relations to spatial ones,[12] which sounds right in relation to the particular not-adding-up quality of the stint at the mic or the horses in the lobby, for example. The gist is that the spatial setup comprises the work rather than any dramatic unfolding in how the crowd navigates the situation. And hence perhaps the artist's odd description of her own role, disavowing direction: "My work is a participatory work, I only extend the invitation."[13] In any case, the heavy tableau-like condition also has implications for what kind of afterlife the performances have: They're easily fixed, whether in memory or recorded image, and the reduction actually seems to amplify the work. It survives stunningly well as afterimage.

Maybe we could also claim that tactics have a proclivity for the emotional, and that also gets sidelined in Bruguera's role with the mic. Dissidence is a fiery game, and its currency comes out of passion, but her strategy is unfathomability. ("I only extend the invitation.") She claims the advantage of enigma; she reveals practically nothing and speaks in a flat-footed way that sounds like the opposite of intrigue. It's the formless, in some military thinking, who have the better chance of emerging intact.[14] She stakes a claim of ethics and proceeds in cunning, defying the usual location of the ethical in the visible, as though ethics without cunning is like knowing how to sow but not to reap. Her dispassion is discipline, attentive to the five martial errors enumerated millennia ago: to be too willing to die, too eager to live, too quick to anger, too puritanical, or too sentimental.[15]

And then let's add this: Bruguera adopts the strategic plane but seems to want her audience to reply tactically:

In that sense, they would be "citizens." But here's a co-
nundrum, because Being Citizens can consist in anything
at all that they decide to do or say—the specifics don't
matter. I can accept the idea that she adopts the position
of power in order to deploy it as an artistic field, but in
actual situations power is not OK with failing to elicit the
reactions it seeks or to exercise the control it exerts. So
she is using the methods of power but amputating them
from the controlling logics that would normally give rise
to their use in the first place. I'm not sure what this gives
us: Does the abdication of control over the ends effectively
annul it as a real situation? Are the relations that are set up
authentically political if they're so confected? Can there
be any real politics in it?

I guess the answer depends on whom you ask. It's cer-
tainly true that politics has a pronounced theatrical aspect,
and this is especially the case in Cuba. For some, maybe
holdouts from a time when the lines were more clearly
drawn, it's troubling that the emancipatory fiction of the
open mic modeled but didn't actually deliver. But on the
other hand, maybe the problem for politics these days is
not to contradict appearances but rather to confirm them,
to deprive them of their palliative illusions. Another way
to ask about politics might be in relation to subjectivity.
Presumably, the idea was that by getting up and speaking
out people would experience some enhanced independ-
ence or autonomy—the classic prerequisite for political
action. Was that the dividend paid out by the uneasiness
that the performance gave rise to? Or was that old idea
of a collective consciousness just refurbished, leaving the
exhausted ideas of consensus—and their implicit claims to
ethics—undisturbed? This is probably why Lupe was key,
but I'll get back to that later.

Back to spectacle for a moment. The spectacle of the performance, the spectacle of Yoani, struck some people as just too quick to satisfy Western expectations of "the dissident," too satisfied with the black-and-white fables ("free speech," for one) that attract foreign sympathies. In this version the catharsis is secondhand, the "second tear" that kitsch sheds as it watches itself being moved. This would apply no less to novice Cubans than to jaded international culturati. But the even queasier question is about aftermath.

What Happened (Round Two)

The things we were arguing about had to do with the experience we'd had that night, but now we have to talk separately about the places where the performance took root afterward, since they totally eclipsed the event. The work went viral, and within a couple of days there were videos, wire stories, blogs, interviews, and rumors, all circulating urgently. Very quickly, it didn't matter what had been said or by whom or whether it counted as politics: What mattered was the bare fact of the mic and its apocryphal revolt.

The first wave was ecstatic. The performance was global news, generally running under headlines about things like "the winds of freedom."[16] "The crowd looked on aghast and exhilarated," the *Independent* gushed in London. "The government branded those involved as 'dissidents.' Too late: Havana had tasted free speech and it was electrifying to watch."[17] A video excerpt on YouTube was getting hundreds of hits as soon as it went live. Miami was all over it. Yoani wrote about it (her blog is carried in translation by the *Huffington Post*), and lots of other people did too. The performance's strong signs had a short lifespan, but they proliferated afterward as snippets, tall tales, and rumors—

weaker, but dispersing easily and profusely. That kind of
mass production of weak signs is exactly the kind of political
ferment that you get at the intersection of a networked age
and a clandestine society.

The next wave came from officials, and it was harder to
figure. A couple of days after the event the organizing com-
mittee of the biennial denounced the "mediocre political
take-over of an artwork" by people "far from culture" ("pro-
fessional dissidents . . . paid to manipulate public opinion,
lie, censure, mutilate and systematically limit the freedom
of speech and thought"—all of which are crimes in Cuba).
But like all such communiqués the wording was precise, and
while it read like a Stalinist screed it was also careful not to
implicate the artist. A couple of days later the Cuban minister
of culture told the leftist Mexican newspaper La Jornada that
Bruguera was an exemplar of revolutionary commitment.[18]
Many people took note of the apparent anomaly, and specu-
lation was rampant: The artist won, but she won ugly, saddled
with all that approbation.

The performance was "consummated," according to vari-
ous perspectives, in its aftermath.[19] Yoani called the biennial
committee's statement the work's completion, and others
said it was the minister's comments that gave it a real close.
Either way, the idea was that things should definitely not
be taken at face value. Meanwhile, the business of "saving"
Bruguera's position of apertura ("rescuing her in the corral
of positive critics")[20] required the negation of Yoani ("that
famous blogger muchacha," Minister Prieto had called her),
since conquer must proceed from divide: The next best thing
to winning outright is to break the enemy's alliances.

Another possibly helpful side note: This all happened right
after what had been maybe the most shocking and unnerving
among the many shocking and unnerving political purges
that had happened since 1959. Just a couple of weeks earli-

er, and following some nasty remarks by the *Commandante* about the "honey of power" and the corruption of others, two of the highest-ranking members of the Central Committee had suddenly resigned from all their various state and party positions, with practically no explanation.[21] Likely, the culture minister had not yet forgotten just exactly how unstable anybody's position really was. Sure, in one direction he was telling the Latin American Left that Cuba was open to discussion (and sure enough, there were comments in response talking about the singular dignity of the Cuban project despite, of course, the imperialist aggressions),[22] and, in the other direction, he was telling the party that things were under control. The first line was the official one, and there's a good chance that the second one was pure survival. Prieto is no novice, and he speaks the language of "Yes, but . . ." to perfection: Yes, he supports the "critical spirit" of young artists, but it's not anything different from the ministry's own "analysis," and they're all together in the business of "defending the utopia." Yes, the artists are "reflecting on problems," and so is the ministry, but the problems are basically ones of bureaucracy and inefficiency—which might surprise those critical spirits who tend to focus more on things like the lack of democracy. His job is to adulterate the plural message of the work and collapse it into a universe of For or Against the revolution—exactly the terms that Fidel had set up in 1961. Back, for a moment, to the issue of using power. Of course the minister is using the artist, but the question was whether she had used him equally well, whether she had jangled the dynamic between the two halves of Machiavelli's old centaur—force and consent.

So, the net effect flies in all directions. The postpartum denunciations of Yoani "completed" the work of Tania because they exposed the "liberalizing discourse" as a lie,[23] and meanwhile the whole episode remained invisible in

the Cuban media, even though the vice minister of culture was there and even though national TV recorded the whole thing.[24] The flamboyant gesture embarrassed the regime and made it look good. It made Tania look daring and valiant and like she has way too much latitude with the powers that be ("They've treated me with kid gloves . . . maybe too well"). She makes a space that can be claimed by angry, dissident Cubans *and* by the minister of culture. We might be dealing here with the point at which polysemy crosses over into fatal ambiguity, or it might just be that that was all that was possible. (Or maybe the point is that a tiny step counts because it's a step. To gauge the scale of possibility, Bruguera's words are chilling: "My work is to push the institutional limits and theirs is to preserve them, and in this 'dance' we all know what we're doing and that the music will stop. . . . [But] the dialogue has been strictly with the directors of the biennial and the Ministry of Culture, and not with other political organs, and that's an important step; I haven't been forced to sign anything.")[25]

In Reverse (Lupe Crying at the Mic)

The performance's fate was that it ran in reverse. It climaxed before it got going, and then it had to keep reaching for a thread. It was the opposite of what a rally is supposed to be, in other words, which would build to an emotional crescendo that convinced people about the truth. Nor was it like that earnest vein of works yearning toward dialogue or reconciliation: It was set up for sharply punctuated, individual utterances—likely unconnected from one to the next, likely unsatisfying in terms of any of speech's jobs other than the one of catharsis. Its register was loss more than defiance because precisely in the act of defiance it found debility. Without even meaning to, the performance reversed and

annulled the forward obsession of the horizon machine. It refused to resolve anything. The dialectic, as Adorno once said, swings to a standstill.[26]

A lot of how an artwork works has to do with voice, and we usually want that voice to allow us some intimacy with it; with Bruguera, we get the opposite. Another part is structure, and we usually want that structure to find its way to an end, but Tania wants a hung jury. Another part is proportion, how it fits into the scale of the world or our experience, and Tania tends, more and more, to be in some bigger or louder or angrier register than we are probably expecting. And then there is perspective. Cause related, convinced, and vehement, Tania's work never seems to split the difference with irony or skepticism.

Catastrophe is the backdrop and the currency. In Beckett's play of that name, the eponymous event that is the sole subject of the play within the play is finally made present by way of minuscule scenographic adjustments: Pajamas are rolled to the knee, clawed hands are clasped, and so on. Tiny indicators adding up to a vague sense of malevolence. Tania, working some decades further into the disaster, turns up the volume and creates a fracas to confront that catastrophic state of inertia. One is testament to the annihilation of the heroic bourgeois subject, and the other engenders something along the lines of his return or, at least, his replacement.

It was interesting that the more articulate ones in the crowd—and they were there—didn't take up the offer. It would have been a better rally if they had. Maybe that was because of how schematic the idea seemed—that the fact of the mic signaled anything like real freedom to speak or that the work's tiny oasis represented any kind of real political space: that being free to speak wasn't the same as being heard. The deliberately pictorial quality of the mise en scene accentuated this. This was a failure, at least on some level:

Rosa Luxemburg notwithstanding, the most revolutionary deed probably is not simply to state things as they are. The performance set out to refuse an annulled political condition and wound up performing it instead.

But what really happened? Sure, "free speech" is mostly an alibi anywhere, concocted in the service of mostly dishonest ends, but, even so, it's different in a police state. I could argue that it mattered because it was at least something, even if not much, and there would be some truth to that. I could insist that, although the words didn't add up to much of anything, in any case that night the illusion of total control took a hit. Weakness was made visible, and something unknown was—almost—imaginable. The performance connected to history and put art back into a historical scale, a historical ambition. But like repetition generally does, while the performance destabilized the original podium, it also endorsed its undertow, and arguing for the artwork's parenthesis of good runs the risk of sidestepping the substantial dilemmas that it set into motion. The performance in the patio was full of painful contradictions, and that was Step 1. And then Step 2, the afterimage, which framed the performance as refusal, traded the off-balance feeling and reduced the emotional room to maneuver because it settled the question of what it was that had happened. Seen in the frame-within-the-frame-within-the-frame, the troubling ambiguities—that sketchy participation, that centrifugal sociality, those unclear edges—stopped making you anxious for things to add up. And then, the final step. The piece begins with the unbearable charge of Lupe's feeling and ends a year or so later when it's restaged in a suburban museum north of Manhattan. The symbiotic-neurotic relation between originals and copies stalls out, leaving behind the stray and frightening intensity of the upsetting and implicating moments in the patio.

The performance in the patio ran in reverse. It began fallen, from the catastrophic condition of Cuban society and from the slack commitments of Cuban art. It wasn't really unpredictable what people would do that night, and the only real question was how far they would go. And Lupe, who couldn't go anywhere once she got up there, nonetheless went the furthest. It was Lupe who nailed it when, on the brink, she opted out of the language of the patio. Lupe at the mic, crying in the name of nostalgia, regret, frustration, impotence, confusion, anger, and lots more besides. It was because of Lupe, wrenched apart in an artwork's truce between miserabilism and triumphalism, that I couldn't get that night out of my head.

Postscript

I wrote this text in July 2010. Since Bruguera's attempted reprise of this performance in December 2014, I have debated whether to expand or revise, in light of those subsequent events. What follow here are thoughts about that return to the third power.

The 2014 iteration was to have staged an open mic in the middle of Havana's Revolution Square, the regime's central space of symbolic power and authority. As was copiously covered in both the arts press and in mass media at the time (copiously, that is, in many places, except Cuba), the performance was shut down before it began, and the artist was arrested and then detained on the island for a few months. She became a cause célèbre.

That iteration, like the earlier one, gave rise to a fractious debate between supporters and detractors. What was notable, though, that next time around, was the locational split—namely, the virtual silence on the part of artists in Havana—their lack of support. The only one to speak out,

and critically at that, was Lázaro Saavedra, who was promptly attacked—by figures outside the island. Some observers have attributed that silence to fear and/or self-interest on the part of Cuban artists, but I question the sweeping condemnation of that position. And so, questions about things like what comprises "useful art," in political terms or about who is the actual audience for the work again come into focus.

Sequelae of that 2014 return included the establishment of the Instituto de Artivismo Hannah Arendt and then Bruguera's call to fellow Cubans to offer themselves as candidates for political office when President Raúl Castro stepped down in 2018.

At base, Bruguera's performance was about the sea change that's been going on for quite a while in Cuba, in which the national focus has been shifting from a dream of social ethics to a savage capitalism that dreams in the private confines of property. In a recent interview, she had this to say in response to the perennial question about what art can really do:

> I think art, because it's art, and because it's about what you feel and it's about things that are not put into words, it's about what is happening, the fluid of life, things we don't understand and want to get at and to know what it's about, gives you a space and a leverage to talk about things other people don't feel they have the language to speak, or are afraid to talk about, because in other contexts it is forbidden.[27]

Art, in other words, is that bridging space that speaks about, acts upon, and moves into intelligibility that which we need to understand.

In the case of Cuba, "politics" is a particularly brutal description of failure. It is tempting to hope that this trail of returns just might have some real impact in this extremely tricky and fraught moment. That the repercussions of the

performance, in both its iterations, catalyzed response only from the quarters that it did, however, leaves that as an open question.

2

The Tenuous Moonlight
of an Unrequited Past

After September 11, 1973, Santiago de Chile,
in The Battle of Chile, Chile: Obstinate
Memory, *and* Nostalgia for the Light

Later others will arrive; we are also the people yet to
come. What do we do with that inheritance?

— PATRICIO PRON,

MY FATHER'S GHOST IS CLIMBING IN THE RAIN

The filmmaker known above all for his insistence on remem-
bering—his resolute mission since the unraveling mayhem
of 1972–1973 Chile—begins in 2010 with a ruse: gentle and
roseate in tone, steeped in the golden light of reminiscence.[1]

Back in 1972, he had written an urgent letter to his friend
Chris Marker:

Our political situation is confusing and the country
is in a state of pre–civil war, which is causing a lot of
tension; the bourgeoisie will deploy all its resources. It
will deploy the bourgeois legal system. It will deploy its
own professional organizations together with Nixon's
economic power . . .

We must make a film about all this! . . . A wide-ranging piece shot in the factories, the fields, the mines. An investigative film whose grand sets are the cities, the villages, the coast, the desert. A film like a mural, split into chapters, whose protagonists are the people and their union leaders on the one hand, and the oligarchy, its leaders and their connections with the government in Washington on the other. A film of analysis. A film about the masses and individuals. A fast-paced film vibrating with the energy of daily events, whose length is unforeseeable. . . . A free-form film that draws on reportage, the essay, still photography, the dramatic structure of fiction, the sequence shot—that will use everything, depending on the circumstances, and the way reality proposes it.[2]

But then, almost forty years later, he opens the narrative with this:

These objects, which could have come from my childhood home, remind me of that far-off moment when one thinks one has left childhood behind. They could have.

The objects in question are the simple ones of a quiet domestic space, aglow in the softness of afternoon sunlight. We are apparently, again, in the realm of document and representation, except that we're not: "They could have" come from his past, but they don't. If, before, we had needed truth, proof; if that was the imperative, then now, it seems, we need something else.

I had first seen *Nostalgia for the Light* (2010) not long after coming home from that meeting in Lima mentioned in the Introduction. The group was mostly of an age that would have placed their parents as protagonists and/or victims of that

brutal period, and the meaning of those years was a matter
of tremendous urgency for them. It seemed to me that, for
them, the exhibition project was a ferocious act of vindica-
tion. For his 1997 film *Chile: Obstinate Memory*, Patricio
Guzmán had shown his earlier film to groups of young people
who were contemporaries of my companions in Lima: That
film (*The Battle of Chile*, 1973–1978) had documented the
mounting conflict over Salvador Allende's Unidad Popular
government and the coup that ushered in a seventeen-year
period of state violence, during which some one hundred
thousand people were tortured, three thousand of them
disappearing into presumed but never verified death. The
government of agreements that had succeeded the generals,
in 1989, had assiduously followed the policy of silence set by
their predecessors: While each of the affected countries in
the region had set a distinct course in the administration of
remembering, among all the amnesties and pardons and tri-
bunals, Chile was exceptional in its dedication to forgetting.[3]
There were reasons for this (not least among them, cautions
from Pinochet: "If anyone lays a finger on one of my men,
the rule of law is over"),[4] but the upshot was that the radical
ideas and the optimism of that "revolutionary tide"[5] were
canceled out as legacy, substituted by some attention to the
aftermath's individual victims. The broad societal legacy of
a revolutionary coming-into-being was expunged, and legal
procedures indemnifying the perpetrators and pieties of un-
certain consolation were inserted in its place, all amid the
encompassing neoliberal philosophy of governance that had
been installed by Pinochet (aided, famously, by the "Chicago
Boys").[6] And so, at screening after screening in Santiago in
1996, Guzmán's epic had been met with angers rehearsed in
the 1970s and left unleavened by the intervening years (the
claim, essentially, that the coup had been necessary in the
face of communist threat): Only toward the end, when it's

shown to a group of young people related to victims of the dictatorship, does the film elicit a reaction more redolent of a national catastrophe.[7]

There can be no return to that fused, intimate sphere of the childhood home or, for that matter, to the fierce certainties of that other time's commitments. The next generation receives the past as inheritance: They live its aftereffects, they live it belatedly. Their "postmemories" of it are mediated less through recollection than through imagination,[8] creating space (as many hope, and some are able to believe) for transformative effects.[9] But for that process to stand a chance, we need to access the past by way of a different kind of narrative than a historical one: We need a way of rendering visible that doesn't have a horizon or, anyhow, doesn't have one yet. I don't think that comprehension is delivered or even offered in *Nostalgia for the Light*—it's there only as a not-yet. ("I believe," Ellen Willis once wrote, "that redemption is never impossible and always equivocal.")[10] The filmmaker needs displacements in order to tell a story that can't be narrated. The space of generational transition is one way to do that, and another is a different way of making sense, a way of listening not pointed toward hearing (or, not yet), to know about what it was that happened. If trauma is fundamentally untellable but needs nonetheless to be told, then we need—the filmmaker seems to say—to leave the usual world of time with its narrations leading from then to now to then-to-come.

And so Guzmán takes us to the Atacama Desert, another world in this world, a "planet of the past,"[11] to stage his reflections on the nearness and distance of the past.

Flashback

Guzmán made that first film and called it *The Battle of Chile*. He edited it in exile in Havana with Marker's help and also

that of Alfredo Guevara and Julio García Espinosa—iconic figures in their own right in the movement of "Imperfect Cinema" that was giving voice to the utopian, anti-imperialist energies swirling throughout Latin America. Patricio Guzmán, exiled from Chile since just a couple of weeks after the coup that killed the democratically elected socialist president Salvador Allende, sat in Havana making his epic, absorbed to such a degree that it was not until the years-long process was completed that it really sank in that his own life had been torn apart, that he had, as he put it later on, "no country, no topic, nowhere to go, no future."[12] He had shot that film in the midst of cascading events, starting from the realization that Allende was already in trouble, and chronicling the collapse. Guzmán told the story of *The Battle of Chile* in three parts, beginning near the end ("The Insurrection of the Bourgeoisie") and following that with the coup: Oddly, he waits until the last chapter to put the "power of the people" at center stage.[13] Actually, he begins right at the end: The prelude is footage of the bombing of the presidential palace; thus the entire film is in the form of a flashback. We begin by knowing the ending, and we calibrate everything that happens in the nine months in between against that eventuality. The film starts from what is, for Guzmán, a catastrophe, and in the course of its four and a half hours it toggles back and forth from one irreconcilable side of the conflict to the other, constantly searching for some dialectical building up of a future sense but finding inevitability instead. The film starts from and even is itself punctuated by catastrophe, since the last shot of part 1 is of the cameraman filming his own death: A soldier aims and then fires, and the camera falls to the ground. The film is no hagiography: It's candid about the conflicts within Allende's coalition and about his inability to reconcile them, and that opens searing questions about why it failed. By the time Guzmán gets to the subject where his

considerable sympathies lie, it's in the realm of elegy—the antithesis of culmination.

The Battle of Chile was hailed as a masterpiece, winning prizes and accolades ("landmark," "spellbinding," "overwhelming," "thrilling") on several continents, though none at all in Chile, where it could not be seen. General Pinochet was voted out in 1988 in a turn of events that was not supposed to have run that particular course, but despite that the change that came was a guttered one. The Transition—"pacted"—elevated the leaders of the democratic opposition but hemmed them in within the institutional framework put in place by the dictator. "Transition," then, referred mostly to personnel, and even some of them remained in place: Pinochet retained direct authority over the army for another ten years and held a senate seat after that, and the congress seated a contingent of "designated" senators, among various other provisions designed to protect preexisting lines of power.[14] The 1980 Constitution, along with a "self-amnesty" decreed by the military in 1978, remained in force, clear proof—in case any was needed—that the transition was an agreement among political elites: This led to a government that was nominally social-democratic but with the market as arbiter of value and with an ascendant business class "impatient of reminders of the past, and guided by pragmatism."[15] The pact was with the past.

The first postregime government was led by the same man who had engineered that state of civil war,[16] and he presided over a fragile "consensus." That fragile "consensus," the "democracy of agreements" formulated by the Concertación marked a passage, as Nelly Richard puts it, from a "period of politics as antagonism . . . to a politics of transaction."[17] That fragile "consensus" needed to disguise its continuity with the past with the pseudonovelty of its "discourse of change."[18] This placed a strange pressure on the process of transition,

since the past was quite literally not past: There had been no real break from it.

The Transition was smeared in other ways too. The subject of torture was excluded from the Report of the National Commission for Truth and Reconciliation.[19] Although state violence was recognized to have occurred, it was never recognized as criminal, and so legal procedures could aspire to discover the fate of a particular individual but couldn't do anything about it. The Transition process was premised on a baseline of reconciliation, which in turn implied some process of forgiveness. The problem was that it wasn't possible to name the things for which the forgiving should be done, and there wasn't any contrition either (Pinochet, in September 1995: "It is better to remain quiet and forget. That is the only thing we must do. We must forget . . . FOR-GET. That's the word").[20] Built on a fragile "consensus" that depended for survival on a blotted amnesia, the Concertación governments had to accomplish precisely what, as Juan Carlos Rodríguez puts it, the dictatorship had left unfinished: the erasure of the crimes of the past. "The only way available for dealing with state violence," he says, "was to displace it from its juridical conceptualization as a crime into the non-juridical theatre of national tragedy."[21] The focus on the individual status of "victims" partialized the zones where the tragedy was understood to have taken place, separating them by inference from the rest of the national body and pathologizing anyone who still hurt. The focus on the individual status of "victims" coincided precisely with neoliberal logic, mitigating against a sense of collective social purpose and contributing to a "questionable and convenient dissociation between 'them,' the 'victims,' and 'us,' those who were not directly affected by the climate of fear."[22] The focus on the individual status of "victims" encouraged a belief that the damage done was on a personal rather than societal level and done to only a small

percentage of unlucky ones—already a way of isolating and disowning them—and shelved the trauma into private rather than public space. OK, enough—the Transition seemed to say: Get over it.

In the social space of Concertación, diversity became noncontradictory. "Politics," no longer a momentous concern having to do with struggle between opposing visions, became a "history of small variations, adjustments . . . that only proclaim a pre-reconciled future: a future unburdened of all expectation, freed from the weight of uncertainty."[23] That fragile consensus: that "tranquilizing 'we.'"[24]

The Battle of Chile had thrilled audiences internationally with its tale of valiant struggle, but back at home that struggle was blanketed, anesthetized, disappeared. The government of agreements was a society of agreements, or allegedly so, and it was back to that muted space that the filmmaker decided to return in 1996 to show those people the face of what they were so busy forgetting (on one side) and so ardently attached to (on the other). A year later, a film titled according to Guzmán's own allegiance on the matter—*Obstinate Memory*—traced its way back.

Hindsight

As in the epic we begin with the bombing, except that this time it's colorized, the black and white of the document shifted into a bluish tint as though to say that, by now, those images have converted from fact—events in the public sphere—to the much less certain place of memory. The images are prostheses, and the film has a new task: no longer to insist that something happened but to figure out what, if anything, it might mean now. Ghosts filter in and out as Guzmán and the other rememberers conjure the loss—all except for one, a human rights activist who had lost most of her family to the

violence and who—confronted with a photo of *herself*—says only, "I have my doubts."[25] The camera lingers on her, and it hurts to see because she's so still.

There is recognition that even if the dream had been of unity, of a nation brought together in democracy, pluralism, justice, freedom—that the pact of agreements existed in fact because the disagreements had proved intractable.[26] Allende is marked as having failed, in "sacrific[ing] the ends for the means"—and History now writes the entire episode only in terms of its cataclysmic, spectacular, photogenic end: the energies of the dream lapsed long ago. In The *Battle of Chile* Guzmán had hewed to the classic Marxist view that classes are the protagonists of history, and consequently the film's characters were classes, not individuals. By the time of *Obstinate Memory*, though, they're mostly lonely and bereft figures, filmed within the confines of interior spaces—so contained, in comparison to the raucous streets and union halls of the earlier film's drama.

What had happened to all that energy? Why, even after the return to democracy (more or less), was there no resurgent swell of progressive fire? Why such quiescence, in a country that had a tradition as a functioning democracy, a country with a strong Left and highly organized working class? For one thing, that kind of collectivist project was the antithesis of the "free" markets envisioned by the dictatorship: The opposition to that capital cosmogony was a crucial edit that had to be made to Chilean history. The new Chile became the eternal Now of commodity time (memory, as a form of reuse, stunts consumption). And so the urban working-class protagonist of the early 1970s was decimated and the radical peasant movement wiped out: The new urban economy meant deindustrialization, and the introduction of commercial export agriculture effectively displaced rural workers and peasants. A steady diet of repression finished the job. A heroic,

or even a clearly defined, social subject was hard to identify in the new, "miraculous" Chile after 1973, where collective identities yielded under pressure to the atomized spaces of the market and, somewhat later, the post–Berlin Wall ideological compaction.[27] As for the former militant Left—either returning from exile or else emerging from clandestinity, they were out of place and out of time—"subjects without scripts,"[28] whose visions of heroic resistance, whose codes of honor and morality, had failed.

But these were not the only ones who had been organized. There had also been a massive student movement in the mid-1980s forceful enough to have been credited with much of the momentum that had voted No to another term for the dictator in 1988,[29] but "Pinochet's children," too, had evanesced as a fighting force. It was no longer the hope of a better future that animated them, says Ana Ros (who writes from that very vantage point), "but the threat of regressing from a limited neoliberal democracy to a neoliberal dictatorship: . . . there was no clear space for them in the times of 'agreements and negotiations.'"[30] For them, as for those who had come before, the end of the dictatorship was also the end of their political life.[31] The time of fire had yielded to an amniotic silence.

The time of fire had drowned in the vacuity of the miraculous transition. But we ignore the past at our own peril, or so the rememberers hold, and so Guzmán returns to that enervated landscape with the story of those times that had become so incredibly remote. He returns with that story, in the name of hindsight.

Chilean society had been sharply divided during the Unidad Popular years and before then too, and that was no less the case when the filmmaker returned to it in 1996 to remind people of the price paid for their previous disputes. Hindsight exists in the name of clarity, but what happens this time

around goes against the script. The *Battle of Chile*, seen at last in Santiago (although only in private), now proves the *need for* the coup (a "surgical intervention"), and the coup itself is said to lead in a straight line to the crumbling of the Berlin Wall. At least for some, even most, of the people he shows it to. But in the most wrenching scene, it's the children of militants who find in the film—at last—a narrative that consoles them. This is the catharsis that all this remembering and all this telling has yearned for, and the filmmaker could have ended it right there. He could have filled our hearts with belief in the rightness of witness and the possibility of hope, even now, but instead he does something very strange. A philosophical man pronounces the end of the dream as a mere "tremor," and the falseness of that note slowly infects the entire aftermath of the film. The whole, voraginous slew of feelings we've witnessed, careening among fury, fear, heartbreak, regret, desire—all trumped by this.

Obstinate Memory zeroes in on the personal tragedies recounted head-on by its rememberers. They're pretty stoic, for the most part, especially when they're shown old photos and softly reply: "Disappeared." Not once does the present state of affairs come up—the hobbled political system inherited from the dictatorship, the charges of genocide filed—in Spain—against Pinochet, the deepening divide between those with and those without. It would have been a better political film if it had, and some critics took note of Guzmán's apparent preference for individual nostalgia over collective memory, as though it were the betrayal of an alliance.[32] As though in the contest of scales it's the collective that addresses itself to History, immense in reach and duration, while the distaff register of an individual's memory ranks as nothing more than evanescent sensations. But perhaps the argument being made by the filmmaker is responding to a different question, no longer only about which version of the past merits hallowing

but, instead, about the limits of a political narrative aimed squarely at History.

Trauma

The filmmaker's project for forty years has been to find ways of going back. His returns have moved along a path set out by the task of grieving, and the language of his returns has staked out more and more space for what those tellings might give rise to in those to whom they are told. In contrast to those earlier films that started out with the maelstrom, *Nostalgia for the Light* opens with the gigantic precision of the sky.

The film is resplendent, symphonic from the first, filling the interstices of its doleful recollections with the staggering imagery of interstellar space. They are images that surpass the real and incite wonder, and they are best seen, as it turns out, from Chile's vast Atacama Desert. In that place there are three groups of searchers, all looking to the past, and so the filmmaker weaves together the questions of astronomers, archaeologists, and the bereaved: How is it that the universe exists? From whom do we descend? Where are the corpses? The desert's air is so transparent that it's the planet's natural observatory, and its saltedness and dryness have mummified the remains of those who traveled across its ancient trade route, millennia ago. And during that awful interval after 1973, the Atacama was, in its remoteness, the junta's preferred site for dumping bodies. In that place, the mothers of the ones who disappeared return in an excruciating ritual day after day and for years on end, scraping the desiccated surface in search of fragments.

It's a long time before we meet them, though, and so after the opening softness of the childhood reverie the film expounds on, first of all, the nature of time. The abstract awe of stargazing is, in part, because in looking out into space,

we're actually looking phenomenally back across time, and that's very hard to fathom. If remembering depends on the stability of time—enough stability for there to be a clear demarcation of then and now—then what kind of memory can we have if, as a young astronomer explains, the "present" doesn't exist? If we experience everything only in the delayed time that it takes, for instance, for light to arrive? He makes a cosmic argument that, at least on some level, it's the past that is more graspable than the present, to which the filmmaker suggests: "The present is a very thin line," and the scientist, in reply: "A puff of air would destroy it." "Only the present moment existed," Guzmán had said of that innocent, far-off time intact in the past, but now the present was barely hanging on, a phantom unrequited in its effort to strike a deal with the drastic unknowns of the past. "That noble venture, which woke us all from our slumber," the filmmaker had said elsewhere, "that time of hope is forever engraved on my soul."[33]

We spend a long time in these disquisitions, half of the film absorbed in their existential wondering and rapturous beholding. Only after all of this does Guzmán bring the conversation around to the topic we expect. Only after tracing the glyphs painted onto rocks ten thousand years before, only after looking hard into the night sky does the film turn to the layer that mediates between the deep pasts of rock face and starlight, glimmers from the depths of the sky, and to the effort to speak of another incommensurability. There's a sudden and piercing intimacy, and the impact is visceral: Even though we're already accustomed to dwelling in uncertainty ("we try to answer two questions," says the scientist, "we do so as best we can, and four more arise. But that's science. It's never resolved"), still the sense of impossibility that comes with the sight of those few old women scratching in the sands has a rawness that the ecstatic and sparkling sky is powerless against. The old women's indefatigable search isn't the kind

whose end brings closure: Even when it's successful it's still equivocal, a source of both "great joy and great disappointment," in the words of one, who had identified the remains of a foot as belonging to her disappeared brother. The foot reconnected them; it was evocative and consoling, but it was also proof that there was no more reason to hope (the "tiny, heartbreaking commonplace," which C. S. Lewis named in his own grief).[34] The skewed time of loss, when presence and absence get so confused. The whole idea of searching is pointed toward catharsis; it's supposed to triumph against the injury's pain, just like the idea of public memory is supposed to do. But when Vicky Saavedra was reunited with that foot still in its maroon sock, she took it home with her and stroked it and stayed up with it all night, and then she went back to the desert: She searches still.[35]

Guzmán literalizes stardust throughout the film, inserting passages of floating, sparkling flecks of light like hinges between the scenes. He literalizes stardust, which seems like a risky thing to do in aesthetic terms: tragic subject matter, interspersed by the borderline kitsch of pretty twinkling motes (it helps somewhat to know that it's actually real dust, stirred up one day by the film crew in an old, disused observatory—though that's not revealed in the film).[36] The stardust is beautiful, but it's also a cliché, or very nearly so, and because of that the stardust immediately raises a question around itself.

The stardust keeps coming back, and there's an adjacent recourse to those entrancing images of deep space, as though to form a spine stretching along the film's duration that holds the various threads together. The different stories and their different temporalities keep interrupting one another: cosmic, archaeological, historical, memorial. Time doesn't make sense here, not in the familiar way of moving along, the lived experience of time passing that connects people to one another in the mutual perception of past, present, and coming

future. Time is unsteady, out of joint: The astronomer argues the present out of existence, and the filmmaker's reminiscences of childhood have to be swarmed by a cosmic haze in order to connect with Now. The past acquires meaning by coming into relation with the present, but the narrative here progresses more by a process of substitutions than of connections, the disarticulated strains of the tale held together by stardust. The past acquires meaning through its orderly relation with the present, but Guzmán shapes time into a tesseract: "A memory reaches out and touches [your] mind and [you] live proximate to it all day."[37] The past acquires meaning by being told, but trauma resists narration, resists the clear assignation of meaning. Trauma authors narrative breaks, memory gaps and voids, and so the filmmaker opts to break the timeframe we normally inhabit. Judith Butler says that

> the presumptions that the future follows the past, that mourning might follow melancholia, that mourning might be completed are all poignantly called into question . . . as we realize a series of paradoxes: the past is irrecoverable and the past is not past; the past is the resource for the future and the future is the redemption of the past; loss must be marked and it cannot be represented; loss fractures representation itself and loss precipitates its own modes of expression.[38]

Which brings us to the substance of the telling.

Vanishing Point

The Battle of Chile had aired for the first time in the country in 2003, on a cable network (the major channels still refused to show it). That year, the thirtieth anniversary of the coup, those events were copiously evoked, the traumas "amply cited,"[39] and, perversely, all those "well-worn emblematic

images" (the bombing of La Moneda, the national stadium, etc.), in their very ubiquity, had effectively come to cancel out the faces of torture, suffering, and death, emptying them of density and weight.[40]

There's no agreement on remembering: The vanishing point is a pictorial fiction. Some feel that the past, especially such a ruinous one, is better left behind, that healing consists of freeing the present from the past's weight. Some feel that the very possibility of justice depends on memory, that the work of repair proceeds from answering to the past and, therefore, from remembering it. Some feel that the instinct for amnesia that often accompanies trauma (even Allende's widow wanted to forget)[41] is worth attending to, that the organism knows best what it needs. Some stand to lose a lot if certain aspects of the past are brought to light, some see the present as the product of a past catastrophe, some see what happened then as a narrow escape and some as a mere "tremor."[42] To some extent, this is an argument over what ought to be remembered, and in that sense it's about History, but not entirely. According to the doctors, traumatic material presents with a temporal delay—the event yields trauma only retrospectively. And unlike the smooth and continuous space of historicism, traumatic remembering proceeds erratically, tracing a jumpy and resistant and eruptive course—outside of the linearity of historical time. The messianic undertones of those who advocate for it make memory an offer of consolation, a promise pointed toward a salvific future. And so it's odd that the filmmaker, who has dedicated his adult life to that act, would present it to us here as an unreliable ally. The first thing the film tells us is that there is slippage in the act of returning, and repeatedly along the way he pulls the rug out from any certainty about closure. In fact, the film is structured in a way that refuses closure, constantly moving in and out of story lines and leaving each thread dangling,

and then—just like he did in *Obstinate Memory*—exiting under a cloud of doubt. He keeps leading us to the places we want to go, places where we imagine that things can be made whole, and then, so quietly, he plays a note that tells us otherwise in its lingering. Yes, he avers that memory is fundamental ("Those who have a memory are able to live in the fragile present moment. Those who have none don't live anywhere"), but he says this on the heels of an avatar of memory who, like the stardust, like the philosopher of the "tremor," rings a disconcerting note. The coda doesn't close anything; it opens into doubt.

The junta killed Valeria's parents when she was tiny. To-day, she is an astronomer, and she finds the comfort she seeks by locating the answers to her questions in metaphysics and deep space. She imagines herself as part of a cosmic cycle that neither begins nor ends with her story; she imagines her murdered parents as stardust.[43] (Her grandparents, who raised her, sit impassively, silent aside the young woman's poetic phrasings.) Her answers, then, place all the palliatives at the greatest possible remove—the ends of the universe, the ends of time. This is not generally what people have in mind when they agitate on behalf of virtuous remembering.

Nostalgia for the Light is an essay, prismatic, fragmented, and ruminative in form: It meanders and pauses; it scatters its threads. The essay was something that Adorno had a lot to say about, rising to its defense against a tide of soulless sci-entism. His retort: The essay "abrogates the ideal."[44] Essaying thought is a "constellation"[45] that moves in multiple direc-tions, its filaments articulating themselves "according to the configuration that [they] form with the others . . . discreetly separated elements enter into a readable context; it erects no scaffolding, no edifice."[46] The essay thinks in fragments because that's how reality is, and here especially this calls to mind those vexing interludes of stardust because, as much

as they work like metaphysical oases, they're also incongruous, discontinuous, militating insistently against a too-easy conflation of the source of mystery, on the one hand, and the root of pain, on the other.

The essay doesn't know, which is why it gets written. It finds its way along the way, proceeding with the tentativeness of an open question made intensely present. The essay, Adorno says, is full of "incompletely redeemed aspects,"[47] its details drawing in others as negation: "The untruth in which the essay knowingly entangles itself is the element of truth."[48] Guzmán had been working essayistically ever since The Battle of Chile, turning his subject this way and that, but it was done in search of dialectical synthesis; it knew, precisely, where it would end. Thought's utopia, Adorno goes on, consists in "hitting the bull's eye,"[49] but the essay thinks differently, desiring yet mindful of its own fallibility and provisionality and devoid of final principles.[50] The essay doesn't know; its impulse is opposite to the theological[51] (which makes the quasi-theological suggestion of the stardust even queasier): Its concern, Adorno wrote, "is always a conflict brought to a standstill."[52]

The experience of watching Nostalgia for the Light is not so much of witnessing redemption (or of the watcher's attendant catharsis): It feels more like a way of raising the question of what it might mean for a telling to work. As though that basic question could now be reanimated, after so many years in which its answer might have seemed so self-evident as to make the question paltry. What might remembering be for? The loss is at last suggested in full, as irrevocable, and so the work to be done can be seen anew—not as repair ("irrevocable" voids that option) but as something else, though the filmmaker declines to name it. Thinking through thought in the wake of loss, Judith Butler

looks for signs of life: "Such violence cannot be 'thought,'" she says. It constitutes

> an assault on thinking, negates thinking in the mode of recollection and recovery. But what then emerges in the place of thought? Or what new thought emerges? It is not as if thinking ceases, but after such an internal break, it continues, and that continuation is founded and structured by that break, carries the break with it as the signature of history. We might say, in Benjaminian fashion, that thought emerges from the ruins, as the ruins, of this decimation. It does not constitute its reversal or recuperation, its animated afterlife. Animated precisely by what is not recoverable, this is a thought that is unthought to itself and thus opaque, but nevertheless alive and persistent.[53]

All those ideas that tied remembering to redemption—maybe they were necessary stations on the path. Likewise, that essentially messianic proposal about recovery of the past as opening the way forward. But by the time Guzmán makes *Nostalgia for the Light*, the questions seem to arise in ways that have a different relation to their possible answers, ways that are immune to the magnetism and seduction of crystallization. And I think that, in that, he's not only thinking about telling differently in relation to cogency; he's also reconfiguring the relation between history and the future.

The difficulties of enunciating trauma are legion—a kind of extreme case of the elusiveness of remembering in general. We tend to be full of contradictions when it comes to our wounds. We despise them, and we desire them too. "They grant power and come at a price . . . suffering yields virtue and selfishness . . . victimhood is a mix of situation and agency . . . pain is the object of representation and also its product."[54] I

think it might be just these contradictions that account for the stardust.

Orbit

The beloved foot is an equivocal presence, and I suspect that if we let it loosen a bit from its status as symbol, we might understand why. Some say that mourning wants to be perpetual, since ending it (closure, acceptance) is something like killing the lost one yet again: Once mourning is "complete," they're abandoned back there in the past while the one who still lives resumes without them.[55] Melancholia attests to the irreducibility of traumatic loss, its definitional irreducibility to rational or simplified expression. Ever since Freud we've had the habit of tying mourning and melancholia together in a tight configuration, with the latter understood as the (pathologized) failure to reach a state of the former. Melancholia is stuck, and mourning is progress. But maybe, the film seems to suggest, there's another way to think about this.

Anyone who's delved into the considerable literature about memory and loss will know that there's a school of thought— often poetically voiced—that puts incompletion at the heart of its arguments for what to do. The idea is that mourning is not a destination, that it's never simple, and that, while it generally has a clear beginning, its end is often either far distant or phantasmagoric. Mourning is not incandescent, it doesn't terminate in comprehension and peace, the argument goes, and so the sufferer must embark on a process of reconciling with the state of loss itself. This is fine, as far as it goes, but the problem is that it draws such a bright line between the state of loss and everything else. Maybe closure is not the destination; maybe mourning and melancholia coexist, by necessity: Maybe we're seeing what it might look like to think *through*, rather than in contest against, the loss.

(But let's not romanticize things too much here: As Butler points out, "it probably remains true that it is only because we know [melancholia's] stasis that we can trace its motion, and that we want to.")[56]

What we expect from mourning depends on how we think about overcoming. One view sees the encounter with the past as a good lesson in disenchantment, a prophylactic against ingenuousness: We become cumulatively more disillusioned but also safer, more inoculated, and maybe even more capable of mourning fully. Countering that kind of thinking, though, there's the alternative possibility that actually the dynamic is more like a continual process of cycling through modes of illusionment-disillusionment-reillusionment, with no pejorative attributions to the baseline of "illusions"—no imperative to elevate a strong reality sense over other modes of being and being-in-the-world. This approach—more Winnicott than Freud—suggests that there might be something worth thinking about here regarding the role of invention, fantasy, the fantastic:[57] Might they allow the traumatized to dwell with the real and historical fact of the loss without being trapped in its closed space? Isn't this the experience of traumatic loss itself—that it's at once real and unreal, and that our job of surviving within it is to keep both of those states alive? We might mistrust this as reliance on, endorsement of, "living with illusions," but isn't that based on an iffy belief about the facticity and totality of "reality"? There's a saying in German: "die Seele baumeln lassen," let the soul unwind. In a less freighted scenario, we accept the idea of these modes in the form of play, not only as necessary to the process of feeling "real" but also as a form of flight unstigmatized by the taints of escapism or frivolity, as a way of being that's freed of the either/or options of literalness or delusion. Play matters, and it shares a lot with the space that Guzmán inscribes in *Nostalgia for the Light*: It occupies its own time and space,

separate from those of routine life; it depends on make-believe—in the process, confirming the existence of imagined realities alongside of the "real" ones. Adorno said that "truth abandoned by play would be nothing more than tautology,"[58] and Winnicott pushed the point: fantasy as "more primary" than reality, as a way into it.[59] Especially in cases like this one, when the reality defies reason, when it's been made unknowable: spaces that give freedom to know otherwise, to emerge, nearly intact. Maybe that's a way to think about how *Nostalgia for the Light* gives such credible weight to both the real and the fantastic; maybe this is why Guzmán's resolutely agnostic film keeps returning to stardust.

The film seems to say that consolation lies not in overcoming but in honestly inhabiting the loss. We want this history to be bookended, to be bracketable inside a start and finish, because it seems like that's the way to make the pain stop—stop somewhere—but I think that what *Nostalgia for the Light* tells us instead is that that's not going to remove the pain from the central psychic place. It seems the project is no longer that intentness, straining to speak and hear the truth. Now it's about listening, and listening to these people yields whole realms of uncertainty that are the veins of the film. It's a project of freeing listening from the imperative of understanding,[60] of attending to a sense,[61] being on the edge of meaning.[62] Listening, then, as emerging from a logic of evocation rather than of manifestation,[63] tuning in to sensibility instead of signification. That kind of listening might open meanings that have been shut by messages impatient to know.

The question of what we want from history is a nagging one, even though it suggests at least one answer that's incredibly easy to arrive at: If we don't know where we've been, we can't really know where we are.[64] But there's something so abstract about that answer that it's always felt suspect, as though it's missing another kind of need that still aches underneath

the question. Both Tzvetan Todorov's ideas about historical memory and Svetlana Boym's theories of nostalgia—ubiquitous references on the subject—imagine paired ways of going back, one good and one bad—the "bad" one having to do with literal recovery or repetition, an end in itself fueled by a moral duty to remember, and the "good" one serving an analytical and synthetic function of application to the present time. In these schemes, the former creates an image that is symbolic and fixed (reflective), while the latter is transitive, refractive, responsive to the differential between then and now. But despite this distinction, what the returns sketched here share is a teleological core pointed at an end, whether vindication or instrumentalization. Either way, the act of remembering is undergone toward some further desire. I have a feeling that *Nostalgia for the Light* is getting at something different, something less deferred. Maybe even something about the nature of expectation, the folly of it.

Fantasy as a way into reality: spaces that give freedom to know otherwise. This might be what we hear in Valeria's voice. In putting *that* at the end of the film, maybe Guzmán undermines, or even negates, its status as an ending. It seems to say: This is not cleared, much like the not-actual childhood home had deferred the onset of the narrative. Maybe we could say that it ends the time of depleted sadness—not the sadness, which would be impossible, but yes, its power to sap us. The film neither begins nor ends with a sharp edge, mnemonic parallel to the journeys it traces in its subjects. *Nostalgia for the Light* is a liberating film because it's so unsure, because it takes us to so many places where words give out. It's liberating because it problematizes the meaning of all those things—expectation, hope, revolution, inheritance, legacy, history, eternity, evil. It's liberating because it doesn't know, it no longer knows, and that creates new space to think about what we want from knowing. Tenuous moonlight, as

opposed to the solar moralism of certainties. "Moonlight," in part, for the wonder we bring to that transparent, ringing source of light, for how intimately we link it with feelings of love. And "tenuous," because of the instability of that illumination's meaning. It makes sense that this kind of figure would surface in exilic poetics—the battle is no longer the same as the one that was lost long ago. Maybe desire is the final way of going back because it's also a way forward. And what this whole project has been about, at core, is making a space for desires that aren't just symptoms of the loss.

Desire

In a 2002 interview, Guzmán says that "the historical memory of a nation shapes its expectations."[65] That seems pretty straightforward as a backdrop to the earlier films, which are, basically, arguments for remembering. But *Nostalgia for the Light* seems to be coming from a different conviction, as though in recognition that "remembering" is not a straight line leading from past to present to future, that there are as many confusions as insights provided by it, that recall is always a matter of re-creation and, in that, an imposition of desire onto "fact." That remembering is not a transformative epiphany, and maybe this is why Guzmán has always left room for ambivalence in his history telling.

Even thirty years later, the topic of the coup was still radioactive. Guzmán's recourse to the stars reflects the force with which that history had been ejected from the earthly plane, but I think it might reflect something else too. It is just as hard to face our hopes as our suffering. In proximity to so much containment, the cramped entryway to a spacious and slowly unfolding chain of thought. In proximity to such oppressive, painful disquiet, doubt resounds as a component of faith. This work made of a broken, enduring love, history

sketched in a path picked across the ruins, pushing gently against the inertia of a world in denial. Pushing gently against acedia, Barthes's "horrible figure of mourning . . . hard-heartedness . . . impotence to love."[66] "I fear a catastrophe that has already occurred,"[67] he wrote: pushing gently, then, because there's no heroic narrative demanding consent.

If the inveterate traveler Peter Matthiessen was right that "every trip that really sustains us is in fact a journey home,"[68] then maybe what *Nostalgia for the Light* does is to bring us close to the longing to which loss gives rise. The deep sky at night. The apparition of such pure beauty, radiant with light, darkness, and power. *Nostalgia for the Light* is tremendously sad. The stars are the space of sadness, and the stardust is the mortal time here among us, where we live. Starlight is the age-old metaphor for wonder, stillness, eternity, and in the film it's also the presence of the sorrow that comes from a world and its hope having been destroyed. But the real loss is not the object but rather our capacity to love it, and that one is recoverable: That's what the film takes on. It's possible that the question underneath all of this is not so much what we want from history as what we want from art, what we want the experience of it to make possible. The word "art" here seems poor and thin, suggesting something delimited and already known. For Benjamin, aura's power came from the unique phenomenon of a distance,[69] placing the experience in the realm of imminence. We're all mourning, one way or another, and in *Nostalgia for the Light* what's offered to us is a paying attention and a waiting, a disposition toward what might come.[70]

The power of the film is partly because of the jolt of the grief. It's a brutal and unpoetic grief, raw and frontal. It makes all that prettiness that preceded it feel unseemly, as though we share some unnamed guilt for having gamboled around in the starlight's existential allure. The radical pasts of the 1970s

are very difficult to historicize meaningfully now. There's a strong temptation to romanticize (or demonize), to saturate with recycled affect, to "approach the past (and its ambiguities) in ways that arrest the sign or sew up meaning."[71] Complexity is eclipsed in the desire to produce a coherent storyline that explains to us, now, the intensities of the time, then: a time whose passions and commitments square hardly at all with those of our present moment. Such narratives not only settle the question of what happened (when in fact that can't be known with nearly such certainty or clarity); they also attribute to those events a set of meanings that is by now largely anachronistic—failing, that is, to read history honestly, in terms of the charges we now bring to it, and pretending instead that its meaning is already lying there in wait of our neutral excavation.

Agnostic Guzmán, finding the lost ones in the sky. Any contemplation of cosmic origins—any experience of the sky—puts us in the presence of a surplus that can't be fully accounted for. The filmmaker inserts the incomprehensibility of the night sky into a world too sure of itself. They say that enlightenment is a matter of inhabiting the present and mooring there (here), with an unencumbered relation to past or future. For those of us who find life more tangled than that, though, past and future are present to us in ways that can be intensely difficult. Pretty much everything in the world we inhabit tells us to point forward, because that's where hope lies. After the long journey of this cycle of films, after their transit through flashback, hindsight, trauma, vanishing, orbiting, and desiring—all those ways of going back—we end in a place whose consistency is the fragility of a truce. *Nostalgia for the Light* is, above all, a reticent and mortal work. Randall Jarrell said that a novel is a narrative that "has something wrong with it."[72] A helpful rejoinder here, since the longer you watch *Nostalgia for the Light* or think about

it in retrospect, the more things that seem to be wrong — cosmic lyricism, not least; transcending closure, above all. And although I'm generally wary of this kind of formulation, still it seems to me that it's because of those "defects" that the film has such power. If it didn't make me wince, it would be too easy to take it as a story with an ending. *The Battle of Chile* had known from the outset how it was going to end. In *Nostalgia for the Light*, though, it's the opposite, and the motif of unrequitable searching proposes a very different relation to purposefulness, expectation, and knowing. It announces the porosity of its meanings at every turn, and its restless switching back and forth between themes, scales, and realms is at odds with the filmmaker's final utterances about the home we might find through memory. But then again, narrative closure was never a plausible scheme to sustain a story about an open wound. Guzmán remembers, and he traces his telling along the spare, moonlit edge between past on one side and future on the other: history and longing. There's no great goal in sight, but there is a sensation of life. The invitation is open for the next generation to join him, and the next.

3

Something That Opens
a Wish and Closes a Door

After December 1989, Romania,
in Videograms of a Revolution,
Autobiography of Nicolae Ceauşescu,
and 12:08 East of Bucharest

I took her hand in mine, and we went out of the ruined
place; and, as the morning mists had risen long ago
when I first left the forge, so the evening mists were
rising now, and in all the broad expanse of tranquil
light they showed to me, I saw no shadow of another
parting from her.

> —PIP'S FINAL LINE IN *GREAT EXPECTATIONS*,
>
> STANDARD EDITION

I saw the shadow of no parting from her.

> —PIP'S FINAL LINE IN *GREAT EXPECTATIONS*,
>
> FIRST EDITION

What writes the ending?[1]

Romania was a dark myth for me, a place of muffled rage.
There was a grandfather I never knew who had come over
from there: His heart exploded long before I was born, but all
the family's considerable fury was understood to have come
from that place. So I knew about it elliptically, as a shadow,

and when 1989 happened there it felt completely different than all the others. Romania was the last, the most violent and most chaotic, and, later on, the most oblique of them all.

The events of December 19–25, 1989, were the Romanian response to an ordeal that had been grinding on for decades, intractable and brutal in its resolute dehumanization of the entire population. They had lived in a crippling state of subjugation and dependency, the product of a toxic mix: economic shortages (food, heat, light . . .), no reliable information about the world beyond the national borders (or within them, for that matter), draconian restrictions on travel, constant fear of denunciation and treachery, constant suspicion of everyone, ubiquitous erosion of any kind of social contract, and—the coup de grâce—the envelopment of pretty much everyone in the corruption, the contamination of their (moral) sense of self by becoming complicit in the sacrificing of others. Betrayals and self-betrayals—likely the worst of all. When the uprising finally came, it blew through the country with none of the decorum of the other "revolutions" that preceded it elsewhere in eastern and central Europe. To the contrary, Romania was full of fury and violence, aswirl in conspiracy theories, deceptions, and recriminations.

The thing about Romania, about what happened there, is that almost from the start it was clear that nothing was what it seemed or was claimed to be. There were fundamental questions: Was it a revolution or a coup? How many had been killed (hundreds? thousands? tens of thousands?), and by whom? Was it spontaneous or a plot? Popular or military? Did "the people," and their rage, really accomplish anything? It's not so unusual for events like mass uprisings to be hard to parse authoritatively: They're pure chaos, for one thing, and they're also times when lots of people probably have good reason to hold their cards close. But still, Romania was different. It was so opaque, so false, that Baudrillard coined a

term—the "Timisoara Syndrome"—to name the astonishing new extreme to which reality had become auxiliary to its representations. Agamben pushed the point: "In the same way in which it has been said that after Auschwitz it is impossible to write and think as before, after Timisoara it will no longer be possible to watch television in the same way."[2] Romania was not just a matter of obfuscation, cover-ups, manipulations, fakery, and lies: It was the obliteration of any grounded sense of reality. This was counterintuitive, given that those events had been broadcast, live, across Romania and the world: We saw it happen in real time.

The "revolution" there didn't author that existential swamp: Decades of Ceaușescu's depravity had already created the conditions for incredulity as a way of being, for the total mismatch between what was lived and what was said to be. But the "revolution," as it played out, left such a bad taste that even a population well accustomed to deceit felt betrayed. There was no oxygen left to breathe after the lies laid their claim on peoples' will to believe, so foul was their pollutant.

Films were made about the TV revolution. Harun Farocki, a master at reading images for what they do not admit to be, teamed up with the Romanian director Andrei Ujica to plow through the thousands of hours of obligatory footage that had been shot by state TV and reconstruct, as much as possible, a story that held water.[3] Their *Videograms of a Revolution* (1992), though spare in intervention, nonetheless brackets itself in two moments of full-frontal, bloodied address, in extremis. In that, they avow the truth of the event, notwithstanding any of the lies that surround it. Corneliu Porumboiu's *12:08 East of Bucharest* (2006), on the other hand, takes the fantasy of the revolution at its word and restages it as farce, although I think with great affection for what it gave rise to in his elders: He was only fourteen at the time of the events, and his re-creation is played out through

the eyes of those old enough to have participated—although, as it turns out, they probably didn't. Probably. He, too, gives the narrative a symmetrical opening and close—in this case, a wistful shot of a barren street, pretty and a little sad in a daybreak snowfall—another bracketing that breaks with the mood of what sits in between. This is how both films contest the runny margins of their untellable tales. *Videograms* puts us in the same space of confusion as the people who lived those scenes: We have no privileged position from which to synthesize any understanding of what's happening. There's also a baseline of confusion in 12:08, but it comes from a different source: not from the document but from memory, from people fabulizing retrospectively. Even hindsight, however, proves unable to clarify matters. A long time before, Flaubert had said: "Language is like a cracked kettle on which we beat out tunes for bears to dance to, while all the time we long to move the stars to pity."

The "truth" of what happened was and still is invisible. In what follows, I'll walk through these films that look back on those days, returning to those events as they try to unravel some strand of truth from the blanketing confusion, whether in the name of therapeutic, purgative knowing or, alternatively, giving up on knowing, seeking remediation by effacing its centrality. My own return to their returns is not so much to figure out the events as to read their readings, after the after the fact.

"An aphid settles on the dictator's forehead and plays dead."

For example:[4]

1967: Decree 770. The declining birthrate must be reversed, in order to "build the nation": contraception and abortion are banned. Romanian women undergo mandated

monthly gynecological exams, and all pregnancies are monitored for the full term. Securitate (secret police) keep tabs on operations performed in all hospitals across the country.

1981: In the name of "complete independence" from foreign influence, the Conducator (Führer, Duce) determines that Romania's external debt will be paid down ahead of schedule. Extreme austerity measures go into effect, including rationing of food, heat, and gas—effectively impoverishing, starving, freezing, and immobilizing the population. Among the indicators of success, Romania's infant mortality rate quickly tops the European charts. (The debt is indeed paid off ahead of schedule, but the shortages remain. Later on, Robert Kaplan reads these initiatives as "a policy to break the people's will.")[5]

1988: "Systematization" comes in the wake of the Conducator's travels to North Korea, China, and North Vietnam. Romania's 13,000 villages, bastions of (a modicum of) self-sufficiency, are to be reduced to five thousand, six thousand max, and the eleven million displaced peasants concentrated into new "agroindustrial complexes." Thereby, their everyday peasant thoughts, customs, and attitudes will be transformed into those of the collectively minded "new man." In a related vein, it is mandated that all Gypsy music played in public be revised to include Marxist lyrics.[6]

The resettlements create, as a bonus, a huge new underclass of poorly urbanized peasants, conscripted to work in the new factories—"neither horse nor donkey," according to a local proverb. (The miners from the Jiu valley who will, a while later, descend swinging clubs and axes on the heads of student demonstrators, are progeny of this idea.)[7]

There were the building projects. Starting in 1984 (and continuing, unfinished, to the bitter end), the House of the People begins to rise. The largest building anywhere (except the Pentagon, apparently) and also one of the ugliest, it tops a

titanic new avenue running along ground that until then had been the historic heart of the city. The Conductor suspends virtually all other projects and state expenditures, whether civic, social, industrial, or agricultural, in the name of this particular indicator of greatness. The upshot, in some accounts, was a social space that brooked no room for interior life, a social space filled with selves estranged from themselves.

There was the cult of personality, extreme even by the measures of the time. Weekly television programs were dedicated to the activities of the Conductor, whether megalomaniacal displays related to affairs of state or the intimacies of his beloved Sunday afternoon hunts. There was the abuse of minority rights: Ethnic Hungarians, ethnic Germans, Gypsies, and Jews, all with tenure on Romanian lands, were nonetheless considered a stain on the national body—and so his "maverick" foreign policy (basically, not toeing the Soviet line and instead making nice with leaders from Kim Il-sung to Queen Elizabeth II of England to Richard Nixon) came with a deal to sell off Romanian Jews to Israel and ethnic Germans to West Germany ($4,000 per exit visa).[8] As Ion Mihai Pacepa—Ceaușescu's intelligence chief, later defected to the United States—puts it, "Jews and Germans, along with oil, were Romania's best export commodities."[9] The Conductor ruled beyond parody.

There was the "security service in cowls": Herta Müller estimates that around 8 percent of Orthodox priests were paid directly by the Securitate: "It won't have been much different among journalists, doctors, professors, lawyers."[10] Something like one-third of all adults—estimates vary—were party members and/or informants, with most of the rest implicated or drawn in, somehow, whether willingly or not. And some estimates put the number of those who had either been imprisoned or else had a family member imprisoned at a quarter of the population.

At first, it had seemed that the Conducator would weather the 1989 storm: After all, he was reelected as general secretary on November 24, the same day that the entire communist leadership resigned in Czechoslovakia. In Romania, there had been almost no pushback. But within the span of about a week he went from uncontested, if detested, to dead — brought down, along with the equally despised Elena, in perhaps the only moment in Romanian history when pretty much everyone wanted the same thing. It didn't last long, it was messy and ragged and incomplete, but it was decisive anyhow.

Nicolae and Elena were hated for what they did to the people, to the nation, and especially because of how they did all that — their capriciousness, their rule according to whim, their total disregard for the responsibilities of government, of the rule of law, of the public good — and they were just the latest in a long line of farcical figures who had held power in Romania.[11] They were hated, but they were not the first.

". . . and when someone passes by carrying bread, the sidewalk smells of hunger."

Romania has an unenviable geographic situation,[12] wide open to invasion from multiple directions: Over time, Byzantines, Visigoths, the Huns under Attila, Avars, Gepidae, Slavs, Bulgars, Hungarians, Tartars, Turks, and others have all done just that.[13] The country has great natural resources — fertile soil, powerful rivers, beautiful mountains, and vast reserves of coal, oil, and iron. There are gold and silver deposits. The Roman province of Dacia (later, Transylvania and Oltenia) was legendary for its prosperity and became the most important granary of nineteenth-century Europe, exporting wheat, maize, barley, rye, and oats. Up until World War II, Romania was a prosperous, if primitive, country. By

the end of the war, though, much had been laid waste, and then a massive transfer of resources to the Soviets completed the process of pauperization (this was a replay of what had happened with Hitler, earlier).[14] In the early 1960s, Gheorge Gheorgiu-Dej (installed at Stalin's behest)[15] began to move away from the USSR, and the economy rebounded, based on a policy of rapid industrialization. That eventually proved disastrous, though, as large swathes of the population were dislocated and environmental degradation erased whatever fiscal gains had been made. Consumer production, including food, suffered as the commitment to export goods expanded. Dysfunctional management rounded out the cycle.[16]

Farmland was collectivized as of around 1961 or 1962, eviscerating the traditional cultural cycles of village life and wiping out the subsistence farming that had sustained the peasant population for centuries. Meanwhile, production was largely converted from food to industrial crops—oil seed, sugar beets, hemp, flax, cotton. In the 1970s, huge tracts of farmland were turned over to strip mines and oil fields. Newly dependent on the transport system to move goods around, peasants transformed from self-sufficient to indigent thanks to the few roads and fewer trucks that comprised the country's infrastructure, resulting in widespread food shortages, which were then exacerbated by a decision by the Conducator (newly installed as general secretary by the Politburo in 1965) to export whatever food there was for hard currency earnings. The only functional economy was the black market, and bread rationing—in the breadbox of Europe—began in 1981.[17] The next year, in response to austerity measures dictated by the IMF, the Conducator ordered drastic measures that imperiled peoples' basic survival. In return, widespread sabotage by workers tanked per capita productivity, and the long-standing pattern of, as Kaplan puts it, long periods of docility interrupted by brief but spectacular eruptions of vio-

lence got another go.[18] Demoralization was, to put it mildly, pervasive and deep.

In the midst of this Dantesque spiral, in 1977 Bucharest was hit by a massive earthquake, causing widespread damage and loss of life: An estimated 13,000 were killed or injured and eighty thousand left homeless (opening the way, as it turned out, for the Conductor's elephantine architectural vision to unfold not long thereafter). To the international sources of aid that began streaming in, the Conductor requested a suspension, so that he could think about what they really needed: The bandages, tents, food, and drugs cease to arrive, and, after a hiatus of a few days, donor countries are informed that the needs are for computers and other technical machinery. Russia donates $22 million in industrial parts, and others follow suit. The stream of bandages, tents, food, and drugs does not resume.

We have to think in terms of the international shorthand for Romania—Dracula. We have to think in terms of the Balkans, a "synonym for a reversion to the tribal, the backward, the primitive, the barbarian."[19] We have to think about the fact that the initial casualty estimates in December 1989 were eighty thousand—a shocking number, by most measures (the actual number turned out to be more like one thousand)— but those estimates were nonetheless accepted as credible: Such slaughter was entirely conceivable.[20] For people inside the country, that credulity was a measure of their fear and of its longevity. For people on the outside, it was the Balkans.

There's a long history of thinking about the Balkans (thinking about them from the vantage point of "The West," that is) and about the limit case of Romania, in ways that can readily accommodate the Conductor's demonic excesses. Although geographically inextricable from "Europe," the peninsula nations had long been thought of as Europe's ghost, "the persistent reminder of its own disavowed past,"[21] a "reposi-

tory of negative characteristics against which a positive and self-congratulatory image of the 'European' and 'the west' has been constructed."[22] George Kennan, in 1993: "What we are up against is the sad fact that developments of those earlier ages, not only those of the Turkish domination but of earlier ones as well, had the effect of thrusting into the southeastern reaches of the European continent a salient of non-European civilization which has continued to the present day to preserve many of its non-European characteristics."[23]

But neither are the Balkans competently "Oriental." Marcus Ehrenpreis, in 1928:

> The Levantine type in the areas between the Balkans and the Mediterranean is, psychologically and socially, truly a "wavering form," a composite of Easterner and Westerner, multilingual, cunning, superficial, unreliable, materialistic and, above all, without tradition. This absence of tradition seems to account for the low intellectual and, to a certain extent, moral quality of the Levantines. . . . In a spiritual sense these creatures are homeless; they are no longer Orientals nor are they yet Europeans. They have not freed themselves from the vices of the East nor acquired any of the virtues of the West.[24]

It is, said John Gunther,

> an intolerable affront to human and political nature that these wretched and unhappy little countries in the Balkan peninsula can, and do, have quarrels that cause world wars. Some hundred and fifty thousand young Americans died because of an event in 1914 in a mud-caked primitive village, Sarajevo. Loathsome and almost obscene snarls in Balkan politics, hardly

intelligible to a Western reader, are still vital to peace
in Europe, and perhaps, the world.[25]

In a more contemporary, and sober, accounting, Kristine
Stiles points to an ancient schism in Romanian history and
consciousness, "both of which have been split for centuries
between the philosophical and teleological world views of the
Occident and the Orient, as well as along the geographical
political exigencies of North-South and East-West." Such
divisions, she says, "make Romanians especially vulnerable to
psychological fragmentation, and contribute to the renowned
'distrust of all the cherished notions . . . of progress and his-
tory' that is 'characteristic' of Balkan peoples."[26]

In the 1920s, the Legion of the Archangel Michael (later
known as the Iron Guard) perfected an initiation rite that
involved sucking blood from self-inflicted slashes in the arms
of all the other members of the group and then inscribing a
blood oath vowing to commit murder whenever ordered to do
so. Those murders were inaugurated with further bloodletting
by all and imbibing the fluid as a group pact. "Romanian
fascism," says Kaplan, "was by no means standard-issue."[27]
During the war, the Iron Guard was so brutal that it was too
much even for Eichmann, the SS officer in charge of carrying
out the Final Solution: In early 1942 he had pleaded with their
leader, Ion Antonescu, to halt the gruesome killings of Jews
temporarily, "so that the job could be done more cleanly by
Einsatzgruppen . . . but the Romanians were in a killing fren-
zy,"[28] and Eichmann was ignored. According to Raul Hilberg,
"in no other country during WWII, except Germany itself,
did national character play such a role in determining the fate
of the Jews."[29] All this notwithstanding, Antonescu (deposed
in 1944, executed in 1946) was, in 1990, considered the most
popular figure in twentieth-century Romanian history.[30]

The Romanian character and temperament have long been the subjects of travelers' interest. Robert Kaplan spent a little time there and issued this verdict:

> Atop the Latin bent for melodrama was a Byzantine bent for intrigue and mysticism, inherited from the Orthodox religion and from centuries of Byzantine political and cultural influence. This mystical streak was further intensified by the Carpathian landscape itself, darkened by fir forests and teeming with wolves and bears, out of which arose a pantheon of spirits and superstitions and the richest folk cult in Europe.[31]

He gets especially worked up in thinking about the "archaic predispositions" of its "excited peoples."[32]

And then there is Dracula—Vlad the Impaler—the folkloric fundament who emerged from the shadowy forests of Transylvania. Impaling was, according to Maria Todorova, reported by practically all Western visitors to the country, whose "morose western imagination"[33] was apparently fired up by the "exoticism" of the "excessive, non-functional cruelty" they encountered there, "a violence one is tempted to call *Id-evil*, a violence grounded in no utilitarian or ideological cause. . . . The brute Real of 'irrational' violence, impermeable and insensitive to reflexive interpretation."[34] Indeed, according to Christina Stojanova, "Romanian folklore teems with [infinite] species of bloodsucking, flesh-eating and sexually disturbing creatures of the night, disruptive of harvest, livestock and family life."[35] Says Bram Stoker himself: "Every known superstition in the world is gathered into the horseshoe of the Carpathians, as if it were the center of some sort of imaginative whirlpool."[36]

Prostitution, black marketeering, and informing on your neighbors are all long-standing traditions in Romania, Kaplan reports.[37] Typically, and historically, everyone "protected

themselves through devious alliances."[38] "Explosive and short-lived paroxysms of passion have also characterized Romanian history: this trait [was] combined with the ability to make expedient and contradictory deals."[39]

"The Balkans," Churchill once said, "produce more history than they can consume." Putting the matter in a parallel but different light, Eva Hoffman writes that "among all the shortages in Romania,"

> perhaps the most serious is the shortage of a usable past. The recent past represents a kind of negative capital, an almost pure deficit. And, if the new goal is something like a pluralist democracy, the longer past has few precedents for it, few points of reference around which new ideas might coalesce. Romania's history is marked by discontinuities more than continuities, by oppression more than independence, by various forms of authoritarianism more than by liberalism. . . . Why, or how, a collective past should matter in the present has always been a puzzlement to me, and I don't believe that the mere act of remembrance is a guarantee of learning, of profiting from experience. And yet today's Eastern Europe is a living lesson in how much it does matter. It matters if you had a grandmother who, in your childhood, told you tales of a time in which heroes fought for everyone's freedom. . . . It matters because such stories point you toward certain standards and actions; they humanize ideas; they make it plausible that you might fight for freedom, too.[40]

In 2010, the Romanian National Museum of Contemporary Art had this to say about its own public:

> This is an exhibition about shattered illusions and defective mentalities continuously perpetuated in Roma-

nia. It is about "Ceauşescu" type of attitude within the communist era as well as its present times pernicious sequels. About Communism in Postcommunism.

In which way the contemporary Romanian society relates to the apparently indelible imprint of Ceauşescu's "Golden Era" which haven't disappeared but hybridized with most strange neo-capitalist formulas? Consequently is this a large part of this society doomed to collective failure, to moral and cultural stupidity, to inferiority complexes, to a bad karma unable to shift toward a benefic posture, to defeatism and aggressiveness, to fatalism?

Ghosts, fetishes, clichés, propaganda, frustrations . . . everything seems to jeopardize recovery . . .

Unsolved problems pertaining to a gloomy communist past, still viciously present, uneducated people, doubtful financially powerful individuals, corrupted politicians—gibbons in Armani suits—and the rest of the society reduced to "surviving" and to moral slavery . . . certifies about an obvious failure on a macro-social scale. Romania seems to be a country interesting only for its socio-pathology, for the almighty Ugly (aesthetically, ethically, morally) present everywhere, for its insane society in which creative intellectuals, inclined mostly always to compromise, deprived of elegance and altruism—are forced to face problems below normally admitted confines, otherwise to temporary/permanently migrate to more generous horizons . . . or to keep living in aggressiveness and financially dispossessed.

Lack of culture, the massive amount of stupidity, the degrading attitudes, overflowing pessimism inevitably lead towards passive strategies, as Attali once stated: "self renouncement, repentance, putting their hope into others help." The phenomenon of "Ceauşescu-ism"

and its persistence in post communism, the simultane-
ous existence of communism and capitalism within a
nowadays so called democracy with very strange shades
of incipient totalitarianism . . . all these in the larger
aspect of the global crisis and world reconfiguration . . .
generates a seek hybrid society. Dominated by rough
energies, low levels of human quality, public opinion
shaped for scandal and mediocrity, vulgar mass media
excessively manipulative, overlapping attitudes of sub-
mission and continuous mental poisoning.

Abjection as a dominant rule, predominant ugliness
and vulgarity as general strategy, subliminal fears once
induced by totalitarian rules, are these the premises of
a karmic perpetuous conviction, or possible products of
atonement of a future paradoxical redemption?

Under the circumstances could radical irony exor-
cize these all?[41]

It is not uncommon for commentators to see, in the shat-
tering of personal identity accomplished by Ceauşescu, a
furthering of this long historical process of destructive disar-
ticulation, resulting in a widespread social psychosis in which
people had the ability to experience "a real meaningful and
coherent self only in relation to the enemy party."[42] The
transition in Romania had no social base to work with and
from, no traditions from which to start, no experience of a
lived collective experience with anything approaching integ-
rity. People didn't know how to work together, or how to act
on their own, or how to trust one another. The Securitate,
understood to be omnipresent and omniscient, fostered what
Mariana Celac has termed an "intra-uterine" personality,
"withdrawn, fearful and suspicious of the outside world."[43] All
this may shed some light on how Romania's 1989 was received
abroad: Maybe we just couldn't accept these woebegone

people as true revolutionaries, since we're predisposed to see their attempt at self-liberation through this lens and therefore automatically discount their ability to achieve what we think of as emancipation—we think of them as having gotten, in Ceaușescu, the leader who was *of* them, not as some aberrant or misfit presence. And, for that matter, it might not be just us outsiders who inclined to think in those terms.

" . . . where the clematis unravels its own summer, blue and hypocritical, saving its most beautiful blooms for the rubble."

A few things were clear:[44] the Ceaușescus fled, were captured and then executed; a self-appointed "National Salvation Front" stepped in; elections were held five months later . . . But beyond that, it's murky.

There were internal and external myths, both based in ignorance and both mutually supporting. The official discourse was ridiculous and its claims absurd. There had been no reliable news channels for decades, so rumor and gossip had become predominant sources of information. As Peter Siani-Davies has noted, "these had deformed reality to such an extent that the bounds of the lie had become practically unlimited, because, if nothing is believable, everything is plausible."[45] Moreover, the foreign press reporting on those events had no experience with Romania, since the country had been virtually closed. And then there was the fact that the other revolutions had happened peacefully, so it made a better story if Romania was a violent mess: On December 19, the *New York Times* had equated Ceaușescu with Caligula, asserting that he had ruled by the same dictum of "let them hate, as long as they fear."[46] A variety of indicators had surfaced, suggesting that plots may have been in motion to oust the Conducator (either for a few months or since 1971,

depending on which version you subscribe to; either among the army or the Securitate, depending on which version; either among an internal opposition or fomented by foreign powers—ditto).[47] In fact, the plot mentality was an accurate reflection of a society in which, for decades, there hadn't been a feasible option to trust anyone, given the "climate of suspicion so thick . . . [that it] made it a reflex to see an organized action behind many events that may be adequately explained by confusion, self-interest and improvisation."[48]

It started in Timisoara, a city in the Banat region next to Hungary and Yugoslavia—the Romanian city farthest from the East and closest to the West, its gateway to the world beyond. Timisoara was considered the least Romanian of Romanian cities, which was to say more cosmopolitan and less saturated with old patterns of division and hate. People there had some idea of what had been happening elsewhere, thanks to the Hungarian and Yugoslavian TV broadcasts they could pick up.[49] "It could only have started in Timisoara" was a common refrain at the time.[50]

The inevitability of Timisoara also came from the historical mistreatment of Romania's ethnic Hungarian minority, who numbered some 2.1 million. Kaplan compares their treatment to that of the Palestinian Arabs, and it was Ceauşescu's repression of them that provided the spark in December 1989. In response to his attempt to exile the Rev. Laszlo Tokes, a pastor of the Calvinist Reformed Church and vocal opponent of the regime, the resultant street protests, beginning on December 16, started a chain reaction that escalated in the next three days from a few hundred people chanting anti-Ceauşescu slogans to many thousands rioting and looting—and to indiscriminate shooting of those crowds and tanks rolling over old women. The uprising was a nonevent in the national media, but people heard about it by word of mouth, and Radio Free Europe was airing hourly updates,

reporting live against a backdrop of gunfire, screams, and frenzied chaos.

Addressing the nation from the TV studio on December 20, the Conductor alleges that Timisoara was an "interference of foreign forces in Romania's internal affairs," an "external aggression" by "fascist agitators." The next day, he addresses a crowd of one hundred thousand, again in full denunciatory mode, but just a few minutes into his rant the rumbling begins, a rising chorus of jeers, boos, and insults, and then a chant: "Timisoara! Timisoara!" Visibly stunned, the Conductor extemporizes an offer to up workers' pay (workers had been bused in and given flags to wave), but the spell has been broken. More shooting, more bombs (maybe— it's not clear) and, instead of running, the people escalate.

Having started out as an address from the Helmsman, all this was covered live on TV and with an estimated 76 percent of the country watching.[51] By the time the censors managed to cut the feed and replace it with patriotic songs, it was too late: People had seen. Nicolae and Elena scurry from the balcony, bodyguards in tow. Reinforcements are ordered in—troops, tanks, antiterrorist special squads, helicopters, Securitate in plain clothes, and snipers all around the square, who take aim at the crowd from above. The morning after that bloodbath, the Conductor tries again to address the crowd from the balcony of the Communist Party headquarters but is shouted down; we are now at the brink of civil war. Once again the pair scurry off, this time to a helicopter waiting on the roof.

That same day, the minister of defense, Vasile Milea, had allegedly suicided. The general consensus now seems to be that he had decided to order the military not to fire on the people and so was executed on the Conductor's orders—a version of events that had also, apparently, persuaded the military rank and file, who then switched allegiance en masse to the people and to the revolution. His replacement, Victor

Stanculescu, also ordered his troops back to the barracks—unbeknownst to the Conducator—and then "chose" Iliescu's group to succeed Ceauşescu, amid the struggle for power already being waged by various factions. (The Securitate remained loyal to Ceauşescu "until his televised cadaver persuaded them to renounce their mission.")[52] The helicopter that had rescued the Ceauşescus, as it turned out, actually hadn't, instead ferrying them to a secret location where their trial, a kangaroo court lasting around two hours, was staged on December 25—Christmas Day. The charges against them, all affirmed in the military tribunal's verdict, were of genocide, damage to the national economy, and abuse of power. Footage of the trial and of their dead bodies (they were taken out back and shot at its conclusion) was released immediately (actually, the footage was not of the executions but rather of their restaging: The cameraman had been stuck in traffic and missed the actual event, so it had to be reperformed for him). "Ceauşescu's execution was like a cleansing of the soul," one of Kaplan's informants had said: "a blood-letting, the first spiritual exercise of our nation. . . . So bloody, so pure, our minds swayed between Christ and Ceauşescu. But it was no good; it was still not enough. It was like I wanted to eat his flesh. No, we were not released that day."[53] (Speculation about the whereabouts of their burial site remained rampant: Its location was revealed only in 2010.)

So then, what really happened, and was it a revolution, a coup, or a foreign intervention? Coups—the "traditional form of leadership change in East European communist states"[54]—are generally seen as simpler than revolutions, usually with minimal bloodshed, a relatively quick return to normality, and a limited sphere of change. Still, the fact that Ceauşescu absconded in full view of the crowd means that it also had, to some degree, the character of a revolution, at least in terms of the imagery: It was the imagery of a revolution,

a leader forced out by the people. And in fact, it resembled a revolution also in the mass mobilization, the chaotic and widespread violence. The radical change associated with revolution, however—political change, at least—did not happen. This is more or less how Richard Andrew Hall saw things. "Without the Revolution," he says,

> the Coup might well have failed, but without the Coup, neither would the Revolution have succeeded. . . . The very atomization of Romanian society that had been fueled and exploited by the Ceauşescu regime explained why Romania came last in the wave of Fall 1989, but also why it was and would have been virtually impossible for genuine representatives of society—led by dissidents and protesters—to form an alternative governing body on 22 December *whose decisions would have been accepted as sufficiently authoritative to be respected and implemented by the rump party-state bureaucracy, especially the armed forces and security and police structures.*[55]

There is the "Yalta-Malta" theory, namely, that the United States and USSR colluded to get rid of Ceauşescu. Versions of this vary, sometimes with the United States running the show and sometimes the USSR, but either way, the idea is that their interests coincided enough that they conspired to manipulate everyone—the protestors, the intelligence agencies, and the military—to take Ceauşescu out.[56] Both the matter of foreign intervention and of internal subversion remain unverified and unrefuted: It seems that the only real clarity on the question is provided by the empirical evidence, cited in many accounts, that by around noon on December 22 the Central Committee building had filled with people from the streets but by 5 p.m. it was full of soldiers and Securitate. In

the space of a few hours, this suggests, the revolution was lost to the "internal opposition."[57]

By December 24 there had been all-out war in the streets. "Terrorist" assaults continued until December 27, but then, abruptly and mysteriously, they stopped. Even now, nobody knows the real story about who the shooters were or who gave the orders to shoot or to stop shooting.[58] The National Salvation Front assumed power, promising elections in May, which they won in a landslide, but that did little to clear things up. Iliescu and his minions comprised, as Kaplan puts it, "a group . . . not just of former communists, but also of mystics and demagogues with criminal records."[59] Consequently, the ideological positions or goals of the revolution were a moving target. Initially, the overriding and sole stated goal—on both sides—had been to get rid of Ceaușescu. But being anti-Ceaușescu did not necessarily mean being anticommunist, although it moved in that direction once the NSF leadership filled with "reform" communists. The tangle of ideologies and interests was summed up by Kathleen Verdery with the following exasperating line: "Iliescu is not a Stalinist; he is a reformer, for whom opposition is, nonetheless, 'counterrevolutionary.'"[60]

The political leadership at the end of 1990 was pretty much the same as it had been in 1989. There was scant movement toward any public reckoning, much less punishment.[61] TV and other media remained under state control, and even the old anchors and commentators remained mostly in place, though they did protest that, although "physically we are the same people, mentally we are completely different."[62] In spite of all this, the NSF received messages of support from around the world—France, the USSR, Hungary, East Germany, Bulgaria, Czechoslovakia, China, the United States, West Germany, the United Kingdom, NATO, Austria, the

Netherlands, Italy, Portugal, Japan, and Yugoslavia, among others.

Already in the first days after December 25 there had been a bitter sense of deceit. "With the first doubts about the true nature of the revolution," Siani-Davies says, "each of the individuals who had participated on the streets and carried their own personal vision of the events, usually expressed in terms of heroism and bravery, was required to equate this with a growing perception of falsification."[63] A second wave of opposition, hot on the heels of the first, took root in the lie of the "transition," but it, too, became immediately garbled.[64] New waves of protests began already in January 1990, with many more to follow, and by that June the violence crescendoed in the brutal suppression of a months-long student strike at the Piaţa Universităţii.[65] As Pavel Campeanu noted that same month, the revolution was in "a stage in which the power born of the anti-Ceauşescu revolution does not control the Ceauşescu apparatus, but rather the Ceauşescu apparatus controls the power born of the anti-Ceauşescu revolution."[66] That the name Ceauşescu appears, four times, in this summary, is eloquent.

An infernal process of fragmentation and jockeying for power was the revolution's spawn (Richard Andrew Hall has suggested a "conjugat[ion of] conspiracy: he conspires, they conspire, you conspire . . .").[67] The opposite, in other words, of the heroic myth that unites a country as it looks forward to the horizon. Given the condition of Romanian society and the Romanian psyche, the fact of the uprising was remarkable, but its shakiness as a political project was probably inevitable. Romania was the "spectacular final act" of the collapse of communist regimes across Central and Eastern Europe,[68] at the same time as it was the revolution that was not.

"The woman with the chestnut-red hair done up in big waves is cleaning her windows. Beside her is a bucket of steaming water. She reaches into the bucket and picks up a sopping gray rag, she reaches onto the windowsill and picks up a moist gray rag, then she pulls a dry white cloth off her shoulder. After that she bends over and picks up some crumpled pieces of newsprint. The windowpanes shine, her hair opens up in two sections, divided by the open casements. When she closes the casements she closes her hair."

Farocki and Ujica's film is an archive in the form of a documentary.[69] Embedded in the idea of a documentary is a conceit of the "real": that the film is, because of its relation to reality, able to make substantial truth claims. This basic idea has come under pressure with more recent documentary work, which also wants to expose itself as a protagonist in the act of narrating. "If documentary is the film genre *par excellence* dedicated to 'truth,'" says Manuel Correa, "the task of the critical documentarian is questioning the deployment of truth without failing to be faithful to it, either."[70] Documentaries generally are in the business of edifying, relying on constructions that clarify the story—good/evil, us/them, and so on—which are the ideological underpinnings that are often buried in representations of history.

Documentaries generally contain performances by social rather than professional actors: On the face of it, this lends authenticity, since they're not "acting" or "performing" for an audience but rather simply going about their business. But this was not the case in Romania: Even before the action moved to the self-conscious staging of the TV studio, there were cameras everywhere, people filming people who were aware of being filmed and, therefore, aware of being actors in the process of (apparently) making history.

If, as is sometimes contended, there's an inherent problem with the documentary form in that it presents "a closed story, one that is finished when the viewer has finished seeing the film — that the film provides a kind of closure that's inappropriate to the topic"[71] — then at least that one difficulty was overcome, we might say, by the nature of events in Romania and of their unrelenting refusal of closure. If, as the popular documentarian Ken Burns sees the matter, documentary filmmakers are "tribal storytellers who craft tales about the past in which the nation can find its identity,"[72] then this is not an attribute that finds realization in our case. If, as Ann-Louise Shapiro said, "I could also make the audience conscious of its own desires toward the material — the desire for belonging . . . for heroism, for solutions,"[73] we find no such consolations here. If, as Shapiro also claims, the traditional documentary "enables viewers to have the coherence, manageability, and often the moral order of their lives reaffirmed,"[74] then this is yet another thwarted vocation in the "documentary" made by Harun Farocki and Andrei Ujica about the events in 1989 Romania. If all of these formulations regarding documentary have, at base, some element or task of reassuring people or stabilizing history, in other words, then what kind of documentary function is their film undertaking instead? By necessity, their film is confusing, repetitive, slowly unfolding; its aesthetic is raw, grainy, out of focus — inseparable, that is, in its own uncertainty and unevenness from the events themselves.

Farocki once said about Lumière's first shot that "even in the very first film, the foundations are laid for the main stylistics of film: it does not create signs, it seems to find them in reality . . . as if the world spoke for itself."[75] Refusing that self-evident-ness as false, his film with Ujica includes, in its DNA, the problems of and inherent to making the film: the contradictions involved in representing that history, those

events. Narrativity itself is a central subject of the film,[76] but that's only part of it: The film's self-reflexivity does indeed call attention not only to its own telling and to those other layers of telling that it unspools, but it does all of that in light of the fundamental problem of truth that envelops that whole past and, therefore, the whole project of its telling. Jill Godmilow has said of Jeff Wall's immaculately staged photographs that they "are not 'authentic' but they don't lie because they are telling something that's truer than reality. Because they skitter along the thin edge between real life and theatre, they are able to uncover the secret story—the mythic constructions and uncertainties that constitute our lives."[77] Multiply those mythic constructions to the appropriate degree, then, to understand what a truth-telling lie might look like in the case of telling the story of the Romanian revolution. Farocki and Ujica stay inside the perimeter of their subject, thereby exemplifying, rather than telling about, that miasmatic matter.

At this point it might be useful to take a short digression into the history of documentary film in Romania. The Romanian film industry had been nationalized in 1948 and granted generous subsidies to promote its house style of socialist realism[78] via the studios dedicated to fiction (Buftea), documentary (Sahia), and animation (Animafilm) projects.[79] After 1989, thanks to the remorselessly propagandistic nature of Sahia's productions in particular—including the "'prettifying aesthetics' that were compulsorily applied to rural Romania by the Sahia type of documentary,"[80] the whole idea of documentary work had become "negatively charged," as Adina Bradeanu puts it, and the genre dwindled in national estimation and production.[81] The document was corrupted.

In this atmosphere, *Videograms of a Revolution*, Farocki and Ujica's documentary about 1989, came about in the following manner:

1991–1992 — I saw images of the shootings in Rumania and heard about 60,000 dead bodies. I also watched a report about the cemetery for the poor in Timisoara, where mutilated corpses had been found — torture victims of the Securitate it was said. Later this turned out to be wrong; the bodies had been autopsied in a hospital nearby. Baudrillard therefore came to the conclusion that there had been no revolution in Rumania, or at the most, a fake television revolution. In 1990 I read a book about the fall of Ceauşescu, edited by Hubertus von Amelunxen and Andrei Ujica. I had the idea for a film in which a handful of people who understand something about politics and images would analyze in detail a series of images from those December days in 1989. To make a film like a seminar. I visited the book's two editors. Andrei Ujica suggested that we make the film together, and in summer 1991 we went to Bucharest. . . . We began researching images that had been made in the days of the revolution. It was not difficult to gain an overview of the given material. First of all, nearly everybody who had been filming in those days knew each other: staff of the Centre for Documentary Film, television people, students. . . . Television had many hours of material, broadcast by Studio 4 during the revolution, which hadn't been taped by themselves. In some cases they had copies viewers had made with VHS recorders — aware of the specialness of the historical moment. When we were working in the television building at night, soldiers would hang around with their submachine guns, as if the old regime were still a threat. After we had again and again seen images showing tens or even hundreds of thousands of people coming together in order to achieve the overthrow of the old regime it seemed absurd to call this a television

revolution. We dismissed our initial idea of a filmed analysis and decided to reconstruct the five days of a revolution, from 21 to 25 December 1989, from various sources of material, as comprehensively as possible . . . it was important to us that each shot of our montage would appear in strict chronological order.[82]

In its "reconstruction of the revolution," the film is determined to give those events some kind of tangible second life, some kind of legitimacy, and in its "deconstruction of its politics of representation" it acquires a doubled status, both itself and about itself. *Videograms* is both inside and outside its subject, because that's what the revolution itself was: The film is congruent with its subject. We see through the official TV cameras—beholden first to Ceaușescu, then briefly to the rebels, and then to the new leadership—and we also see the events through amateur camcorder footage shot by the protestors/revolutionaries on the streets for the duration of those events. There were a lot of those cameras (while it had been required that every typewriter in the country be registered with state security, no such provision applied to cameras): It was as though everyone in Romania was trying to record and broadcast everything they themselves did, as Shapiro put it, "so that later on there would be evidence, or proof, of where they stood and what side they were on."[83]

Those cameras are searching and shaky, catching often distant or unclear or even uneventful happenings, and the action often stretches out beyond the edges of the frame. The film starts with the testimony of a woman shot during the street battles—with the evidence of the carnage and the raw emotion of the battlefront, signaling that the space we're entering is one of *verité*, that we're being brought in very close to actual events and, thanks to that, we're being placed in the privileged position of the one who can know the truth.

It's a brutal opening:

I want to say something. Pass on a message for me.
 Speak to the camera, you'll be on TV.
You're recording sound and vision?
 Yes.
My name is Rodica Marcau. I'm from the Timisoara
co-op store. I defended the store on Sunday. The Secu-
ritate shot at us on our way home. Some were arrested
and tortured. They were beaten with rifle butts. I am
bed-ridden now but in the name of the co-op I wish
to join the youth of Timisoara and Bucharest and of
the whole country in the great revolution. We want
a better life, freedom for the young people, enough
bread to eat and happiness. We don't want a dictator.
We want Ceauşescu to be put on trial here in Banat.
We want to thank the chief orthopedic. Also Dr. Teicu,
who operated on me. She must operate again soon to
remove two bullets. We wish to thank the doctors. All
of us in the hospital support those in Opera Square. Let
them remain strong! Let them continue! Let them hold
out! We don't want the Securitate. I heard they want
us to accept them. I say no! The weapons should be
destroyed. Let us remember the four thousand dead.
We want our victims to be identified.

Cut to black.
 There's a blurry shot from a window, of what seems to be a
clutch of people thronging and shouting in the distance: We
can barely make them out. A narrator interjects: "The image
is unequally divided: the major portion is occupied by the
foreground, which is not the focus of attention. The event
has been shifted to the background. The camera gets as close
to the event as the lens allows." A pattern is established of
proffering scraped-together and meager imagery, interspersed

with readings of it: That pattern's repetition structures both the film's own ragged momentum and its embodiment of the disjointed, fragmentary history.

There's that fateful "disturbance" when the Conducator is seen to be astonished, lost for what to do next ("Keep calm! Keep calm! Keep calm! Keep calm! Keep calm! Keep calm! Keep calm! Keep calm! Keep calm! Keep calm! Keep calm! Keep calm! Keep calm!" and then an aside to Elena — "Shut up!"—and then the camera pans to the sky) and, in split-screen, we're shown both the feed that the TV crew kept shooting and the other, blank one to which the studio resorted, and then once again a voice intercedes, in exegesis, providing all the information we need that the images can't give us. We toggle back and forth between perspectives (street level, studio) and sources (sometimes the camera is pointed at a TV screen; we're looking at looking). The shooting and commotion on the streets is equally indecipherable to us and to those recording it live. The huge crowds at night lit only in tiny increments, by candles and tracer bullets (Chant: "free elections!" Shooting. Screaming. Fire. "Down with Ceaușescu!"). Intertitles augur what comes next:

> *December 22. Crossroads* ("Join us, soldiers!" "My glasses are broken!" [no clue . . .] Books "spewing down" from the Central Committee balcony — professional footage, now recording the "disturbances" — "the first to go over to the other side, more out of curiosity than of resolve." The crowd now fills the entire square.) *The cameras go into the streets* (Nicolae, Elena, and helicopter, on a rooftop.) *More and more cameras* (The helicopter takes off, in a clearer shot: Apparently, the source of this one was the Securitate, while the other shot was by a revolutionary sympathizer, but there's no way to know that from the images themselves.)[84]

At the television station (*Voiceover: "two cameramen had managed to smuggle a camera out of the repair room, under a jacket."* They're on the roof. Crowd is shouting, chants: "Freedom! No violence!" First sight of Romanian flag with center emblem cut out, waved by a guy on the street. Man runs over and hugs a soldier. Voice near the camera says "Get that on tape!" "We need the TV. Stop the bloodshed. Let us formulate an orderly appeal." Lots of arguing. Sense of urgency, must calm the crowd. Cameras in the hallways, the elevator [we watch the floor numbers light up as it descends], blocked by a closed door—guys trying to decide what to do, whom to appeal to: Go on air. "Every moment is vital!" Outside, the crowd: "THE TRUTH!" National poet, Dinescu, on air: "now God has turned his face toward the Romanians again. Let us look up to God in silence for a few minutes. But first we appeal to the whole army to join us. The dictator has fled. Lay down your weapons! Return to the barracks! The people are with us. The TV is with us. We are victorious! The TV is with us!")

A cluster, tightly packed: **TV comes to the Central Committee** (Alexa Vissarion, theater director, declares that Dăscălescu, prime minister, will now pronounce the government's resignation. Jostling, booing, protest: But—for legal reasons—he has to be the one to say those words.) **Camera 1** (Dăscălescu announces the government's resignation); **Camera 2** (Same moment, but from slightly above); **Camera 3** (Same moment, from below the balcony.) **The resignation is repeated** (TV cameras weren't ready the first time around, the crowd was too thick in the square, and the truck couldn't get through.) **Attempted broadcasts** (Now

shooting live in the studio. Mazilu—a diplomat and then dissident—speaking from the balcony: End the destruction of villages, end the ideological dogma in the educational system. "Abolish lies and hypocrisy. Competence and responsibility must replace them." Iliescu, presumptive new leader—TV keeps trying to record him speaking from the balcony but there are technical problems. Voiceover specifically notes that this glitch has occurred. Back and forth between Mazilu and Iliescu: two different sets of proto-plans [from the former: new flags; the latter: orderly transition]. All being figured out on the fly. Reports of shooting. Guy at the mic—"we've been informed that someone is shooting." Then someone else says—no one is shooting. "Please tell us what is happening." "Tell us! Tell. But not like that." "All together—someone's shooting?" Yes. "We must keep calm. No violence." Chant: "keep together!" "We shall stay!" TV shows Nicu Ceauşescu [son] to prove he's been arrested ["We must thank the people who understood that we had to show him on TV. The whole country must know, it is no rumor"]. This section is filmed off a TV set, apparently in the TV studio. Close up on Nicu, flashes of fear, bafflement, his eyes shifting around and a blank look. Seems to have wet himself. Sounds of gunfire, explosions. Then a cut to the direct camera feed of Nicu et al.; in the foreground of the shot there's another camera filming the scene in front of our camera. Now, shot of crowd at night, people climbing up on a tank—this is again at the Central Committee. Intermittent volleys of gunfire, pleas over the loudspeaker for the shooting to stop— no avail. You can see the bullets hitting the building, sparking and ricocheting. Plea from the TV station, now under attack [maybe]. "We shall stay on air.")

December 23. (In the yard outside the TV station. Another battle, shooting from inside at attackers. Cameraman running over to tank. "Film the tank!") **Where are the shots coming from?** (*voiceover: "Belief in the enemy's presence is a habit, recollected fear." Forty years of using fear to keep power. Fear was "a weapons system, the east European equivalent of the Western high-tech arsenal. A psychological substitute for material advantage. Time froze. The basic movement was that of idling. The basic feeling the inertia of fear. The shooting started only yesterday, and people are acting as though the war has been going on for a long time."* This is the most extensive commentary so far—one and a half minutes. A British journalist staging his report on the street, crouching-running toward the camera, shooting all around—does one take, then says—once more, the shooting was too loud for the camera to hear him. And again, and again.)

December 24. (Dead bodies in the back of a truck— victims of the terrorists, according to a soldier being interviewed. By now there's lots of press on the scene, so we see cameras shooting other cameras, and the chanting swells when the cameras point to the crowd.[85] Then, in the studio, people singing—"The heavens were radiant. The angels came on a beam of light.") **Identifying**. (A guy being arrested on the street, and then another. Roughed up by a soldier. Shooting starts again, people scramble.)

December 25. (Lots of cameramen shooting off the screen of a TV, anticipating an announcement. *Voiceover: "For the same reason, the streets are deserted. Everybody is watching and hoping for images from a single*

camera, which still has access to what is happening. Camera and event. Since its invention, film has seemed destined to make history visible. It has been able to portray the past and to stage the present. . . . Film was possible because there was history. Almost imperceptibly, like moving forward on a Möbius strip, the side was flipped. We look on, and have to think: If film is possible, then history, too, is possible." Room is silent, dark—lit only by the TV—people watching and waiting.) ***Communiqué.*** (Announcement by broadcaster, at a desk in front of the flag: "On December 25, 1989, the trial of Nicolae Ceauşescu and Elena Ceauşescu took place . . ." Now back to the room with people watching. ". . . before a special military court. The charges were: [1] Genocide. More than 60,000 victims. [2] Subversion of the state powers by armed violence against the people and the state powers. [3] Destruction of public property by damaging and devastating buildings, causing explosions in cities, etc. [4] Subversion of the national economy. [5] Attempting to flee the country to gain access to more than 1,000 million dollars deposited with foreign banks. For these severe crimes, the accused, Nicolae and Elena Ceauşescu, were sentenced to death. Their funds were seized. Sentence was passed and carried out. Our evening program will carry pictures of this." The watching room is silent—maybe stunned. No visible reaction.) ***The last camera.*** (Footage of Nicolae crawling out from the belly of a tank, helped by a soldier. Then a shot of him with a doctor—voiceover explains that the law requires that they be found to be in good health. He keeps talking; now Nicolae is submitting to the exam. Shot of a lot of people crowded together in a living room in front of a TV. One has a movie camera; actually, lots of them do. Shushing one another as we hear the

same voice and same words. People in the room — "incredible! What an actor! He's great!" [Nicolae has just made a dismissive gesture.] They're fidgeting, but not a lot. No sound, just a lot of white noise from the take. The camera is a little wobbly. "With that, dear viewer, we end our transmission for today." Long take with no sound of Nicolae and Elena at their trial. Expressionless.) ***The corpses on TV***. ("That's him!" We're in the darkened living room. "That's Elena. That's it, then. Turn it off." Credits roll: All the many camera operators are listed — dozens of them. Each shot is attributed to someone, even if unknown name.)

And so the story goes.

TV is the through-line in this jumble. After decades of being the ubiquitous presence milling the world into that tremendous sludge of lies, TV transformed in the space of moments. It became searching, protagonistic, enacting, sacred:[86] In Eva Kernbauer's reading, "the possibility of filming produced the revolution."[87] Before all that, Romanian TV had had an extremely formalized "camera rhetoric" (Farocki), but what happens in the studio is the opposite of Ceauşescu TV — gaggles of people in the frame, cacophony, uncertain hierarchies: Romanians feasted on the new TV's chaotic footage, superabundant in unresolved detail. The popular uprising was reflected back to itself in the new semiotics of the new TV. Hito Steyerl pushes the point: "As things become visible, they also become real. Protesters jump through TV screens and spill out onto the streets."[88] We see the events as

> a revolution played out as a struggle for images: the dictatorship begins to topple as its image is interrupted, its performance rendered vulnerable. . . . We see the Romanian revolutionaries triumph when they occupy the national television station and "own" its broadcasts.

> By seizing control of the production and exhibition of
> the television image in Bucharest, the revolutionaries
> assume the power to govern.[89]

The film proceeds from the simple fact that the insurgents
stormed not the Presidential Palace but rather the TV stu-
dio: This suggests the power that those images had in killing
the regime, a point that climaxed in the reexecution of the
Ceauşescus so that the deed could be recorded and broadcast.

But that making visible wasn't so simple. Decades of expe-
rience had undermined the idea that seeing confers knowing.
TV had now become an authority, in one sense, but it was as
slippery and devious as any other actor, in another. Already
within a few weeks of the December events, there was talk
that the revolution had been faked *by* TV. It's a commonplace
that the image is not identical with what it represents and
that, moreover, that nonidenticality is often in the form of
outright lies and shams. The conviction that this is the case
is widespread and not limited to totalitarian state media, but
it's especially the case in media environments made seamless
by totalitarian control. What we see in *Videograms*, though,
is that a disruption of the media surface, in what Kernbauer
calls "key moments of authentication," can break the spell.[90]
There had been that decisive instant with the Conductor
stopped in his tracks, just that moment, and it cracks the ve-
neer of his dominion wide open, it cracks open the veracity
of that whole world that he had screened onto peoples' lives.
That break restored faith in the *possibility* of truth-telling in
images, and that's exactly the propellant, the energy—both in
the midst of those December events and in their retelling in
Videograms. That dynamic continued for a while, even once
TV had started looking a lot like its old self, because there
was that new, tantalizing possibility of getting to the bottom
of something—something that seemed to have no bottom.

Farocki, the master vivisectionist, exposing the organs of the corpse to view, his will to truth and to unriddling the tangle of history, but contending, this time around, with the fact of truth's extreme unavailability.

The space in which the uprising transpired stretches from the Central Committee headquarters to the TV station, along the axis between political and media control—and the images shot there delivered that space of dominion, in its suddenly beset condition, to the country's living rooms. This changed the relation between that public and private space, dismantling the absolute hierarchy between them. As actions in the streets devolved into confusion and panic, people were united through their TVs, both in gathering around to watch as events unfolded and also in the knowledge that everyone else was doing the same thing. It was, effectively, the kind of mass gathering that had been illegal for decades, the assertion of a collective purpose in a repurposed public space.

But we shouldn't be too quick to celebrate. With an eye for the telling detail, Andrei Codrescu describes the TV's own transformation, beyond the on-off switch of Conducator proxy, thus:

> It could be that for a few glorious moments the first rebels to arrive at the television station created a free atmosphere unparalleled in the history of the country, an atmosphere in which all ideas of "taste" and "propriety" lost meaning. Whatever could be put on the screen was, whether it was a one-legged beggar with a delirious story or a rock video brought out of a secret drawer. But it couldn't have been long after, however, the young revolutionaries (if that's who they were) started becoming "responsible," and the "spontaneous" provisional government showed up with its own TV script. The television station then became the

headquarters of the new government, which, as far as most people were concerned, was born out of video like Venus out of the seashell.[91]

Baudrillard had condemned the Romanian events for the mendacity of their appearance, but *Videograms* leaves the matter open. For one thing, by restricting its scope to the five days of violent conflict in Bucharest, it rejects any potential perspective opened up by hindsight. This has the effect of putting the viewer in the same boat as those who lived those days, a space of suspension, uncertainty, and anticipation. The film returns the focus to the events themselves, mining them, and not their historicizing sequelae, for insight. But while this approach may jettison the search for "truth" as perhaps too romantic an endeavor, still the idea of truth remains important.

It's a lot easier to write off the whole business as a fraud than it is to try to understand. And so the film builds layers of tragedy, one atop another: the tragedy of the demented Ceaușescu himself and then that—or those—of the profound damage done to the entire population, during the regime, during the violence against the revolt, during the redirection of the revolution away from a new political reality. The anti-idealism of the film, paradoxically, gives this dispassion an almost shocking impact.

Stepping back, though, it seems ironic. The holy grail of radical cinema, as imagined by the likes of Eisenstein, Godard, and Kluge, was to create images that could play an activating, galvanic role with regard to their viewers. To some extent, that's what happened in Romania, "where the image is the condition of history and history is the condition of the image"[92]—but the fact was that those images had nothing to do with advanced thinking about film aesthetics: There was no formal innovation, no semiotic analysis, and instead

the filmmakers "seize the necessity of realist legibility as the key to widespread accessibility."[93] But that victory had been short-lived, and the film seems to revolve around that fact, "taking on a nostalgia for the revolution that is always located outside the frame."[94] Maybe this is why they inserted a clip, after all the credits have rolled, of a man exhorting people to take care of one another, ending on a wish that all may have a merry Christmas.

"The child with eyes set far apart and narrow temples is carrying a picture in front of him. The picture shows the forelock and the black inside the eye. The picture is on its side, the forelock reaches down to the child's shoes. We're not burning the frame, says the servant's daughter."

Ujica returned to the subject in 2010 with *The Autobiography of Nicolae Ceaușescu*, a three-hour montage of the Conducator as he had been portrayed on Romanian state TV.[95] *Videograms* is a portrait of a portrait of events, and this film is an autobiography, by way of a proxy representation that had been assiduously groomed by the subject himself. That being said, it's unlikely that he could have imagined the effect of all those pieces being strung together.

For one thing, it's just unnerving to look at him for very long. Ceaușescu was a monster, but he was also, by many accounts, for real. One of the things that makes the footage of him so riveting is that he seems entirely sincere: not a craven dissembler but a true believer. Ujica confirms: "He was anything but a hypocrite."[96] His physical bearing is off-putting in its oddness, always stiff and awkward and with a singularly robotic way of waving his hand. Alongside Mao, who exudes warmth by comparison, he seems not quite human, and even Nixon seems relatable when seen alongside the Conduca-

tor. At one point (and one point only) we get a glimpse of emotion from him, as he invokes the memory of his parents when receiving an honorary doctorate from the University of Bucharest—except that, in wiping away a tear, he wipes across his forehead instead of his eye. Always in Conducator mode, he emits his impoverished, bombastic, overheated sense of self, always playing to the bleachers even if addressing a small group in an interior space. Elena, meanwhile, is quietly malevolent at every turn.

Like the earlier film, this one is a chronological narrative pieced together with archival footage, but, unlike the earlier film, which covers a period of five days, this one spans twenty-four years. This time, we see the subject in two basic modes: presiding and in reputedly intimate moments. The former category is vast, and we witness him addressing massive crowds, receiving flowers in tribute, conferring with other heads of state—Mao, DeGaulle, Nixon, the British royals, Brezhnev, etc.—officiating at titanic parades and pageants (of which the one in North Korea is by far the most surreal). There are so many of those extravagant spectacles that it begins to feel as though the purpose of those shots—at least now, in their posthumous showing—is for us to see the staging, rather than the content or meaning, of all those events. This was the world that the Conducator moved in, and it was also the media diet, the imagescape, that Romanians had lived with for all those years. The one time when anything but adulation appears is from the 1979 Communist Party Congress, when Constantin Pârvulescu, a veteran cadre, denounces the reelection of Ceauşescu to secretary general as rigged: Likely, this footage was not destroyed only because the accuser was promptly shouted down by the delegates.[97] As Ujica puts it, "Even though anyone would have realized, by watching it, that the people in the audience were cheering first and foremost because they were scared to death, this

very demonstration of fear disguised in loyalty confirmed the triumph of the apparatus over any attempt at dissent."[98] In addition to that first, relentless mode there is the second, of (equally staged) excursions—hiking, hunting, and, in an especially peculiar sequence, playing volleyball. There's also a clip in which Nicolae and Elena take a tour of Universal Studios.[99] This mix gives the film and, by extension, the media self-portrait engineered by Ceauşescu a disquieting status, neither fish nor fowl, neither History nor home movie.

Autobiography goes from one thing to another with no transition, no relation—from a shot of hunting bears to one of the proscenium at the Twelfth Communist Party Congress; from a shot of the pair of them, bundled up in white fur on a sleigh dashing through a snowy wood, to one of the Conducator berating what seems to be a small clutch of party cadres about needing to work harder (Elena, off to the side, looking pissed); then—we're hunting again; then—on to the next thing. During one especially memorable hunting sequence, which opens in a close-up of a dog with a game bird in its mouth, we see the odd sight of Elena sitting at a nearby table playing cards with three toughs. The film goes straight from a "normal" day to a shot of Ceauşescu reading an officious address about the "disturbances" in Timisoara: Just like everywhere else in the film, there's no lead-in, no segue, and this treatment negates the uprising's climactic status, leaving it as simply another clip in the eternally ongoing reel. Given all this, it's not surprising that Ujica likens *Autobiography* to the experience of remembering: episodic, discontinuous and disconnected, phantasmatic.

Unlike *Videograms*, *Autobiography* has almost no offscreen commentary to explain what we're seeing: If the earlier film is dedicated to achieving transparency, the later one dwells, even luxuriates, in the stultifying opacity of its subject. One of the only interventions into the film's surface consists of

incongruous noises inserted into the soundtrack—a sequence of rumbling, then screaming and mechanical clicking, which are, it turns out, related to the massive earthquake that hit Bucharest in March 1977. We hear all that while the screen is black: You can only figure out in retrospect what it was, but in the moment it reads as a nonspecific indicator of doom and suffering. What's made visible by *Videograms* are the mechanisms of pseudotransparency, the maze of nested concealments. It might be that *Autobiography*'s muteness (and, in fact, it is intermittently silent),[100] coming some two decades later, is meant to indicate that comprehension is just not an option. Maybe, it suggests, even those long years after it all happened, the reign of Ceaușescu still cannot be transformed into a history—only an autobiography. Maybe the uncanniness of that whole era, with its saturation in what (actually, who) was claimed to be the core of all Romanian identity, was still too stuck to the bones of the filmmaker for him to split it off into the past and the Other. But still, paradoxically, this film at least has no doubt about what happened: It's one declarative moment, one irrefutable image after another. There's no down-blending of its primary sources with inventions or imaginings or clarifications, and the effect is to leave raw events at their full potency, neither contextualized nor explained into meaningfulness.

Despite being a documentary, *Videograms* makes all of its documents conditional, and this has to do with the fractured and slippery nature of the story it wants to tell. But while there's ample skepticism about mediatic representations of reality, about the truth content of images, nonetheless the film went about its narration by strictly following the chronology of events, as though to counteract an ultimate conclusion that it doesn't add up. *Videograms* partakes of the three main paradigms of argumentation—ethos, logos, and pathos, but in each case through some degree of displacement. It appeals to

ethics in its very being, insisting on as transparent a version of events as possible, but it refuses to name an outcome to that struggle. It appeals to logic, presenting events in sequence to build its case, using disparate and nonaligned sources to fill in the gaps wherever possible, but it is, finally, as much a record of those gaps as of the events, which are often pointed toward obliquely rather than actually captured. The film appeals to emotion throughout—through the dramatic intimacy with which events are filmed, through the focus on faces and expressions as they watch those events, through those faces as they watch from the interior of their homes, but its last words caution us not to be carried away. "That's him! That's Elena. That's it, then. Turn it off."

"And that while down below a field is blundering about with no sense of boundaries, Paul is intent on gazing at the sky, in search of a white moon."

Corneliu Porumboiu was fourteen when 1989 happened,[101] and he made his own film about those events, 12:08 *East of Bucharest*, quite a while later, in the midst of the flowering of a "New Wave" in Romanian cinema—films, like 12:08, made by the ones who had been children at the time and had come of age in the murk of the aftermath. As Ujica saw it, the difference between his generation and Porumboiu's had to do with the closeness to or distance from facts on the ground: "We are dealing," he'd said,

> with the "two faces of reality" in cinema. While I start from fragments of reality, which I try to compress through syntactic devices into an aesthetic discourse, the Romanian New Wave directors start from an aesthetic presumption, which they try to dilate through morphological means until it becomes fragments of

reality. We find ourselves . . . on the two different sides of the Möbius strip, with neither of us being able to identify the point where it twists.[102]

What's "real" for one generation doesn't hold for the next: We might say that if Farocki and Ujica's project had been optimistic, even idealistic about the possibility of truth, then Porumboiu's film is a record not of the revolution but of the complicated condition of (dis)belief. He is, we could say, borrowing Oscar Wilde's old quip, "a child of realism who is not on speaking terms with his father."[103] It's memory, not an attempt at history, that builds the groundwork for this story's fabulist truth, and it also recalls Nietzsche's latter-day musings about existence in the aftermath of pain: emerging into a self "with a few *more* questions." Even if "the trust in life is gone, [the] love of life is still possible—only, one loves differently." That "differently" plays out like this:

> What is strangest is this: afterward one has a different taste—a *second* taste. Out of such abysses, also out of the abyss of great suspicion, one returns newborn, having shed one's skin, more ticklish and sarcastic, with a more delicate taste for joy, with a more tender tongue for all good things, with gayer senses, with a second dangerous innocence in joy, more childlike and yet a hundred times more subtle than one has ever been before. . . . If we who have recovered still need art, it is . . . a mocking, light, fleeting, divinely untroubled, divinely artificial art, which, like a pure flame, licks into unclouded skies.[104]

It's a simple story. The host of a local TV talk show in a small town has decided to commemorate the sixteenth anniversary of the day Ceaușescu fell. The way he plans to do that is by determining whether events there in his hamlet

count, or not, as part of the glory: whether "we, the people in this town, took part in this moment in history. . . . Was there a revolution or not in our town?" His guests are the sodden schoolteacher Manescu and the bedraggled Piscoci, a retired Santa. The first half of the film is taken up with the sundry details of small-scale, quotidian dysfunction: drunken brawls, amnesia and hangovers, unreturned phone calls, whimpering kids, a disappointing breakfast. These transpire inside of dim and drab interiors whose residents are continually subjected to the petty annoyance of boys lighting firecrackers in their doorways for fun. Dawn's blue light: An enfilade of street-lights cuts off across an unlovely cityscape. The takes are mostly long and unspectacular, like tableaux in which next to nothing happens, filled with unremarkable details (jam on the toast, choosing a tie). The score is unadorned. Life in these parts is small-bore and mostly dreary, although everyone seems well-enough adjusted.

We see Manescu at his school, leading a make-up class for students who failed an exam on the Ottoman Empire ("What am I supposed to do if you can't even cheat properly?"); we see Piscoci angling for a better deal with the town's Chinese merchant (also the source of all those firecrackers); we see Jderescu in the studio berating a brass band for playing a "latino" tune instead of "something Romanian" and berating the cameraman for abandoning his tripod. The tuba player picks up a mic and starts a jaunty dance.

Once they all finally get to the studio (there are various detours), the "action" begins, which is to say they sit at the desk and talk, while the camera jiggles and cuts off their heads and zooms randomly from time to time. A backdrop of the town square spreads behind them, empty of people. The answer to the question on the table is to be found by determining whether people had gone into that square before or after 12:08 on that December day, before or after, that is, the

moment when Romanian TV had announced Ceaușescu's deposition.[105] Jderescu's preamble resorts to Plato (the cave) and Heraclitus (same river), and both references are, while ruminative, confused: We know from the start that the past is going to be a problem.

Manescu delivers. He says that, on the night before the fateful day, he'd been listening to Radio Free Europe reports about Timisoara, and so he and his friends had decided to go to the town square to protest and "put an end to the communist nightmare." A long and inconclusive debate ensues, with callers questioning his claims and one another's. His story unravels, and the conversation becomes circular, shouldering aside Piscoci, who busies himself with sneaking nips and looking peeved. Finally called upon to speak, he confirms that indeed he was not in the square, not until later on, but that, in any case, who cares? "One makes whatever revolution one can, each in their own way." His disavowal reads, for the critic Dana Duma, as "half sad and half funny, and eloquently reveals the frustrations of many Romanians who apparently still lament the missed opportunity in 1989 to show their courage and their determination to break with communism."[106]

But I don't think so. I don't think it was communism that was on the old man's mind either back then or there in the studio but instead a different source of regret, which cuts much closer to home. Piscoci launches into a beautiful, lamenting soliloquy: He'd gotten up at 7 a.m. that day, no, it was 6:30; he was still getting up at 6:30 then. He recounts an argument he had with his wife; he'd overreacted a bit—even at sixty years of age, he was still sometimes too jealous. "Sometimes I have this feeling, that it's what killed her." He went to work, then left early to buy her flowers. The square was deserted; in fact everywhere he went was deserted. He couldn't go home empty-handed; he felt ashamed. "Thank god, I had the idea

to pass by the botanical gardens. I broke a window pane and stole three splendid magnolias." He brought her the flowers, and she didn't say anything, just kept on with her housework. "I glanced in the mirror, and I saw she was smiling. I liked her smile. That made me happy. It meant she liked the flowers. But she wanted me to know she was still angry. I wanted to show her that it was all the same to me, so I turned on the TV. At that hour, we often got Laurel and Hardy, or Tom and Jerry . . . but at that moment Ceauşescu appeared, making a speech. He promised he would give us all a hundred lei. I told Maria that with the hundred lei from Ceauşescu we would go for a holiday by the sea, in Mangalia, but she said she couldn't trust me or Ceauşescu. And the transmission suddenly stopped. We carried on planning; we thought that if we went to Mangalia, we could still keep enough money to visit the monument at Adamclisi. She asked me to promise that; I gave her my word. The transmission returned, and all kinds of people appeared on the screen saying the revolution had been won. Maria burst out with joy, but I regretted the hundred lei Ceauşescu had promised."

Piscoci's love story is a tough act to follow, especially in a film that has spent nearly all its time sunk in the minutiae of dreary days and flimsy nitpicking. Hangdog Manescu has resorted to peevishly ripping up a piece of paper. Chen calls in to vouch for Manescu's character, and Jderescu, exasperated with everyone, asks him why he sells those firecrackers ("Supply and demand"). The mood is shifting, the whole point of the show seems to be escaping, the host can't make any headway; he's resigned but somehow also can't let it go. Manescu, too. It all feels like something in between intimate and hopeless. We're close to the end of the story, and there's been so little relief—just those few words of care and sweet remembrance, but there's one last caller before the show runs out of time. "My name is Tima," she tells them. "My son

died on December 23, 1989, in Otopeni, Bucharest." She has a lovely, patient voice. "I'm not about to reproach you, Mr. Jderescu, I'm just calling to let you know it's snowing outside, big, white flakes, big white flakes. Enjoy it now, tomorrow it will be mud. Merry Christmas everybody!"

The show peters out; Jderescu says goodbye in barely a whisper: maybe chastened, maybe sad, maybe failed. The camera jiggles one last time, and then we're back on the street, blue in dusk. It's snowing, still unlovely, but also beautiful. Jderescu:

> 5 . . . 4 . . . 3 . . . 2 . . . 1 . . . Come on man, I'm freezing to death. The old man was wrong, they all turn on at once since they invented photo-electric cells. 5–4–3–2–1 [sigh] . . . You messing with me? Anyone else would've already broken you in two! [a light comes on, dim and yellow; it does basically nothing to illuminate, both because it's too weak and also the sky isn't dark enough yet for it to matter.] Well done, boy. It's calm . . . and beautiful. Like my memory of the revolution. It was calm and beautiful.

"Allow me to explain," Piscoci had said. "The revolution started in Timisoara, right? Then it spread across the country, all the way out to our town in the middle of nowhere. . . . Look: Do you know how they turn the streetlights off and on? Have you ever noticed? First Timisoara, then Bucharest, then little by little the whole country. The revolution is like the streetlights, they light up in the center first, then they spread all over town."

The streetlight seems a bit brighter now, and everything is quiet as the rest of them come on too, one by one in some places and all at once in others.

Porumboiu makes a crucial distinction, that 12:08 isn't about the revolution but rather about "how those events still

percolate in peoples' minds today."[107] He shows the minor figures, the bystanders in the uneager margins, the wrenchingly hapless avatars of what history had been imagined to be. His slice of humanity seems nervous, more than anxious, which is to say that the emotion we get from his characters seems more at the level of bodily fibers on edge, more than the (semi)processed awareness that anxieties are. And he nests all of that in an ode, a suspensive ode to belief.

The film, apparently the first to treat those events "without fervor,"[108] won the Camera d'Or at Cannes: To Westerners, 12:08 was a comedy (the New York Post declared it "the most hilarious film I've seen this year!")[109] while, as Andrei Cretulescu explains, "the natives (the intelligent ones, at least) bit their lips not to cry."[110] Romanian cinema had been stuck for at least a decade, "mostly engaged in a pessimistic reflection on post-communist reality, in the growing social polarity, moral confusion, corruption, and cynical pragmatism,"[111] and that preachiness had "already saturated the patience of the Romanian public."[112] A big part of the problem was that the revolution had remained glorious in the official version, ignoring the fact that life was still a mess: The "revolution" existed as a black hole, sucking tremendous amounts of energy and stoking an eternal sense of betrayal.

Postliberation national cinemas generally assign themselves three topics: what led to, what happened during, and what changed in the aftermath of the upheaval. This schema was thwarted in Romania in a few ways. Not much had changed, for one thing—not enough to qualify as a real revolution; what had actually happened still wasn't all that clear (it still isn't); and what had gone before was tricky to elaborate, for reasons of pain and complicity.

Reflecting on that new cinema, A. O. Scott observed that the films are generally devoid of "didacticism or point-making" and that their principal commitment is to honesty rather

than to verisimilitude. That "honesty" seemed to lodge most profoundly, or most ethically, in an intimate space drenched in its own complicated dynamics of revealing and concealing.[113] Those new filmmakers, for the Romanian critic Andrei Gorzo, feel a "sense of duty toward reality."[114] The year 1989 remains an inevitable point of reference, mostly in the form of its ghosts, evidencing the revolution almost entirely in terms of the doubts and suspicions that stewed in its wake. We have, then, a different neurology of story making. There is a continuing attachment to fact, history, and truth, but in an anamorphic vein proper to the deep ambiguities that never stopped shrouding that particular past and pointed away from a more dramatic narrative arc. In these paeans of depleted and famished care directed toward those unlost but unfound groundings, those causes at once obscure and grandiose, those desires sometimes so near to anomie, we see a way of returning that hopes, in the form of its bituminous tonalities and shivery, uncertain presences, to sketch a different way forward.

Ujica says that a historical figure like Ceauşescu "usually traumatizes its own nation *in personam* and as a ghost for about one hundred years. . . . During this sort of period, art, and nowadays mainly cinema, usually takes on a psychotherapeutic function over collective trauma."[115] If he's right about that, then it explains the very, very little that later films about these events offered up in the way of consolation, their indifference to catharsis while mostly "summon[ing] up a genie who can do everything but fulfill our wishes."[116] We might also find in Ujica's words an indicator of why, in 12:08, Porumboiu leaves the high-minded documentary form and opts for something more akin to reality TV, also taking up "reality," but for different purposes. The people in the film are exemplars of interior dislocation and tiny catastrophes. If only they had pictures they could look at, pictures that would

name what they fear, the film seems to say, then they might be able to start crawling out of their numbness, their stupors, their byzantine, self-crumbling avowals. At the end, a narrator says, "The revolution is like the streetlights, they light from the center out to the most humble back street." One way to read that is that it's a process of affirmative contagion, which spreads with its own pattern and logic. But another is—people are cowards, they'll only act once a clear narrative has been established, and then they'll be nothing more than followers or pawns. The very ambiguity, not to say eliding quality of his sentence, seems to speak from the center of its intent.

What's clear is that 12:08 keeps its distance. It uses the plot device of a TV show to frame the virtual revolution that had been experienced on TV. It puts a picture of the square, the very space that's being recalled, right behind that dubious process of recollection and tells us that it's actually just outside the window of the room where that conversation is taking place. It's an endlessly self-reflexive, shambling mise en abyme—and yet, a passage into love.

"This bad taste, this will to truth, to 'truth at any price,' this youthful madness in the love of truth, have lost their charm for us; for that we are too experienced, too serious, too merry, too burned, too *profound*. We no longer believe that truth remains truth when the veils are withdrawn. We have lived too much to believe this. Today we consider it a matter of decency not to wish to see everything naked, or to be present at everything, or to understand and 'know' everything."

Which brings us to lying.[117]

Farocki and Ujica insist that the revolution *was*, and Porumboiu says that even if that's the case, we're likely asking the wrong question. For that younger generation, the

fact of the matter was that, regardless of any specifics about heroism or the lack thereof, their world disproved any claim of transformation or release. Life had continued in its miserable vein, and the insistence that the revolutionary inheritance was something brighter stood as a flat-out lie.

Hannah Arendt's late essays on lying and politics draw a line between political history in the wake of the "great wars" and all that went before, and that line is drawn by the lie of its disappearance. It's a history that "seems no longer to establish, but rather to eliminate, the very possibility of its own remembrance," as Cathy Caruth recounts,

> a new and perplexing phenomenon: the advent of a history that is constituted by the way it disappears from consciousness, that eludes or erases memory in the very act of creating new events. In this sense Arendt's political writing, and Freud's psychoanalytic texts, unwittingly and unexpectedly meet at the site of a disappearance, at the place where history — as modern lie (Arendt), or as death drive (Freud) — seems to move forward through the erasure of its own memory. History emerges . . . as the performance of its own disappearance.[118]

Public space converts from the site at which history is made to the one where it is made to vanish, the site of the lie that denies what everybody knows. The lie's vastness, its audacity, is to wear away the whole framework of factuality as such. The lie, says Caruth, "moves out of its subordinate position . . . to become an absolute framework in which nothing but the creation of the lie acts in the world."[119] In other words, says Arendt, "the difference between the traditional lie and the modern lie will more often than not amount to the difference between hiding and destroying."[120] Romania is an extreme example of this historical process: In the very act of "making history," it makes history impossible.

Herodotus, allegedly the first to "write history," described the need for his project as follows:

> These are the researches of Herodotus of Halicar-
> nassaus, which he publishes, in the hope of thereby
> preserving from decay the remembrance of what men
> have done, and of preventing the great and wonderful
> actions of the Greeks and the Barbarians from losing
> their due need of glory.[121]

Romania, however, was not classical Athens and had no such glorious victory over powerful foes to boast of; they had no such democratic exceptionalism to laud themselves for, and over and above their fellow men. In Timisoara, Baudrillard had said, "the corpses, the violence and the death did not make the scandal but rather the corpses forced to function as extras, as if they were hostages—not to mention that we as viewers were taken hostages."[122] The Romanian revolution was, he says, "really less violent in its acts than symbolically virulent through the discrediting of its own process. The logical connection of information and history has been turned against itself, and its infernal cycle has brought out a sort of speculative clash in which historical consciousness is struck down."[123] The fakery had been transfused right into the "witnessing of history." Yet, they still needed history.

Baudrillard only gets at part of the lying—the mediatic part, the part that derives from the status of the image, which is a modern-postmodern issue. But in Romania there was also the fundament of lying, an ancient proclivity that was not only constitutive in the events but also deeply formative of the environment in which those events took place and in which they were witnessed. And in which they were, later on, represented. This is not a matter of the status of the image but rather about the status of believing and of living in a state of perpetual misgiving. In this situation, undecidability doesn't

work so much as a virtue, a refusal of premature or illegitimate closure: In the context of Romania, it was the normal state of things, and in post-1989 Romania there was a hunger for release from that state of being.

The upshot, for Baudrillard, was that "we" got more out of all that than the Romanians did, in one sense (they "taught us a lesson about freedom, not by reaching it but by trapping us in a false process of political liberation indexed in fact to *our* Western demand that they be free"),[124] but still, "they" got the last laugh:

> We hold to moral and conditional forms of liberty, while they adopt an unconditional form, finding a parody, a paroxysm of liberation through the image, of the liberation of the image itself, its total mobility, its total disconnection and projection in the space of virtuality and simulation. Why would the image, once liberated, not have the right to be false?[125]

The image is liberated from its bonds to facts, to the real. The image is energized by its liberation, it gains—what? Strength? Potency? The capacity to convince? Baudrillard is the most prominent outsider to have bothered himself with poor old Romania's problems, but my guess is that his views were anathema to Farocki and Ujica and also, differently, Porumboiu. Or, to put it another way, his cynicism arose from having the latitude to be cynical—a luxury not available to all with views on the matter.

Let's look at it in a different way. First of all, lying, dissimulation, dissembling, simulation, hypocrisy, spin, self-deception, all took so many forms and came from all directions. There were the lies told by the Conducator; the lies told by the regime in the course of the revolution; by officials in its wake; by people to themselves, desperate to believe: These are not all the same, and we have to assign motivational intent.

And so we'd be wise to bring to each set of them differing demands, for different sorts of truth.

We have, on one side, a romantic fetishization of authenticity and truth — witness the status of post-uprising TV — which balances, if not resolves, the previous way of life. Did that produce the need for a truth that could be proclaimed from the same balcony from which that mythomania had spewed? Desire is given a powerfully displaced expression, but, for its own absolutism, it's bound to disappoint. George Steiner says that

> we shall not get much further in understanding the evolution of language and the relations between speech and human performance so long as we see "falsity" as primarily negative, so long as we consider counter-factuality, contradiction and the many nuances of conditionality as specialized, often logically bastard modes. *Language is the main instrument of man's refusal to accept the world as it is.*[126]

Situating the concept of truth, and of its twin, transparency, squarely within the confines of "the West," Edouard Glissant argues in favor of opacity, which, he insists, is "not the obscure" but rather "that which cannot be reduced" in the manner of the "excesses of political reassurances." "If we examine the process of 'understanding' people and ideas from the perspective of Western thought," he says,

> we discover that its basis is this requirement for transparency. In order to understand and thus accept you, I have to measure your solidity with the ideal scale providing me with grounds to make comparisons and, perhaps, judgments. I have to reduce. . . . Accepting differences does, of course, upset the hierarchy of this scale. . . . Agree not merely to the right to difference but,

carrying this further, agree also to the right to opacity
that is not enclosure within an impenetrable autarchy
but subsistence within an irreducible singularity.[127]

The imaginary, per Glissant, "does not bear with it the co-
ercive requirements of idea. It prefigures reality, without de-
termining it a priori. . . . The thought of opacity distracts me
from absolute truths whose guardian I might believe myself to
be."[128] Of course we can't know if Manescu was remembering
or imagining, but Porumboiu gives him to us as something
other than a liar.

Western philosophical thinking about lying has been, for
the most part, too thin to accommodate real life, much less
real life in extremis: either theoretical in a way that frames the
question in terms of absolute values or moralism or so relativ-
ist that the alleged "pragmatism" of the approach disclaims
any meaningful substance to the term and the act. And even
for the equivocators, it remains basically a simple question
of yes or no. The problem is in the uninflected definitions of
truth and its alleged opposite, which swirl helplessly in what
Martin Jay — admittedly, an advocate of mendacity — calls
"an endless dialectic of purity and pollution, uprightness and
fallenness, sin and redemption, public piety and private trans-
gression."[129] He refers us to a "sphere of interiority that resists
the imperative to be fully transparent . . . lying, in this optic,
is an assertion of the right not to confess against our will; it
reinforces that sense of autonomy."[130] Nietzsche warned that
"Faith makes blessed: consequently, it lies,"[131] and so we have
grounds for the rejection of that quasi-religious imperative to
bare your soul — grounds, in the name of selfhood.

It's sometimes asserted that, in plain speaking, "language
can be like glass, a medium without the infusion of a self.
It pretends the facts can speak for themselves in ways that
the old rhetoric never did."[132] Farocki's film goes a long way

toward establishing a coherent genealogy for the images that we all took as legitimate, but it also tells us that all tellings—even his own telling of a telling—bear the imprint of the illusions that lie behind them. "The highest indication of will," Nietzsche encourages us, "is the belief in the illusion (although we see through it)."[133] Given the alternative of meaninglessness, truth seeking may, honorably, turn to a psychic reality—how events are received—so long as it is recognized as such. Farocki, Manescu, remain troubled.

"As I was saying loving repeating being is in a way earthly being. In some it is repeating that gives to them always a solid feeling of being. In some children there is more feeling and in repeating eating and playing, in some in story-telling and their feeling. More and more in living as growing young men and women and grown men and women and men and women in their middle living, more and more there comes to be in them differences in loving repeating in different kinds of men and women, there comes to be in some more and in some less loving repeating. Loving repeating in some is a going on always in them of earthly being, in some it is the way to completed understanding. Loving repeating then in some is their natural way of complete being. This is now some description of one."

Repetition is related to lying, provided we use another than the hyperbolic sense of that latter term.[134] Let's think along with Hito Steyerl, as she works through that concept:

> [Deleuze] argued that several types of repetition are possible. To summarize it very briefly: the repetition of the same, the repetition of the similar and the repetition of the new, which either mask or unmask difference

within repetition. . . . Apart from the repetition of the same, which is based on habit, there is also another form of repetition that repeats not the same but the similar by repeating the things *that have never been*. This form of repetition displaces the original; it repeats but with a difference. It creates memory, which relates to a present that has never been present. In memory, events are repeated that never existed before like in national memory, which is always based on a fiction.[135]

Repetition, via telling, and in some ways, that telling as the shadow of those events. In Plato's cave the prisoners can't look directly into the light of knowledge but only at the shadows: Their backs are turned. Shadows as copies of reality and, as the origins of representation, understood as a pejorative. Piaget determined that it's only late into childhood—age eight or nine—that we come to understand shadows. Unlike Lacan's idea of the mirror stage as a process of identification, the shadow is here understood not as I but as the other (in fact, for Peter Pan this was literally true). Shadows are representations drawn by line, by silhouette, rather than by volumetric suggestion. In some lines of anthropological thinking, shadows are associated with animism, where the shadow is linked alternately to the soul and to the double. The very tenebrosity of events, of life in Romania, conscripts their telling to the shadows, and so one way to think about these tellings is as explorations of just how much could be seen in the shadowed (shadow) parts of a self, of a world.

Our quest for truth tends to fasten onto the revelatory, which is, more often than not, just another way of lying. The Romanian revolution, all revolutions, want a revelatory experience; it wants—it's famished—in its craving for thrilling, painful emotions, not just some ordinary, fragmentary truth. But there's a crucial difference between truth and

meaning. Romania has refuted settled certainties, and that has mostly been read as adjunct to falsity. What we get from these films, though, is a sufficient subjunctivity, in which we're free to dwell on other kinds of knowing. We can, again appealing to Wilde, "draw the moon from heaven with a scarlet thread."[136]

Farocki, Ujica's immediacy, "as close to the event as the lens allows." Manescu, Porumboiu's presbyopia, which, blurred away from the close-up, somewhere between exhilaration and surrender, sees nonetheless. Ujica's generational chiasmus, with the '89ers leading from events and the ones who come later working with that incredibly complicated currency they had at their disposal. Amused, maybe, but invertedly. It's probably true that Manescu is lying, but I wonder if Porumboiu isn't telling us to look elsewhere for knowledge about who those people are, in the aftermath of those events. To the magnolias. To the snow, before it turns to mud. Blanchot: "When knowledge is no longer a knowledge of truth, it is then that knowledge starts: a knowledge that burns thought, like knowledge of infinite patience."[137] Not all speech is contained in the closed sets of true and false—prayer, for instance (and here I note that protesters in Timisoara apparently chanted "There is a God"!), and all those stories we tell children (and ourselves) to explain away the fearsome dark.

Daniel Mendelsohn reminds us that we go to tragedies "because we are ashamed of our compromises, because in tragedy we find the pure beauty of absolutes."[138] These films are wise enough, each in its way, to explore the place where idealism ends. Each, in its way, absolving the grasping at fixed meanings, tolerant of stormy ambivalences. Each, in its way, setting aside the pain of skepticism and disbelief. That may all be hard to swallow, but Porumboiu's twilight is vivid—that

glowing, luminous blue, that feeling of descending that we all know, setting aside—for a moment—all those inclement verdicts.

What writes the ending?

4

Whoever Knows the Truth Lies

After October 1977, West Germany,
in Germany in Autumn and October 18, 1977

Words halfway to intelligence.
This possibility of thinking in reverse and of suddenly
reviling one's thought.
This dialogue in thought.
The ingestion, the breaking off of everything.
And all at once this trickle of water on a volcano, the
thin, slow falling of the mind.

> —ANTONIN ARTAUD, "THE NERVE METER"

July 30, 1977: The banker Jürgen Ponto is assassinated
 by the RAF.
September 5: The industrialist Hanns-Martin Schleyer
 is kidnapped by the RAF.
October 13: Commandos hijack Lufthansa flight 181
 in Mallorca, demanding the release of imprisoned
 RAF leaders and others. The plane flies to Larnaca,
 Dubai, Aden (where the pilot is "executed"),
 and then Mogadishu while the West German
 government stalls for time.

> *October 18, 12:05 a.m.: West German GSG9 troops
> storm the plane, kill the hijackers, and free the
> eighty-six remaining hostages.*
> *October 18, around 7:30 a.m.: Andreas Baader,
> Gudrun Ensslin, and Jan-Carl Raspe are found
> dead in their prison cells.*
> *October 19: Schleyer is found dead.*
> *October 20: Work begins on the film* Germany in
> Autumn.

The film is an immediate and jagged response to the cat-
astrophic, blacked-out cascade of events in 1977 West Ger-
many. It's a kind of collective statement, an agglomeration of
contributions from ten different directors, opening with one
funeral and closing on another. Right at the start, on-screen
text reads: "Once a certain level of atrocity has been reached,
it's irrelevant who's responsible. It simply has to stop (8 April
1945, Frau Wilde, 5 children),"[1] and then it cuts to a section
directed by Rainer Werner Fassbinder, during which he rants,
brawls, freaks out, drinks, works, phones people incessantly,
pukes, and gets his mother to express yearning for a kindly
autocrat to put things right. By 1979 Fassbinder had already
resolved his analysis into farce (promo posters for that second
film read "I don't throw bombs, I make films"),[2] but in the
moment of the conflagration he offers the shakiness and
agony of living it.

A decade later, Gerhard Richter opens a show of taciturn,
blurred-out paintings of the corpses, the funeral, and the
protagonists, who had still not lost their capacity to incite
fear and rage. Their exhibition in West Germany was bad
enough, but when the paintings were sold to MoMA some
years later, all hell broke loose.

Unlike most representations of the RAF—and there have
been very, very many of them—these two are resolutely ir-

resolute. They come from two different moments in relation to the events and in relation to the processes of revising, occluding, and even forgetting that followed in those events' wake. They're key points of reference in that enormous body of films, novels, plays, artworks, and journalistic and scholarly accounts precisely because they do nothing to lay those events to rest. They are products of an aftermath, just like the events that they recounted were. They're both responding, each in its own way, to the tremendous power that that widespread fear had had, that fear of society breaking apart in a torrent of violence and hatred and lies.

I'm Here

That West German autumn careened, thundered, and shuddered to an end in blood. Blood in Mogadishu, where PFLP commandos were trying to free the imprisoned leaders of the Red Army Faction, a group of hard-left, violent militants. Blood in Stammheim prison, where those same radicals had been isolated after trial and conviction. Blood in Mulhouse, France, in the trunk of a green Audi 100, where the body of Hanns-Martin Schleyer, president of both the Confederation of German Employers' Associations and the Federation of German Industries—and former Hitler Youth and SS Untersturmführer—was found. The commandos had hijacked Lufthansa flight 181, made their demands, and then failed to win out over the West German special forces who stormed the plane. The prisoners—Baader, Ensslin, and Raspe, leaders of the RAF (Ulrike Meinhof had already died there, as had Holger Meins)—were found dead in their cells the next morning, apparent suicides. And as for Schleyer, he had been kidnapped by the RAF six weeks before: Upon hearing of the Stammheim deaths, his captors executed him.

Work on the film *Germany in Autumn* was begun one day later, when Alexander Kluge called on a dozen or so of his colleagues to, together, say something about those events. The bodies were barely even cold, but already the public version of what any of it meant was being hardened into a morality play and a parable, falsely construed, about the unity and resolve of the nation. As Volker Schlöndorff recalled, "Kluge explained that we must create a counter-public sphere and ought not to allow the public stations to have a monopoly on the writing of history."[3] Fassbinder was more specific:

> When we all sat down together back then, one of the reasons why we said we had to make the film was that something had to be done to combat fear. We felt that ordinary people, who don't have any means of production and possibly have more fears than we do, shouldn't let themselves be intimidated by the feeling prevailing in Germany at that time, that criticism in any form was unwelcome and had to be crushed. To make sure that didn't happen, and because we had the means of production at our disposal, we wanted to state very clearly: people can and should and must go on talking, no matter what happens.[4]

The country had been in a state of hysteria for years already: There was a terrorist phantasm under every bed (or else somebody might think the terrorist was you), and the West German state had remilitarized, decimating civil rights and constitutional standards along the way. The media were either censored or had beaten the censors to the punch: A news blackout kept the entire country in the dark for the length of the Schleyer affair (in particular, it was forbidden to allude to his Nazi past), the tabloids ruled, and no alternative sources of information existed.[5]

And so the filmmakers went back almost immediately, since the history was already being erased. Not to reclaim it or define what it meant but rather to inveigh against the claim of closure that erasure was conferring.

It's Schleyer's funeral that opens the scene and then that of Baader, Ensslin, and Raspe that closes it, with a lumpy verisimilitude building up in between, steering clear of any commandeering force of wholeness in the narrative, since this was a story—a direct descendant of the Holocaust, no less—that was impossible to really tell. "What can the story-teller do," asks Andreas Huyssen,

> once reality evades representation and most representa-tions of reality are no more than simulacra? . . . How does one narrate when reality has become functional, as Brecht already pointed out when he suggested that a simple representation of reality, say a photo of the Krupp works, no longer grasps that reality? . . . One of Kluge's basic strategies, in an age in which traditional narration is no longer adequate to capture the increas-ingly complex and abstract structures of contemporary reality, is to render the various language games that constitute social and political reality recognizable as such, to unfold their implications for domination and repression, and to explore their potential for protest and resistance.[6]

Huyssen's comments are fine as far as they go, but they leave out the other force of forgetting that was also at work, namely, the will to amnesia. The RAF had seen the West German state as unrepentant and unreconstructed fascists, and the state, in turn, had directed those same charges against "Hitler's Children." Both sides, both sets of combatants, were operating on the foundation of forgetting that had followed World War II—the state, in the name of obscuring its collu-

sions and continuities, and the RAF, in the name of those sons and daughters for whom that mendacious silence condemned them, as well, to shame.

I'm Afraid

Fassbinder's part of the film looks like a cheap gangster movie with a leaden palette. The whole segment plays out in his apartment, a hovel littered with empty bottles and overflowing ashtrays: No daylight makes it into the filthy space, but the sound of sirens does, at which he panics. He's frantic, overheated, furious, manically indirect, in no condition to respond to the news that's trickling in, but he can't not respond somehow, so he rants about whatever—the news blackout, an interview he blew, the suicides, and the plane: He oozes fear, he berates and beats up his boyfriend, he's querulous and paranoid, intransigent, hysterical, weeping and despairing. He sits naked on the floor with a cigarette and schnapps in one hand and his penis in the other, in a shot sometimes read as total vulnerability on his part ("Fassbinder's most unrelenting exposure of himself . . . radical and unflinching honesty and self-examination")[7] or, alternatively, as an assertion of how hard it is to really look at what had happened ("caught between agitation and powerlessness").[8] Or maybe as both: "The richness of [his] ironies brings home the private dilemmas and self-betrayals Germans faced in the midst of this very public crisis."[9] Either way, no available comfort is going to be enough.

Fassbinder's segment is stagey and fake and also confrontationally intimate, turning the camera around and demolishing the line between drama and reality—a postmortem of a failed movement and of its interiorization among those who cannot yet absorb what that failure means. He argues with Armin about what limits there are—if any—to the state's

right to retaliate. He argues on the phone with someone about
whether they were suicides. He argues with his mother at
length and browbeats her when she says she's afraid to say
anything about whether people should have the right to say
anything (some accounts say this dialogue was scripted; others
disagree). He couldn't care less about the bind she feels she's
in, and when she finally admits that, "as a normal German,"
she'd prefer to be ruled by an authoritarian *Führer*—"but a
gentle, benevolent one"—he pounces, viciously triumphant.
She gets a strange look on her face, almost—almost—a glim-
mer, a smile: On first viewing it looked like meekness, but
the next time around it looked more like she's playing him.
And then, suddenly, the scene is over, and we've moved on
to a view of a treacly pastel landscape backed by the soaring
encouragement of "Deutschland über Alles."

According to Fassbinder, the film should "formulate anxie-
ties."[10] And so that's what he does, stripping the private space
of his home, his body, and his intimate relationships of their
apparent safety: The threat is public, it's private, and it is
within. The more excessive his scenario becomes, the more
you feel his explosive internal pressure: It's like a gargoyle,
recording madness in public. There's a "gathering anxiety,"
as Olivia Laing describes in her ode to loneliness, "around
the question of visibility."[11] He's unsafe and desperate and
seems torn in each moment about what it is that he needs
or wants, swiveling among mania, brutality, fear, tenderness,
and fury. In a way, it's the need for something to make sense
that's the most frightening part. Confinement and exposure,
entrapment paired with intimacy: Not quite safely fictional,
not quite stably real, Fassbinder's tableau feels at once like
a containment, a control exerted over the psychic disarray,
and a release from it secured in the act of leaning into it,
desiring it, and inhabiting it wildly. The alarmingness with
which Fassbinder infuses his version of the tale, suffocating

in confusion and wariness, agitates in two directions—pulling us in and, resistant to interpretation, refusing us entry. It feels unhinged, wary of itself, impacted like a rotten tooth—the result of stress that's been unrelenting and inescapable.

Sharp edits punctuate Fassbinder's drama, constantly interrupting and making it impossible to keep focused as the story keeps snapping back and forth. He defies the power of the story, of narrative, in order to get at the feeling of experiencing events that are historic and tragic and that form who we are because of how they live inside of us.

I Don't Remember

The idyllic interlude yields to another severe cut, this time to the history teacher Gabi Teichert. Although it takes a while for it to become clear, she's wrestling with the fictions of the past, and "since Autumn 1977, she's had doubts about what to teach." Gabi walks out into the winter landscape, klutzy in a too-big overcoat and rubber boots, sloshing through the muck to a hilltop where she begins to dig. Evening falls and birds flock in the sky, but she can't find the clues to the past that she's looking for. She's in trouble at school, they say; she has a confused view of German history, and it's inappropriate to expose the children. The segment is intercut with bits and pieces of past suicides, assassinations, and cataclysms that may help her draw connections for the children between present and past—the nineteenth-century Mayerling Affair (regal suicide for love, and for politics) seen in cartoony paintings, an old newsreel of the assassination of the king of Serbia (the first ever to be captured on film), and then the funeral of Rommel, hero of Africa, whose own suicide came at Hitler's behest in exchange for a state funeral (he had changed his mind about the Führer and joined the plot to kill him). We linger on this scene for a while, the screen jammed with

parading Nazi regalia and hoisted salutes. Schleyer's funeral Mass makes another appearance, but now with the addition of a sidebar in which a young Turkish guy is being arrested outside of the grand church, explaining that he's carrying a rifle in order to shoot a pigeon for lunch. Back to Gabi, literalizing the uncanny: "I'm trying to put things in proper context" (actually, she doesn't speak; it's the voiceover that says this on her behalf).

Dozens of black Mercedes have made their way to the proceedings, and the pews are orderly with their solemn, black-clad ranks. The Esso banners that had flown at the site of the High Mass echo in the stands of giant Mercedes banners at the memorial service, and a caterer barks at his staff to hold their trays properly, smile, and be quick. "Delegated" employees of Schleyer's factory watch a live feed of the service, and line workers on the factory floor shift uncomfortably during the mandated three minutes of silence, all filmed not only by the camera that we see through but by others as well. That double vision is a reminder that what we're seeing has been put together on our behalf and that, in that, it parallels the stories that were put together at that time in the version spun for the German people.

There are other chapters, cycling through a zoetrope of characters: the woman who is inexplicably attacked on the street and another who rescues her (all wordlessly, and the scene even starts with no sound at all); the bloodied stranger and the woman who tends to his wounds when he appears at her door (ambiguously, either suspicious or seductive)— there's even a reprise of the *Psycho* shower scene, which turns out to be just her flight of fancy. There's the avant-garde filmmaker who looks to 1920s Soviet aesthetics for the model of her own denunciatory production (a film about a film about a film), and there is also Horst Mahler, ex–founding member of the RAF, then Maoist, and future neo-Nazi,

pensive and rambling with an interviewer in his prison cell. Alone in the entire film, he names outright the lingering past as fascism and also the failures on the part of the RAF to read the situation clearly and confront it meaningfully. This might have stood as a political punctum for the film, a declaration of conviction, but Mahler's tangents are so cloudy that when the shot ends with the camera panning up to the daylight streaming in through the lone, barred window, it's impossible to know what to think. The Mahler episode, unlike the others, is shot conventionally, in a usual talking-heads way, but we see him sometimes through the interviewer's lens and at others, inexplicably, on a TV screen in a nearly empty theater (it turns out that those stragglers are actually members of the production crew—that is, the crew of *this* film, the one we're watching right now). And so again our attention is directed to the fact that what we're watching is something that's been staged, again breaking the barrier between fact and fiction, leaving both genres in a condition of improbability. The narrative destabilizes, the action sits in unrelation to any comfortable sense of illusion, causing a shudder of uncertainty.

At some point Gabi reappears, her feet soaking in a tub as she muses about "the fairy tales my people tell," and then we're back to the old agitprop. At some other point we see grainy old footage of people lynched on city streets, and then the famous last words of Rosa Luxemburg: "I was, I am, I will be." Oftentimes these characters are spotlit in the midst of noirish depths, isolated in space and from one another, and, often, their stark appearances are contravened by folksy musical backdrops or disconnected bits of abstract sound.

The film's main concession to forthrightness comes in the form of analogy, in a scene of fretful West German censors prescreening a new production of *Antigone* for possible broadcast. They're worried that the drama might be misunderstood,

since its storyline of siblings in defiance of the state might be seen as advocating terrorism—"Female terrorists, even in the fifth century!" one of them says. The scene is also as close as the film comes to farce, since the classical tragedy is reduced to boneheaded speculations about the emotional capacity of German viewers to separate fact from fiction. "Irony is one thing we can do without right now," says one of them.

It had been a struggle to arrange for Baader, Ensslin, and Raspe to be buried and moreover to be mourned, at least in public, since the general sentiment was that their corpses should be left to rot as carrion rather than consecrated as human. Finally, and in one of the historical echoes that prowl the film, the stalemate is broken by the mayor of Stuttgart, who also happens to be Rommel's son. This much less photogenic burial is thronged by young people and skirted by a thousand heavily armed police on foot and horseback, in cars, in armored vehicles, in helicopters. It plays out as the last scene of the film, amid defiant skirmishes and angry shouts of Sieg Heil! This is the only time that those assembled there gel into a unified voice and body, and it's chilling.

The national anthem had swelled back up as that last funeral was winding down, when everyone was gone except for the gravediggers and their truckload of dirt. Right before that sequence, Kluge had slipped in a shot—brief and un-remarked—of an embryo in utero, the familiar drawing by Leonardo da Vinci. And just after the disconsolate, thwarted catharsis that that funeral had been, we're offered one final shot as the music switches from *patria* to nostalgia, from pissed-off irony to dulcet yearning. A sylphid young woman and her small daughter walk down the road, hitching a ride. Some have interpreted this as a sign of hope for the future, since they are beautiful and gently purposeful ("This ending suggests that out of pain and suffering hope for a better future can stubbornly emerge").[12] That may be, although there's also

another young child, one who looks back out of a car window as it drives away, and who is actually Ensslin's son, abandoned by her while still an infant. The film ends on those nameless children, the past and the future, and the song that carries them out is an ode sung by Joan Baez. It's beautiful, really beautiful in the way that plaintive songs from her time can be for people of a certain age: "The last and final moment is yours," it rings. "That agony is your triumph."[13]

So, while one child looks forward another looks back, and then, many years later, the one looking back looks back again when he's invited to help curate an exhibition in Berlin reprising and repurposing the history of the History of the RAF. That show, in turn, nearly thirty years after the deaths, the burials, the whole litany of shock and loss, caused an uproar. These ghosts even then were still present and potent. (By then, however, there was also the Prada-Meinhof line of clothing and accessories.)

I Don't Want You to Know Yet

The question of truth haunts the project. There's no possibility of hindsight, no consolation of distance or context with which to settle into understanding and away from visceral reactivity. That question of truth undermines the primal split between fact and fiction, pushing into unavoidable view the mediated core of what had passed for unadorned truth, proffered by the government and the media in cahoots. The film varied from the state's account of things and hammered home to people (a lot of people, since it was broadcast on national TV) that what had been made available until then was manicured beyond all credibility: The sheer film-ness of *Germany in Autumn*, its continual reminders of scripting, acting, shooting, editing, beyond some postmodern trope, was a way of outing the policed myopia that had reigned. In

any case, the version of events that had been circulated was full of holes and evasions and evident bias. Reality itself—if, by that, we mean rootedness in the lifeworld, the familiar world of mutual experience—had been made unreal and invisible, more feared as phantom than felt as actual. It had lost its reliable texture. So that suppurating wound of what had been experienced was made visible in the film through the openly declared artifice and its narrative of gaps. Its spasmodic rhythms and staccato insertions, the menacing momentum and breaks that jerk the film's momentum to a halt, push its timescape into the uncanny, drawing out an even more uncomfortable and compelling dimension of the "real" that lay concealed within it. That narrative of gaps produced a vacuum, raising a desire in us to know and fill it in, but instead of gratifying that the film gives us a lesson in the limits of the knowable—if nothing else, the multiple and disconnected plots battering at the insufficiency of any single narrative line. That narrative of gaps pulls us along, seizing on details as a way of breaking apart that paralytic force field of aloneness that the violence and denial—ringing against its historical precedent—had created.

The film veers incessantly between fiction and nonfiction modes, a strategy that would, according to Kluge, leave neither genre intact.[14] The very jumpiness of its form defies the whole idea of History as something that adds up, as something that proceeds along a course and arrives at an endpoint, that conforms to a shared sense of time. Likewise, the meaning of "history" becomes slippery and dangerous, either unavailable or menacing. Gabi Teichert searches for a past that can't be found, and meanwhile the various other bristling pasts that pop up in the film's frame inject an urgent confusion into the sense of what the present even consists of or of how Now differs from Then. *Germany in Autumn* embodies the trauma that it tells: the discontinuous temporality, the fragmenta-

tion, the agnosia, the incapacity to integrate meanings, the dissociations, the amnesias, the brittleness, the ghosting of the subject—all textbook.

The film is a mongrel, a jackdaw nest built out of jagged and dark and absurd fragments that caught hold in the fractured attention of that moment. It's made up of a scattershot array of media, cinematic techniques, and sources, collecting together news and documentary footage, home movies, World War II newsreels, stills of paintings and poems, real and staged interviews, archival film, scripted and dramatized scenes, voiceover commentaries, and fragments of pop songs, classical music, and the German national anthem, all in merciless combination. The constant juxtapositions rattle against rather than resonate with one another. The bits don't fuse, and the whole thing feels like it's on the verge of capsizing. Not a rebuttal or palliative but a pointedly alienating take, speaking a different language than the simplistic, moralistic, and hectoring version of events that had been peddled, countering the restrictions on speech, countering the relentless castigation of "sympathizers." It had been forbidden to question, and that massive silence had been secured by fear. The antinarrative strategy was a way to keep the film open as a statement, giving viewers license to, at last, think for themselves, to absorb and reassign all those elements and events and put them together in a way that answered their own questions.

The intentional disjointedness was making a point in the face of the narrative that had been running for years about the RAF and the West German government, about right and wrong and Them and Us. In the spirit of the RAF, perhaps, the filmmakers argued against the premature closure of yet another catastrophic episode in the nation's life, a closure whose job it was to induce amnesia. They declared:

It is something seemingly simple which roused us: the lack of memory. First the news blockade, then the imageless verbal usages of the news media. After the fall of '77—Kappler, Schleyer, Mogadishu, the Stammheim deaths—followed, like every year, Christmas '77 and New Years. As if nothing had happened. In this travelling express train of history we are pulling the emergency brake. For two hours of film we are trying to hold onto memory in the form of a subjective momentary impression. As best we can. . . . A *fool, who gives more than he has.*[15] *Autumn 1977 is the history of confusion. Exactly this must be held onto. Whoever knows the truth lies. Whoever does not know it seeks.*[16]

But in fact, some of the harshest criticism came from the radical Left, for the film's refusal to take a stand, meanwhile seeming "too aesthetic," possibly escapist, too subjective and hermetic.[17] But this missed the fact that the film's feel was actually very real. We could say that the film doesn't so much romanticize or privilege fragmentation for its own sake but instead deploys it as a way of embodying, getting at the reality of how that time had actually felt. It granted legitimacy to all those messy and terrifying feelings that were the byproduct of living in a society intent on eating itself alive, to make some room, maybe, for people to deal with how out of control they felt, without pathologizing that into some accusation of personal failure. The film didn't portray or reproduce much at all. In place of that its allusions and elisions and loops and dotted lines work in a mnemonic way, like clues that point back to how things had been introjected, the damage turned inward. It dismantled the usual building blocks of thinking through, eliminating continuity and causality—the things that comfort us into a sense of coherence—and made viewers keep scanning it for links and signs that might accumulate

into something more. *Germany in Autumn* took those events, which were all too familiar, and dared viewers to reassemble them into something fundamentally different from what they had been told to see. It was, among other things, lobbying for a nonmutual, nonconsensual, nonaligned interpretive realm. It was a way of fighting back. The RAF had been, at core, angry about the lingering totalitarianism of the West German state, and it was exactly that tendency that had bloomed into new virulence as the state responded to their provocations: The filmmakers step away in the name of a more autonomous and individualized fight. *Germany in Autumn* was a much more disorienting labyrinth to live in.

There Are Known Knowns, Known Unknowns, and Unknown Unknowns

The basics of the story are this. The RAF (Rote Armee Fraktion, also known as the Baader-Meinhof Group or Gang) arose somewhere in the midst of the waning of the 1968 student movement and concurrently with radical cadres elsewhere. Frustrated by the ineffectiveness of "words" as a means of changing the world, the RAF was founded in "a logic of vindication," as Jeremy Varon puts it, "in which armed rebellion now would compensate for the virtual absence of violent resistance in Germany to the Nazi regime. In this capacity, lethal violence promised to liberate RAF members from the psychological and political burdens of the past and break the chain of German guilt."[18] The "act of being criminals was the founding gesture of its group identity":[19] The RAF didn't withdraw into a private utopia; they grabbed center stage in the public imaginary and consciousness.

Their questions were exacting but their answers were not, amounting only to a generalized anti-imperialist politics and an antiauthoritarian denunciation of West Germany. The

overall idea was that they would provoke the West German state to the point that it would shed its constitutional-democratic camouflage and show itself for the fascist entity that it really was. That, in turn, would "detonate also in the consciousness of the masses."[20] As many have pointed out, both at the time and ever since, the absence of a revolutionary proletariat or any other mass to mobilize in the stolidly bourgeois, materialist, and politically allergic postwar West German population made this a dubious strategy, and in fact the RAF had little contact even with other elements of the APO (Extra-Parliamentary Opposition). What mutes the triumphalism of this argument, though, is the fact that the country had undergone only a sketchy process of de-Nazification after 1945. The RAF's targets—the corporate sphere, the judiciary, the government—were in fact well-known havens for former high-ranking Nazis, who had never been held accountable for their pasts.[21] The RAF were vehement, most of all, in their self-affirmations: Armored against doubt, as Peter Wollen saw it, "driven by fear of what might happen if their certainties were abandoned, desperately struggling to maintain their sense of self, afraid of each other's contempt, they staggered from idealism to self-destruction."[22] The RAF and the West German state traded accusations of fascism across a vehement divide, an abyssal and impossible gap.

Their early actions met with some sympathy and support, especially among youth and intellectuals, among other things, bringing "a sense of adventure into the boring everyday life of the Federal German Republic,"[23] but their escalation from pranks to arson to bank robbery to bombing, kidnapping, and murder soon resulted in the small band that the RAF was—all children of solidly bourgeois homes, the core of the society—becoming widely seen as an existential threat. In response to their goading, the West German state geared up an apparatus that effectively demolished the idea of civil liberties

and rule of law under the alibi of the crisis, and meanwhile the whole premise of leftist politics was anathematized by virtue of association. Things moved very fast. The RAF's May 1972 offensive spurred a huge manhunt, with 130,000 police searching for them: That entailed various forms of surveillance, police sweeps, checkpoints, road blocks, raids, and more. Any advocacy of the RAF was criminalized, and texts even debating armed struggle were prohibited to circulate.[24] All this brought the experience directly into the lives of the vast majority of the population. A choking atmosphere of fear, paranoia, and suspicion settled into not only public but private space too.

By mid-June of that year, all the principal figures were in jail, and, from then on, the RAF became its own subject. With the "first generation" in custody, the fledgling offspring cells mobilized, but not against US imperialism, or the Viet Nam war, or the Palestinian cause, or the shallow legitimacy of the West German government; not for socialism, a nonconsumerist society, nuclear disarmament, or an end to psychiatry (the putative rallying cries of the first round); but rather around the sole imperative of freeing those in prison. "The group was born again," says Stefan Aust, a journalist who has dedicated the bulk of his adult life to studying the RAF,

> and acting as midwives were the Federal Prosecutor's Office, the law courts, the politicians and the public of the Federal Republic. . . . The perpetrators of terrorist acts now took on the role of victims. In a post-war German society stricken with guilt, that lent them a position which they and their helpers outside prison exploited to the full. At last they could play the part of martyrs. They put on a virtuoso performance allowing them to feature as victims persecuted and tortured by

an unconstitutional state. And the machinery of state readily, and stupidly, went along with them.[25]

Baader, Ensslin, and Raspe's trial was hailed as "the most important trial in the history of the Federal Republic of Germany" in foreign newspapers, "the trial of West German democracy . . . of West German justice."[26] Given all that, it's hard to account for the many problems with those proceedings—mislaid evidence, important lapses in the investigation, anomalies in the official explanation that raised numerous unanswered questions about official involvement or cover-up— and on top of all that the judge leaked information to the papers and was eventually forced to step down.[27] Meanwhile, the harsh conditions of their confinement became a cause célèbre. Prison had radically reduced the scope of their struggle, but it also opened the way, paradoxically, for a much broader kind of impact,

> prompting skepticism about the claims of authority, exposing cracks within the conventional and official wisdom structuring the consciousness of Germans, and further destabilizing the realms of "fact," "reality" and "truth" as the basis for that consciousness. The . . . efforts to isolate the RAF helped grant the group a new ubiquity and fuel corrosive speculation on the intent and application of the state's power.[28]

The "German Autumn" ensued in 1977, six weeks or so of havoc set off by the kidnapping of the business magnate Hanns-Martin Schleyer. A news blockade was imposed after he was taken, and the scant information that was allowed to circulate served mostly as a rhetorical vehicle for asserting an imagined national community of total solidarity against the internal threat.[29] The spectacle came to a close in October with the hijacking of a Lufthansa plane by commandos of the

Popular Front for the Liberation of Palestine, whose demands included the release of the RAF prisoners. The plane wound up in Mogadishu, where it was stormed by West German special forces. The passengers were freed, the commandos were killed, and, the next morning, Baader, Ensslin, and Raspe's corpses were found in their cells, apparent suicides. Schleyer's body was found the next day. The question of suicide or murder has never been settled. Aust, after an exhaustive recounting of the events, comes down on the side of the former—the official version—even after poking insurmountable holes in his own argument: "An invitation to speculation"[30] is as far as he's willing to go. The vociferous and extensive debate about it meant that, even in death, the RAF continued to haunt the nation and to dominate public dialogue.[31] It granted them the final prize, vaulting from iconicity to immortality.[32] They died young and (in)famous, under circumstances clouded with suspicion, "with their deaths captured in chilling photographs ripe for iconic reprocessing and complex myth-making."[33] Seen in these terms, the RAF precipitated the first modern version of the war on terror and of the performance of that in the form of a media circus.

Attacks continued, but it was nothing like it had been, and it all finally petered out for good with an eight-page letter they sent on April 20, 1998, to the Cologne office of Reuters announcing the end of the RAF, concluding as follows: "The urban guerrilla in the form of the RAF is now history, the end of this project shows that we cannot get anywhere along these lines."[34] No regret. A total of forty-seven people had died during those seven years that "changed the country."[35] The events of 1977 became a kind of foundation myth for the West German state, with its victory against the RAF a principal guarantor of its legitimacy: This is now a widely held view.[36] It is not, however, unanimous, and in another version of this

eternally unsettled history, the RAF dethroned democracy, certainty in the good of the state, and more.

But why? There have been some ready answers, mostly along these lines: Postwar West Germany traded reckoning with what it had done during the war for prosperity, its meteoric economic growth intertwined and interdependent with its disavowal of its fascist past.[37] To wit: The Stammheim trials began in 1975, the same year as the tribunal in Düsseldorf for war crimes at Majdanek. The defendants in the latter were charged with up to seven thousand deaths each. Those proceedings happened under the (Nazi) laws that had existed at the time of the crimes, which drastically mitigated the severity of judgment; most of the accused were acquitted. Nonetheless, it was the Stammheim trials that received wall-to-wall media coverage. The proceedings in Düsseldorf went largely unremarked, even though they ran until 1981.[38] The net effect was to cast Germans as victims of left-wing violence, not as perpetrators or accomplices to massive violence themselves. This coincided with how the national psyche was being rejiggered in relation to its recent past: According to Varon, "Germans tended to view themselves as among the war's victims, either of the avenging armies of the Allied powers (especially the USSR), or of Nazi demagogues, or both. . . . The past, in short, necessarily remained 'unmastered' because it had never been seriously engaged as a problem."[39]

Historical amnesia in the wake of trauma can be formidable, but the shape it takes is always contingent on the wounds it rejects. In the case of postwar West Germany, as Elsaesser sees it,

> since German fathers had failed to indict themselves for their monstrous pasts, they were on trial by proxy by the radical sons and daughters in 1968 and thereafter. And since the fathers themselves had taken pains to be sure they would only be seen as fathers, and not as

political beings, their offspring chose to do precisely
the opposite in the aftermath of their abrupt political
awakening. . . . They identified with the latent emo-
tions, the ones that the forced optimism and strident
efficiency tried to hide. Seeing the fathers' cover up,
seeing through it, but being sons by flesh and blood,
they also had to deal with their own internalization of
the father, whose hidden guilt and shame . . . returns in
the son as self-destructive melancholy. To quote one of
these sons: "The wound had folded inwards."[40]

Twenty years later, a commemorative blitz again filled the
national media with the RAF, in a deluge that "took many
aback for its scale and the interest of the general public; it
seemed as if the retrospective took the place of the debate
which had not occurred at the time."[41]

That's one version of things, but another holds that, in
fact, those commemorations had the effect opposite to what
we usually ascribe to remembering: "The televisual *mise en
scene* of national recollection," says Elsaesser, "appeared to
achieve what the police and the security services had failed
to accomplish: the burial of the RAF along with its mythol-
ogy, by once more staging it."[42] The very omnipresence of
the RAF, reincarnate, ensured the invisibility of the real ca-
tastrophe's presence. And so that return buried the radical
past, especially when you take into account the fact that, in
those new narratives, some of the political leaders recalling
that time for the cameras even referred to their own expe-
rience in the Wehrmacht, with its "soldierly virtues," as the
fountainhead of their strength in the battle against the RAF.[43]
Gerhard Richter makes an arresting observation, which might
account for this seemingly unaccountable amnesia: It was
not so much the terrorist *out there*, in the streets, that was
terrifying to the West German people but rather the inkling

of the terrorist *within* that carried such fearsome omens—the sense that such capacity was shared among all.

Knowing Is Not Helping

Fassbinder made another film two years after the deaths, restaging the autumn events as charade. The self-styled terrorists are carnivalesque incompetents who kidnap a Schleyer-like figure, but then it turns out that the whole thing was a set-up orchestrated by a double agent hired by an international dealer in surveillance equipment in order to amp up the level of fear and thereby the demand for more investment in security technologies. ("I recently had a dream," says boss Lurz's associate, "that capitalism invented terrorism to force the state to protect it better. Very funny, isn't it?")

The terrorists have a mandate but it's a scam, and meanwhile the dynamics of violence and reaction escalate into a lurid, ludicrous rampage. They're the spawn of the German intellectual bourgeoisie, frustrated housewives, addicts, and unemployed laborers who seek liberation through proletarian sex—not exactly a sympathetic bunch of characters—and the rest of the cast includes Fassbinder's mother as a regal, bizarre madwoman who wanders around the manse singing lullabies. Along the way there's a tremendous amount of cross-talk, arguing, miscellaneous trashy graffiti from men's bathrooms around Berlin, loopy music, and TVs on in the background. Fassbinder takes language past meaning, past the point of caring: People are constantly talking over one another, sometimes numb and at other times hysterical, and the action keeps ramping up to a kind of bedlam, but none of it goes anywhere.

Clear identities, battle lines and political antagonisms are all gone. Fassbinder's "third generation"—the ones who came in the wake of two kinds of failure—are more hapless

puppets than they are protagonists of anything, and they pass much of their time worrying about how they ought to be passing their time. "The psycho-dynamics of the characters," as Elsaesser dryly notes, "tends to usurp issues of political economy."[44] The film is a shaggy-dog story, winding down on the repeated efforts by the loser terrorists to extract an adequately telegenic ransom video from their charge (they play a tape of random animal noises in the background)—no luck. Lurz smiles, and it ends.

The moral righteousness that Fassbinder had borne in *Germany in Autumn* and for which he had been so profusely lauded ("excruciating honesty") gives way as he stages the fallout in a landscape that's relentlessly, uncompromisingly artificial ("using artifice to strip artifice of artifice," as Maggie Nelson once said);[45] it's almost counterintuitive to note, then, that he's also a lot more generous with regard to the question of why people fail so miserably in their dreams and commitments. The film's camp bends toward despair: It exudes a heartfelt sense of incongruity in simply being, suffused with a tenderness that reads as suspended hurt. Absurdity and excess are not uncommon in Fassbinder's films, but their dominance in this case seems especially apt, a tight fit with the subject at hand—impossible to "objectively" or "factually" portray, since there's no core of plain, evident fact but rather a swirl of unrequited positions, beliefs, and dreams. It takes a different kind of telling even to get close to that kind of reality, and what we get is a creepy, lunatic uneasiness twisting around and around the anguish, paranoia, and tension. There's not so much evil in the film as a powerful, awesome negativity in the face of rancid complacency, a different understanding of where all those darknesses resided and emerged from that didn't opt out into the easy ascription to daddy the Nazi. The opening screen had read: "A comedy

in six parts full of excitement, suspense, logic, cruelty and madness. . . . Like the fairy tales we tell children to help them through life into death."

That same year, 1979, German chancellor Helmut Schmidt was quoted as follows in *Der Spiegel*: "I can only thank the German lawyers retrospectively for not adhering to constitutional law in pursuing their investigations" (referring to the Mogadishu hijacking and possibly to events surrounding it).[46] That same year, 1979, the German cinema went quiet on the subject, apparently at a loss for what else to say.[47]

I Don't Know How to Know

A decade later, Gerhard Richter kicked the storm back up with his suite of paintings named after the date on which things had come to a head, *October 18, 1977*. There are fifteen canvases, and all their images would have been instantly recognizable to any West German at the time. Although some of them are clearly sequenced, something like film stills, he was insistent that there was no prescribed order in which they should be hung: The works are "a cycle without beginning or end."[48] Although the painter has insisted that his work be seen as nonideological and apolitical, he also said he hoped that seeing these pictures would not be "the same as seeing an accident on the motorway and driving slowly simply because one is fascinated by it. I hope," he said, "that there's a difference and that people get a sense that there is a purpose in looking at those deaths, because there is something about them that should be understood."[49] Although the painter has insisted that there is a purpose in looking at those deaths, that there is something that should be understood, none of the images show any of the actions—the crimes, the shootouts, the trial—none of that, none of the context,

and none of them show the RAF figures with one another or with anyone else, and they're already dead in most of the images. Although the painter has said that "these pictures possibly give rise to questions of political content or historical truth," he followed that statement with this: "Neither interests me in this instance."[50] Although the painted images are all taken from photographs, the painter blurs them, sometimes to the point of illegibility. The paintings are all gray, and of that color Richter has said that it "has the capacity that no other color has, to make 'nothing' visible. To me, gray is the welcome and only possible equivalent for indifference, non-commitment, absence of opinion, absence of shape."[51]

We see them before and after their deaths but not the deaths themselves, except in the case of Meinhof's shape, very indistinct, hanging (we only know that because we know how she died) from a rope that can't be discerned. The triad of Ensslin images has her at first looking our way but not directly, as she does in the second image. The source photos were shot in court following her arrest, so it's strange that, in that middle image, she seems to smile—an open, not ironic or taunting face. The last of these images has her looking down, such that we can't even guess at her emotions, yet the grouping is titled *Confrontation*. With regard to Meinhof, we see her young, pensive, and innocent, and then we see her dead, lying face-up on the cell floor three times, with the rope mark across her neck centered in the frame. These images darken progressively, and by the third and final one the floor itself has blacked out enough that some have read the image as her floating, levitating. We see Baader's bookshelf and his record player (allegedly where he hid the gun) and then him splayed on the floor, Christ-like, twice. Seven of the fifteen show corpses, and those images are painted from the official police photos that had been circulated as

clinical proof of their suicides. Consequently, some have read the blurring as an indictment of those photos' veracity. (Richter had used the same smudging technique before, to paint images of clouds and waves—things that in themselves have no clear or stable outlines.) We see their funeral, but the only reason we know that's what we're looking at is because the title says so. In comparison to this one, the other images seem reasonably focused and legible, and so if we take the funeral as the logical conclusion to the narrative, we end in radical doubt.

Richter does a lot to play things down. First, of course, there's the fact of the gray, that antidefinitional proxy, but he doesn't leave it at that. The subjects of the paintings are hypertheatrical, but the titles are deadpan in the extreme. The seriality of the images, the repetition, suggests a certain sameness or similarity among them, working against any dramatic narrative grain pointing life toward death. He doesn't seem to believe that either technology (photos) or painting can position us to truly witness or understand things, so he reminds us in each frame that we can't even really see. Gertrud Koch reads the question in these terms: "If reality cannot be understood, then the most adequate picture of it would be that with the fewest semantic promises. . . . At the end, all that remains of its contents is what Kracauer calls the 'spatial configuration of the moment,' i.e., the awareness that something has once existed."[52]

Eric Kligerman appeals to the Freudian concept of *Decker-innerung*—screen memory—to understand what's going on, "an act of memory that strikes us as strange"[53] in part because there is a feeling of surprise at its heart. The overexposure of the original photos, he contends, had turned them into clichés shorn of their initial power to represent actual events. Queering them, then, was Richter's way of reinvesting them

with a new symbolic power displaced from their original
context. The paintings dwell in twilight, a noctilucent time
of unease, a light that softens nothing: "Post-memory," says
Kligerman, "is based not on the invisible but on the *barely
visible* that provokes an uncanny shudder of what is vaguely
familiar."[54]

In 1975, Richter had written that he first produced gray
paintings as an expression of his own miserable state of uncer-
tainty but then came to see it, "just like shapelessness etc.,"
as something that can "only notionally be real."[55] "Gray is
simultaneously real and unreal," says Peter Wollen, "com-
mitted and uncommitted. In the gray photo-based work the
real is given a 'transcendental side,' each object has its own
particular mysteriousness, becoming a metaphor as it melts
away into an 'incomprehensible reality.'"[56] That incompre-
hensibility lies at the heart of Richter's mourning images—
lyrical, elusive, and unconsoled, wearing their belatedness
as a kind of unreconciled yearning. The paintings are like
an indirect archive, giving less to sight: a decelerated and
delayed evocation. It's as if the painter is saying, "Come with
me"—but then he leaves us stranded in the unknown and
unknowable place his pictures insist on. On account of that
determined elusiveness, they gave rise to a chorus of very
determined anger. Speaking of "some Holocaust studies,"
Geoffrey Hartman has noted that their trafficking in "feel-
ings of mystery and enigma" pushes them over the line from
protectiveness to protectionism—a line that Richter would
seem to deny.[57]

The paintings had first appeared in a small provincial
museum, "without warning and without fanfare,"[58] but none-
theless provoked a scandal. They reawakened the old debate
about the RAF—a subject that, as many claim, had become
taboo—acting like a lightning rod for the fears and fantasies

that came back to life in a flash. A memory unhindered by shock was still, apparently, impossible. The images isolate their subjects—from one another, from their victims, from their context, from their consequences—and the figures are shrouded in an ambiguous, atmospheric blur that can as easily be read as empathetic as distancing. Ambiguity was enough of a problem, but in this case people felt that Richter had gone further: into martyrological, iconic, hagiographic territory. This became even more of a problem once the works were sold to MoMA in New York, since the viewing public there would not come to the images with the knowledge of history that, it was claimed, was necessary in order not to misunderstand.[59] (Peter Schjeldahl, writing in *Art in America*, referred to "Richter's distinctive tone—a depressive density resulting from a head-on collision of irresistible aestheticism and immovable moralism, the fire of the voyeur and the ice of the puritan.")[60] "All enmity should cease after death,"[61] Mayor Rommel had said back in 1977 when he granted permission for the burials, but that had turned out to be impossible.

For his part, Richter explained himself telegraphically. He had lived for thirteen years under Nazi rule and for sixteen in East Germany and so was very familiar with overheated ideological environments and with the seductive lure that comes from their denial of uncertainty or ambiguity; in his notes for the exhibition's press conference he had written:

December 7, 1988. What have I painted? Three times Baader shot. Three times Ensslin hanged. Three times the head of the dead Meinhof after they cut her down. Once the dead Meins. Three times Ensslin, neutral (almost like pop stars). Then a big, unspecific burial—a cell dominated by a bookcase—a silent, gray record player—a youthful portrait of Meinhof, sentimental

in a bourgeois way—twice the arrest of Meins, forced to surrender to the clenched power of the State. All the pictures are dull, gray, mostly very blurred, diffuse. Their presence is the horror of the hard-to-bear refusal to answer, to explain, to give an opinion. I am not so sure whether the pictures ask anything: they provoke contradictions through their hopelessness and desolation; their lack of partisanship. Ever since I have been able to think, I have known that every rule and opinion—insofar as either is ideologically motivated—is false, a hindrance, a menace, or a crime.[62]

Normally, it wouldn't matter that much what an artist intended as their work's meaning, but in this case it was a central preoccupation. In most West German responses to the paintings their refusal to declare themselves was felt to be inexcusable, while in the United States, the commentary absorbed their ambiguity into an aesthetic framework. This was similar to what had happened with *Germany in Autumn*.

This is a story about moving to and from radicalism and fervency, in which the inverse journey is no less driven, and no less prefigured, by the energies and commitments of those originary events. This is a history in which the figure of return is a primary architecture, and at various points that doubling has signaled everything from reassertion to refutation. The manic feel of the films and the spectral feeling of the paintings suggest that going back to this particular past is engaging with a force that actively haunts the present. The RAF had performed their own act of return, linking postwar Germany to the Nazi era: That was a belated encounter, coming so many years after the end of the war, and then in their wake there was this multiply involuted, recurring process of return. Although it is difficult to name the propelling feeling

of either the film or the paintings, we can at least recognize something akin to anguish, which is most of all a state of affective paralysis. Anguish obstructs our ability to learn from history, and it's the need to do exactly that which has fueled all these works that have gone back to the black box of the RAF's meaning. It seems that, perhaps, it's been preferable to lock down into anguish than to risk an open battle with this past. It's sometimes the case that stories can, at least for a while, order our still incoherent, unrequited needs, but it's also possible that these returns were premature, more a matter of requiems than anything else.

Knowing in Time

What had made those events in West Germany traumatic was the incessant nature of the fear, the prolongation of the state of uncertainty, but, in what Jeffrey Alexander refers to as an Enlightenment theory of trauma, all of that would have functioned basically as a learning experience, shocking the country out of old patterns and thereby opening the way to the possibility of something new. Refuting that, though, is the inherent belatedness of the traumatic experience, which "is not locatable in the simple violent or original event in an individual's past, but rather in the way its very unassimilated nature—the way it was precisely *not known* in the first instance—returns to haunt the survivor later on."[63] In fact, Freud's own theory of psychic trauma held that it never comes simply from the outside, and this is what accounts for its belatedness: It's belated because the trauma is seated first in an implantation of something from the outside and, then, in the effort to keep it repressed. It's that internal reviviscence of the impossible memory which makes trauma linger implacably, which keeps it from resolving. "At the end," says Cathy

Caruth, "the original trauma barely matters . . . the trauma consists, essentially, in its repetition."[64]

Trauma is often described in contradictory neologisms: knowing unknowing or unknowing knowing, unexperienced experience, which express something of trauma's tangle of brokenness. We can put a name to what happened and thereby say that we know, but that would be only a pale and thin knowing. It would create a direct correspondence between the event and the reaction; it would set the parameters within which the trauma might be interpreted; it would name something narrower and deceptively clear—a naturalistic or commemorable terror—it would break faith with the truth of what happened, when what we need is a language for something vastly more potent. More potent, for trauma's excess that remains dark and frightful; for its filmy near-imperceptibility. For its quality of filling mental, unconscious, and emotional space without ever announcing itself and, after we live with it for a while, without our being able even to notice it. We live with trauma as a quiet parasite, a slow rot that is constantly eroding the certainty about life that used to be within us. This is how I imagine it must have been to live inside the Reich, and it's the state that was, I suspect, reawakened with a vengeance in the generation that was later on confronted with and by the RAF and its accusations—accusations that were undeniable but impossible to accept.

Some theorists assert that, in the case of societal traumas, any recovery depends on the construction of a "we."[65] For Kai Erikson, though, a collective trauma's

> blow to the basic tissues of social life . . . damages the bonds attaching people together and impairs the prevailing sense of community. The collective trauma works its way slowly and even insidiously into the

awareness of those who suffer from it, so it does not have the quality of suddenness normally associated with "trauma." But it is a form of shock all the same, a gradual realization that the community no longer exists as an effective source of support and that an important part of the self has disappeared.[66]

"We," he says, no longer exists. And so it's worth remembering here that what West Germany experienced was a compound trauma, one accumulating atop another. Shame sheds light here: the shame of the generation that kept silent, that nation of nonwitnessing bystanders who were additionally shamed by the open secret they agreed to keep; the shame of the choice to just move on; the shame of association, of no longer believing in yourself. A traumatic history is a history that disappears. A traumatic history will be disappeared, and the disappearance of a history is itself a traumatic event. And so that past that isn't there, the erased one, will also be the future, an afterimage of something that wasn't present: an "inchoate but harrowing sense that one has lost, left or killed something critical."[67]

Alexander's "we" is born through narrative, a process of "symbolic construction and framing, of creating stories and characters," but, he goes on, "rather than descriptions of what is, [in collective traumas] the contrast between factual and fictional statements is not an Archimedean point."[68] This gets complicated, though, because trauma resists narrative. It resists narrative because the endpoint of any narrative defines its telos, but trauma's end is never a point: It has a beginning but no middle or end. And so Fassbinder's recalcitrant, truculent agony delivers abjection and helplessness, and Richter gives us gray: both states of limbo in time profoundly true to their subject. In these works we see the darkness, but we're denied

the sense of having separated from it. We have survived, they say, but barely intact.

It's incredibly hard to name what it is that we fear so much and to say it in a way that feels close to the sensation of the fear. We can say—Disintegration. Knowledge of, confrontation with death. The Unthinkable, the Unimaginable. But those names feel very far from what they're meant to arouse.

Knowing Alone

They're all so alone. The RAF in their multiple isolations—from any kind of shared project, from the nation they sought to address, from one another in their cells: They had requested to be buried together in a single grave, and at least they got that one final consolation. Fassbinder in his apartment like a tomb, in his constant vacillations into and out of confrontations with everyone he needs: His accusations and condemnations are pure pain. The makers of *Germany in Autumn*, each parceled off from the others in the harsh logic of the film's edits. Richter in his studio, faced with thousands of photos and staring down his own monumental doubts about authoring images. Each of his figures, wholly alone. That's what we know, finally, from these works. All that aloneness elongates the moment of viewing, of reflection, and inundates it with a surplus consciousness of self and consciousness of consciousness. Another maze, an abyss where we're isolated too. We recognize their aloneness in our own.

With the major exception of the flailing Fassbinder, the people we encounter come forward with a flat, numb affect, even in the funerals, even in the funeral for the young martyrs. Those reeling and overwhelming times brought back in such attentive flatness, like a hard-shelled residue. There's never any context, there's never any explanation, and the facts

of the matter, such as they are, emerge only through the confusing, episodic, and illogical breaks and loops and ellipses of the film's arc, the chopped-off moments in the paintings.

Patrolling the spaces between people, stirring together intimacy and alienation, exposure and distance into a bitter stew. But despite that, despite the evident despair in these works, making those enormous efforts to say something that will mean something, to be present and bear witness to those awful scenarios. These are hungry works, engulfing and estranging, and they hurt from that. But they cotton onto their barren, impervious subject and begin to open something that we need to know. More than that, or more importantly, I think, is that they're complex acts of saving loss itself. Even the coolly imperious Richter with his gray gives a way deep into an otherwise unreachable experience of that reality. It's a brittle peace, telling of and about loss and breeding disquiet. Terror had bred loneliness, and as a heartfelt response these works offer consolation in the form of sharing in that. It's a consolation that's frightening, but it's real. If loneliness is a longing for integration, for feeling whole, that remedy is not on offer here. People like to say that that's what art can do, that it can fix that isolation and heal those wounds, but these works say No, and instead they see all the way to the place that Virginia Woolf once called "the bottom of the vessel."[69] Defiantly scarred, in Fassbinder, resolutely unsure, in Richter, that's how they grieve. Everybody's hurt.

They're all telling against the background of dire, total language: the language of the catastrophe, the threat, the defeat, languages of the power to destroy. And so the idioms they devise are in response and in refusal. Antiparadigmatic, language as a space of impassioned suspension, sidestepping language, diagonal feint into poetic estrangement.

And so: alone, lost, and speaking in a way that seems to point to, or at least respect, the need for silence, the mute eloquence of the survivor's gesture. Among its roots, the word "silence" counts *anasilan*, a Gothic verb denoting the wind dying down: Silence, in this sense, is a space in which we can, finally, hear. Silence is what comes from these works, and, while we can't get the answer, the gestures keep pointing to what is lost. Muteness, Caruth had affirmed, "indicates that there's something which is too difficult to utter,"[70] but elsewhere she reads it otherwise: Muteness, "peculiarly, does not seem to be completely opposed to poetic writing."[71] Muteness, maybe, as "the shadow cast by ecstasy."[72] We arrange our tellings between these extremes.

I'm writing this as Trump happens. Over the past few weeks I've begun to understand something about such radiating, insinuating, searing, dread-suffused anxieties, because that's how this feels. I begin to understand why it matters to remember what the RAF brought into being. It always has to do with what we bring to the past, but that's especially the case now in our dawning age of alternative facts and grotesque lies as the new normal—feeling us going off the rails with no idea of what's to come, dreading the helplessness and collapse that has resulted from such radical uncertainty in other times. Learning terror and rage anew. Thinking about what might be possible to say and do through how we tell the story of the past. This past is so hard to tell because there's no beauty, no requited sadness, no redemption of any kind or degree. That bleakness is daunting, and that makes it hard to find a point of traction from which to venture into thinking and to find shape for the feelings about the afterlife of ghosts that not only threaten us in the moment and in the singular but that open vast possibilities for unknown, unimagined—at least, so far—forms of destruction. In a classic knight's move, the RAF

thrust the past back into the present and filled the present with the stench of the past, but they also opened things out into unknown territory moving forward. We don't like the unknown, but here it is.

Conclusion: The Undersong
of Our Histories

After so many stories of men who had lost their memory,
here is the story of one who had lost forgetting, and
who—through some peculiarity of his nature—instead
of drawing pride from the fact and scorning mankind
of the past and its shadows, turned to it first with curi-
osity and then with compassion. In the world he comes
from, to call forth a vision, to be moved by a portrait,
to tremble at the sound of music can only be signs of a
long and painful prehistory. He wants to understand.

—CHRIS MARKER, *SANS SOLEIL*

Bruguera's dare to return, upending the iconic with the de-
mand that the present be brought to account for the promises
that had been made; to restore the independence at the heart
of revolution.[1]

Guzmán, defying forgetting and the narcotic heaviness it
had blanketed over daily life: "entreating the sky, appealing
to the universe."[2]

Farocki, Ujica: patient, forensic probers of the limits to the document's capacity to know, insisting that even a tangled, mangled, and soon strangled rising up amounts to legacy; Porumboiu (born into the grief of the others), the gentle reproach of child to elder: yes, but not how you think . . .

Germany in Autumn's shot across the bow, its urgency to keep the door from closing on what that time might have meant for a country so afraid of itself, of what it had been capable of; a country that had treated its own past as a drastically unsafe truth. The tragedy of radicalism, the tragedy of unchecked intensity, as it turned out. And then Richter warns: Something rings false. Desheltering the veiled, the concealed, the undisclosed, with his parsimonious gray light.

Stories in fragments, thickened with doubt and mistrust, propelled by those hyperbolic conflicts and their inevitable reencounter or, maybe, by the growing fearfulness that comes from moving closer to the truth. Trying so hard to name what hurts: These searching efforts to really understand begin in disappointment, as they must. Experience of the radical past begins with disappointment; it opens longing, remembrance, regret, and lots more besides. All of them, telling in the thrall of the impossible. All of them, looking to the act of telling as a means of contact, consecrating through return. Stories: knowing adjacently, the attraction of the detour, the lacunary eloquence of the telling's silence on entering the space of distress. Stories, the lexical mirage, the necessary estrangement, the precession of the unrequited past. Stories, "means of approaching what cannot be near in any other way; they are the delay and the instrument of fulfillment."[3] Stories welling up, leaving aside the familiar words and turning to those so fragile that they might crumble in the course of being spoken. Stories telling about what the incapacity to grasp the real *feels* like, about that which withdraws, rejects disclosure. Stories for "when the lives lived out of given stories run aground or

run only in a loop,"[4] stories to unmake the made-up mind.
Stories, anticipatory illumination, "like the nocturnal vigil of
that 'inspiring' insomnia when, all having been said, 'Saying'
is heard."[5] If nothing else, we need a meridian, even the
threadiest, to keep us in meaningful tension here, in our
complicated act of faith.

This feels urgent, now. In pre-2016 times, the debased
status of truth, such as prevailed in Romania, was a local
problem: It now belongs to much of the world's people. To-
talitarian control of the media is no longer a requisite tool
for concocting the dystopian reality of public space as "the
site of the lie that denies what everybody knows"; the sense of
"living in a society intent on eating itself alive" is no longer
a matter of purely historical interest. "That fear of society
breaking apart in a torrent of violence and hatred and lies"
is now our daily bread. That mendacious autoconversion
from the persona of perpetrator to that of victim, so essential
to postwar West German peace of mind, is reenacted for us
on a daily basis by men wielding cataclysmic power. I began
work on this book long before Trump was even on the horizon
and am finishing it in the midst of the sheer brutality that
the political arena and public sphere has become: the lies,
foulness, incivility, amorality, cynicism, greed, violence, ha-
tred, cruelty, all achieving a volume and ubiquity previously
unimaginable.

And so I hold this question: How do we live without the
prospect of that world we held dear, where we felt a sense of
historical purpose—the fiery place where we felt at home?
How do we live in the aftermath of that commitment, shorn
of its force? Radical pasts wound the present, at least for
some of us. The wreckage of revolutionary energies, revolu-
tionary hopes, is an especially cruel disappointment, even if
those hopes and energies were themselves unliberatory, as
it turned out. Either way, the societal convulsions they give

rise to and the awful consequences that they trail coagulate around lingering, traumatic shadows that darken the present sense of the possible. We look to those energetic and hopeful pasts in the name of sketching something better than what *is*, and at the outset that act of return was what set this book into motion: questions, then, about why we go back to those pasts and what we want from them. All these tellings pointed against the neutering, official accounts, insisting—each, in its way—that those pasts matter. All insisting, each in its way, that those pasts could speak to what we have needed later on and that, in their failures, we can find something we need—if we really look. Along the way, though, I've come to think that it's more a matter of living in that space of loss: the task of trying to—without illusion—avoid disillusionment.

Wanting to Know

Timothy Garton Ash says that "the relationship of societies to a difficult past is one of the most important problems of this era."[6] We're fixated on remembering the damages wrought by the past, and we do it largely by way of History—narrating the events. That process has come to be seen in much the same way that forgetting was previously, as the righteous way to proceed.[7] But how to square this with the fact that, in the wake of their own atrocious pasts, many societies are living not in a serial order of time but in a concurrent one, in which the past and present are interspersed with each other: The past "somehow gets stuck in the present and refuses to go . . . the past is constantly, urgently present as part of everyday experience."[8] An entire idiom now refers to the ghostly or haunting or uncanny nature of the past—a past that is viscerally, not just metaphorically, present.

The proliferation of truth commissions in the past couple of decades along with the concept of "transitional justice"

attest to this phenomenon: It seems we're in a time when neither historical narrative nor traditional juridical processes are up to the task of dealing with the extremes of state violence and the demi and quasi "transitions" back to peace that have become the norm.[9] Since substantial retrospective justice is rare, officially sanctioned truth telling has emerged as an alternative to punishment, but the problem with the truths of truth commissions is that truth threatens peace: The commissions exist in the gray area between those who need to know, or to be acknowledged, and the institutions that will likely falter if what becomes known is too much. That very grayness is their vulnerability to accusations that their catharsis is false and their solutions not authentically political: Neither punitive nor restitutive, neither fish nor fowl, their bargain with the damage wrought leaves the abominable past as unfinished business. It seems we need another way still of dealing with these pasts.

These pasts remain without a fixed meaning, and one of the things they call into question is the given notion of Truth. It seems to me that we tend to fetishize the idea of truth and its power to heal. We place blind trust in truth as though it were all that is needed to set things right. But the idea(l) of truth is not simple: Like all great concepts, the word is too overloaded with meanings to arrive at any simple determination. Okwui Enwezor points to the emergence of multiple concepts of truth, a cluttered array of versions: "juridical truth, narrative truth, experiential truth, ontological truth, performative truth, and so on," leaving us with a mandate for an entity that disperses among differing visions.[10] And then there's the fact that the mission to spread truth has, historically, been a mostly murderous business.

"Truth" is a big word, and so is "knowing," and the pair retain an aura of dubious reassurance, a cover of iffy certitude—both of them stitched together with wishes, stories

we tell ourselves, and for good reason. Knowing is generally linked in our minds to truth; it's aimed toward truth. In terms of knowing the past, and especially the troubling or traumatic past, Freud is an inevitable point of reference, and so it's worth remembering that his thinking on the matter shifted from the well-known focus on what the analysand can't let herself know to a dawning recognition that acquiring knowledge is just one way of knowing and that knowing is just one way of experiencing. With radical empiricism, William James called for a reconceptualization of the concrete elements of experience, entailing a sweeping redefinition of what constitutes so-called facts. He believed that the heart of experience was to be found in in-between states, passages and transitions, intuitions of relatedness and flux: It was in their very vagueness that richness was to be found. Telling History immediately suggests a vanishing point in the past from which the movement forward telescopes out, but from James we could extract the idea of a nonunitary, or unstable, vanishing point whose essence doesn't require having a final grasp on the matter—making space, perhaps, for apprehension of possibility within a disenchanted universe. The room for doubt defies the vertical logic of revelatory Truth.

There's also the fact that "closure," as such, would likely affront those whose lives have been torn apart: Even the effort to narrate those events definitively runs the risk of reducing what is, in actuality, unspeakable to the relatively lesser injury of that which can be named. Silence, on the other hand, would simply reaffirm the torturers' supreme dominance and their avowal that nobody would ever know: In silence the victim was, and remains, profoundly alone. The ideals of closure and resolution stand on the conviction that the calamity can be experienced, named, adjudicated, and softened into the familiar forms of the real—the place where "normalcy" and "anomaly" have meaning. The "sense of

an ending," as Frank Kermode calls it, grafts order onto the chaos of experience, but these works, each in its way, have their doubts, or, at the very least, their admonitions suggest the limits of those conventions and finalities.

Tolerating Knowing, Tolerating Not Knowing

What do we do when we tell of the traumatic past and, moreover, when we do that in the form of art? For one thing, we regulate distance: We're not proximate to what "happened," but distance grants us structuring absences. Fassbinder: one bewildered mind reaching out to another, uttering disintegration. Richter's smudged indices; *Germany in Autumn*'s discontinuous contiguity; Farocki and Ujica's narrative of gaps; Bruguera's mentor, wordless and bereft; Guzmán's low, lingering heartache, his mourners beneath a spangle of Milky Way, his call for us to accept our incapacity to mend the past. Porumboiu's wise fool, his central insight that we suffer most from how we avoid suffering: His version of history comes forward from that conundrum. None of these work in the vein of tragedy, or, maybe better, we could say that they have slipped the bonds of tragedy: a sign, I think, that they do not believe in the purity of absolutes offered in that narrative form, along with its cathartic expiations. These works seem less about what the "Truth" of the history might be than about what new thoughts it makes it possible to think or what other emotions it might give rise to.

These pasts have been intentionally made scarce, and on top of that they resist being told. They're caught in a bind: Any move toward poetic consolation would appear highly suspect (just think of the reception of Richter's paintings in Germany) because there's so much confusion about how or even whether to mourn them. These pasts are a truth that is, finally, undeclarable, and these works are ways to bring them

to awareness. These tellings are not about historicizing in any obvious way, but, as Walter Benjamin said of storytelling, they provide "amplitude that information lacks."[11] But what about that word? Are we really talking about stories, and, if not, then what other term might better suffice? "Tale" seems too wedded to invention and fantasy; "account" augurs a clinician's eye; and "narrative," at least in its traditional form of beginning, middle, and end, would falsify redemption. "Testimony" brings us back to that problem of Truth. Here's one way of looking at it, in an exchange between Mieke Bal and Cathy Caruth about stories of trauma:

> CC: It's a storytelling of a story that can't be told in the public realm. So it's really not "stories" in the ordinary sense. Nor is it "expression" in the ordinary sense, because what is told—or what is expressed—is not available in any ordinary form. It's not available as a simple story. . . . It's the possibility of storytelling throughout, rather than the actual story itself.

> MB: And that's why it doesn't bother me when people say, "I didn't understand the whole film." I want it to stay in their heads because they couldn't work it out. So they can make further stories.[12]

These works constellate around the difficulties of opacity, lostness, uncertainty; devising languages, idioms that gain, that build a tremendous amount of friction, that release unexpected meanings—that help us pay attention differently. Arguing in favor of opacity, Édouard Glissant recasts it as freeing us toward really knowing: The imaginary, he says, "does not bear with it the coercive requirements of idea. It prefigures reality, without determining it *a priori*. The thought of opacity distracts me from absolute truths whose guardian I might believe myself to be."[13] Lostness, likewise—Keats's "negative

capability," the capacity to tolerate doubts: Lostness plays a key role in those spiritual practices of initiation in which it is the intermediary, liminal stage between separating from the social body and returning, transformed. Labyrinths, thresholds, sites of that pivot from who we were to who we will become. These tellings go back to do something about the past as it lives in, erupts into the present. They return in order to tell, but they leave us hanging. They bring the past close by, but still it's unreachable. I think their indirection lies at the heart of the task: An unapparent connection, Heraclitus told us, holds more firmly than an apparent one.

They share a pausal style, and the breaches are crucial. The incomplete account, the narration full of stops and gaps, recognizes the gravity of what's been lost, forces us to fill in with our own imaginings, our replacements for what is missing. It induces us to feel the horror, or fear, or anguish that was real in the event but that the telling can't quite capture; it wrestles with the complicated notion of wanting the suffering to be of use. They're unsettling apprehensions, speaking from the place where knowing and not knowing intersect; they're urgent confusions, exhausted recognitions, empathic disorientations, oceanic feelings; they're ways of wrapping us up in the difficult truths of the past, sometimes inter- and remixed along a vector sketched in hope. They're crepuscular time, cognitive scatter, they're postlapsarian; they metabolize defeat. They're bristling, goading, unstable alloys of ferocity and submission; they're visceral reactions to the experience of dishonor and death as a daily reality, lived on a monstrous scale. They're circumambient darkness, thoughts that clog the throat, disconcerting schism and saturnine humanism. The works are Oedipus on his circuitous journey, toward and away from unbearable self-knowledge. They're strong gerunds, formed of the verbs of the past and acting in their present as markers of the racing, flaring, disruptive time

of revolution. They're languages of fidelity to emancipatory promises; they're languages of departure from them. The tellings are a roundelay, their phrases looping back: roundelay, work of imaginative sympathy.

It turns out that to understand these pasts, each in its way, is not to know them so much as to gain insight into what *not* knowing means and feels like. These works, each in its way, tell us something about the imperative to know the past through its present presence—a necessary yet irresolute task. We have a few modes in which we meet this dilemma: remembering, representing, repeating, returning, relating—telling.

Remembering: The mark of Cain makes plain the tension between memory and resolution. The traumatized suffer from an excess of memory, and those who come later suffer its scarcity. The former is essentially a solitary matter, fueled by the need to overcome, but the latter arises from a broader hunger, what Eelco Runia calls a "desire for reality . . . an ontological homesickness . . . a wish to commune with the numinosity of history."[14] We live in a time of avidity for the past: It is, says Adam Phillips, "as if the historical imagination, like the erotic imagination, is stirred by a kind of recognition that never quite knows what it is recognizing, but can't let go of it."[15] In that sense, it might be that history writing works as "a struggle to hold oneself together."[16] Taking up the question in a more protagonistic vein, Cathy Caruth suggests that, if remembering is a form of bearing witness and therefore taking responsibility for the truth, then "to testify before the court of history" means to testify on behalf of the future as much as on behalf of the past.[17] We want to remember. But it's not so clear that remembering, per se, is the route to Runia's communion, or Phillips's recognition, or Caruth's propulsive testimony: Chris Marker, who aimed remembering toward radical agency, notes that "I will have spent my life trying to

understand the function of remembering, which is not the opposite of forgetting, but rather its lining."[18]

Representing, in this certain way: When we talk about the traumatic past in these minor keys, it's partly because of our mistrust of the monumental. The monumental, as Andreas Huyssen sees it,

> is aesthetically suspect because it is tied to 19th century bad taste, to kitsch and to mass culture. It is politically suspect because it is seen as representative of 19th century nationalisms and of 20th century totalitarianisms. It is socially suspect because it is the privileged mode of expression of mass movements and mass politics. It is ethically suspect because in its preference for bigness it indulges in the larger-than-human, in the attempt to overwhelm the individual spectator. It is psychoanalytically suspect because it is tied to narcissistic delusions of grandeur and to imaginary wholeness. It is musically suspect because, well, because of Richard Wagner. . . . Thus for a post-1945 sensibility Michel Foucault could claim that what I am calling here monumental seduction represents "the fascism in all of us, in our heads and in our everyday behavior, the fascism that causes us to love power, to desire the very thing that dominates and exploits us."[19]

Monumentalism towers over the pained and constrained effort to guarantee the presence of the dead and the lost. But it's also the mechanism of public space, space of shared memory. The humble scale of our tellings gives rise to a lurking suspicion that they're too scant and, in tandem, a desire for remedies on orders of magnitude equal to what has happened. Do we live in a time in which consolation can come to us only in such splintered, private form? And does that signify retreat, does it substitute only poetic and psychologistic tell-

ings for what remain as historical and political problems? But on the other hand, do we really believe in the denunciatory power and agency of images of horror and all the euphoric clichés that armor them about how simply to show crimes against humanity is already to fight them?

Opposite to the monument's iconicity, these representations waver at an edge, a limit, an impasse, and reach out from there into an intermediate zone of potential: potential for the meaning and import of a telling such as these. They offer a speculative state of mind rather than one framed in obligations of remembrance, forgiveness, or redemption, and, in that, they're bound to disappoint: Speculation always must, because it never knows for sure. But, in refusing to invoke a rhetorical "don't you agree?" they open space for a new understanding of uncertainty, conceived not as a failure to know but rather as the potential for an array of insights to emerge from the event. The past becomes, maybe, elastic with incipience.

Runia grounds his study of the predicaments of historiography by mulling over the contrast between the related forms of metonymy and metaphor. "Whereas metaphor 'gives' meaning," he says, "induces the sense that something is understood, metonymy insinuates that there is an urgent *need for* meaning. Metaphor . . . weaves interrelations and makes 'places' habitable. Metonymy, on the other hand, disturbs places . . . it questions meanings, awakens from us what we take for granted."[20] Metaphor is "in the business of the 'transfer of meaning,' whereas metonymy, by presenting an absence, is a 'transfer of presence.'"[21] Presence, then, is not brought about by metaphorically filling absences, but it can be kindled by metonymically pointing to them. As such, while metaphors pertain to *logos*, metonymies reach us in the domain of *pathos*. As such, we're hit by the reality of what they tell precisely because of the unreality they evoke. And,

as such, they give access to our own dread; they locate the truth of that dreadful history within us. They refuse to really represent. Representationalism, says Runia, by being bound up with metaphor, "may suggest illuminating, surprising, and inspiring ways to see one thing in terms of another, but precisely because of this it doesn't bring us any closer to the inexorable . . . numinosity of reality."[22] We could start, then, by taking these works as metonyms, flickering signals: Guzmán's stardust, for instance, counterfeiting the sky. Those faintly glowing metonymies encourage a different logic of feeling.

Repeating: These tellings go back and repeat. Repetition leads from seeing to recognition, from sight to thought. When something indistinct is repeated, you have a better shot at making it out: Repetition clarifies. Reiterating an image causes you to reflect on it: It creates a delay. The repeating (reflection) of the image occasions our further, or problematized, or denaturalized consideration. It causes a shimmering.

These tellings are a way forward in the form of repetition. Per Kierkegaard: "Repetition and recollection are the same movement, only in opposite directions; for what is recollected has already been and is thus repeated backwards, whereas genuine repetition is repeated forwards."[23] These tellings test one reading after another, looking to understand: They reactivate old conflicts and test their vitality in the present. Derek Walcott, on epic memory: "Break a vase, and the love that reassembles the fragments is stronger than the love that took its symmetry for granted when it was whole."[24] Telling these pasts is love's protest.

These returns make patterns across time, which both amplifies and nullifies their force. Repetition is the seedbed of our experience of time, and it lies at the heart of ritual's force. Chanting and rhythmic frenzy—tools of pattern making— are means of deferring or short-circuiting the rational and the

social brain, opening—offering—an intense interiority. The word "rhythm" derives from the same root as truth: *aletheia,* what is not forgotten. Inversely: With repetition, dramatic action freezes into catechism. Inversely: Repetition indexes our inability to heal and overcome. Inversely: Look too long in a mirror, or say the same word too many times, and what you get is pure strangeness. ("Children are well-skilled in the exercise of repeating a word," Deleuze and Guattari remind us, "the sense of which is only vaguely felt, in order to make it vibrate around itself.")[25]

Repetition emphasizes, prays, bores, lulls, transports, comforts, condemns, conjures spells, memorializes. Even as repetition creates that sense of detachment, the subject's meaning fading from direct contact, it also stands as the trace of intent. Repetition structures, and it also abstracts: It draws you in on another level; it swells into a familiar, rewarding path in our minds. Musical lines often double, but out of unison: The effect is a sensation of floating, deepening echo. Repetition poses questions about sameness and difference, stagnation and change. Desire and repetition often keep each other's company.

Returning: trauma, the mirage of the return. Those undesired returns, proof of time's capacity to exist in nonhistorical form—to defy tenses, to defy presence and futurity. The undesired return's time is as zigzagging as it is dialectical, but that character, that refutation of the historian's logic, also opens a way. The concepts of time traditionally used by historians, says one of them, "are structurally more compatible with the perpetrators' than the victims' point of view."[26] The arrow of time declares the past to be inalterable and irreversible. Experience, though, and especially the limit experiences in these tellings deny that absolute absence of their pasts, which are, instead, stubborn and tough, stuck to the present. In that sense, we might distinguish between irreversible and irrevocable.

Irreversible history thinking promotes an approach of letting bygones be just that: The past is cut off from us, made distant by the forward march of time. Modernism, broadly speaking, chimes with this approach, assuming as it does a protocol of continual movement forward and conceiving of time as composed of moments containing successive events: At base, then, time is something parceled out in increments, related one to the next in terms of rupture more than continuity.[27] There's no going back, and, moreover, it would be folly to do so, since that would be to regress. Constant singularity continually archaizes historical truth, and, furthermore, the past is not a problem in the long run: There's no need to repair what's past, since time has already brought us someplace new. Inconveniently for this view, though, memory of atrocity tends to exist in a durational time that disrupts chronology, such that memory exists less as recall of the past than as something like a sensation of it in its eternal contemporaneity. R. G. Collingwood: "We do call the past, *as such*, into being by recollecting and by thinking historically; but we do this by disentangling it out of the present in which it actually exists, transformed. . . . The past is not merely a *pre*condition of the present but a condition of it,"[28] and in this iteration it has a "new quality." History writing has a new problem: not the erasure or fleetingness or evanescence of the past but its refusal to leave.

The past as irrevocable, however, proffers a repository that stands at our disposal. As a "non-spatial proximity," it "defies the dichotomy of the fixed categories of the absolutely absent and the absolutely present," as Berber Bevernage sees it,[29] and the fact of it grants us "some intellectual space to take seriously the idea of a 'persisting' or 'haunting' past."[30] This past, by its very nature, smudges the bright line between Then and Now.

Relating: the ancient injunction to know the past. Stories as journeys toward emancipation and, equally, as protective,

palliative inventions. Stories, tellings as the torsion between the burning desire to know and what remains without remains. Stories, "the remainder: that which is left to be written."[31] Telling, relating: phenomena constellated around the need to hold onto something. Religion: *re ligare*—to bind fast.

These tellings are not simply instances of showcasing the failure; they're a way—at least we hope—to get closer to the wound without being overwhelmed by it. These returns add to the compulsion to repeat the possibility that, in resurfacing as a telling rather than an aspiration or intent, these histories might come to mean something else, something we couldn't see beyond, then, something not locked in the past.

These are tellings in the wake of damage. That damage comes from the fact of the past, but, beyond that, it comes from things like the obliteration of access to it or to its contradictions, or from the extremely tight relation between victory and defeat. Along that route, they suggest questions about the possibility of telling. These tellings are in defiance of language, meanwhile situated within it. They are, in a way, written by their calamity, which wrecked the language of itself; knowledge of the disaster, it seems, is also a casualty of the disaster. Hence, the broken languages: a language of fragments, a relation of irrelation between the parts that sounds the experience of the loss. The fragments and their intervals form a thread, a meridian. The fissures, the stuttering gaps as parts of the truth, the stuttering gaps as prolongation, traction, moving the incompletion along in the ongoing agreement and then struggle between the fragments. "Do these go together? Yes, but without agreement. Without agreement but without discord."[32] That quality, when we attend to it—when these tellings attend to it— pulls at the thread of the telling and lets us replace false solidity with an opening to discover what we might want from them. The telling as the meridian, the very perplex-

ity itself, as though to say: This is what becomes possible through telling.

Turning point: We merely want a seam of freedom. We want, say these tellings, to forsake false shelters, to unshelter ourselves so that we might understand: "a turning which puts us face to face with the demand of the turning point."[33] These tellings might have something akin to liberation in mind. In some religious traditions, liberation counts as the endless, but not beginningless, absence of pain, while others hold that our existence is inseparable from sorrow: Liberation doesn't equate to transcendence. A line from Peter Matthiessen helps: "I only knew that at the bottom of each breath there was a hollow place that needed to be filled."[34] That hollow place might be where these works resonate, waiting to see what that breath will make possible.

The through line is something in the vicinity of both suspension and paradox, a wavering, delicately spasming historical space related as a tale. Suspension responds to the impossible dilemma: either return as the repressed or recur as the dissociated. Suspension defers the extremes of amnesia and hypermnesia, defers the uncontainable. It defers those hauntingly persuasive phantoms and their compulsive power, the raw dismay that they carry. Suspension pendulates, in and out of the traumata orbit; it salves the rent, scabrous skin of the psyche. Not ready and not reconciled: The works force us to admit that what they address exceeds our capacity to comprehend. We appeal to hope's methodology along with its pendant, memory,[35] and meanwhile restore to the memorable its own fragility.

And paradox: the moral imperative and political impossibility to hold torturers to account, the need and the impossibility to really speak of trauma, the longing for a past and fear of stagnation, the need for and inadequacy of closure. The terms of engagement we're given don't suffice, and this

might account for the complicated voicings in these works. Part of this has to do with the epic destruction, the great gout of exhaustion, grief, and despair. What does it do to enunciate in such circumstances? Blanchot: "There is a limit at which the practice of any art becomes an affront to affliction. Let us not forget this."[36]

These tellings of those frightening pasts, those unfinished times, render them foreign to every tense. These tellings and their diachronic thickness create awareness of our return to it, our interaction with it. These tellings, aware of the past but not seeking their grounding there. Hartman: "A temporal complexity is created very close to the dimensionality of thought itself, and which undermines the attempt to simulate closure, or any kind of eternity-structure . . . that temporal complexity, inseparable from the rhythm of memory when expressed in words."[37] These tellings of amputated pasts and their mortal derangement, the ungraspable experience of the overwhelming imposition of power: the unhappiness of missing origins, the wound of absent memory, of lost trust in the world, of entering the space of distress. These tellings, the welling up and sinking back of the past, both too much and too little. These tellings, with their careful kinds of with-holding, withdrawing from the demand that all be disclosed, choosing what to include and exclude from their worlds in order to make them hold the line against chaos; arriving at the edge of words where they falter and strain, making a shape for the past. These tellings as the political work of the dead, saturated in a crowd of feelings with all the complex associations of hope and disappointment. These tellings that read the wound and don't deny it: going back, perhaps, as an act of kindness to those who have had to survive their own survival.

Against the spindles of amnesia, telling the unrequited past must make it available, knowable as one's own and also

as a truth in common. Telling the unrequited past needs a way of understanding that is motile and oriented, a kind of understanding in which sensing and thinking are not inverse to each other. Telling the unrequited past must be intimate with fear; it must pass through caring in order to matter. It has to say: We are responsible for others. Telling the unrequited past learns that even once it puts things back together they'll fall apart again. Telling the unrequited past has to stay with that shakiness, and it has to stay with the broken heart. When we tell the unrequited past, we need to adulterate "knowing" with our own dogged, intimate, implicated participation in its sequelae.

These tellings helped me and, maybe, others: They befriended me in our mutual questions; they scraped something in me, not so much ringing true as giving a different access to thought—around, and through, our contention with the void of loss. Having found both valor and failure in the past, they form intricate questions around the sense of possibility in the present. We need humility to hear them.

Respect for hope, rejection of pathos, learning to think with pain. Telling the unrequited past does not suffice, but it's a beginning. These tellings, in the wake of the realization: Tyranny is possible now; now, as meanness, self-interest, distraction, habituation, rationalization, confusion, and fear make terrible things possible; now, as power seeks its own increase without check and violence nears like a tremendous storm rolling in from the past. Going back gives a context for our own battles.

Beyond Elegy

We need to leave some things unsaid, at the same time as we realize through telling. *Ultima ratio*: both the final argument and the last resort. Both senses indicate some sort of arrival,

and that's why metaphor, paradox's remedy, yokes together its contradictory thoughts. Last words tend to inflation, manipulation—they're like sucker punches, genuflecting toward History, and they're bound to fail in their task of consolation. Their uselessness derives precisely from their lastness, from the "structural impossibility of dialogue or debate."[38] Better, then, to turn to voices devised to contest the elegy's final say.

The corpse poem sings in the voice of the dead; it voices the thoughts of the dead, not those of the living about them. In that, they're a form of immortality, akin to how we think of both legacy and trauma. The corpse poem stands at a distance, rarely betraying raw emotion: It dismisses the elegy's compensation for and refusal of death, disavowing mourning, rejecting elegy and outdoing it. Not a substitute for loss, as Diana Fuss insists in her odd study of such things, "but a vehicle for it, not a restitution for loss but a means to achieve it."[39] An acquiescence to loss, a complex act of saving loss itself. Its lines "irretrievably breach the boundary between the place where language intensifies (the poem) and the place where language vanishes (the corpse). Giving voice to the voiceless cadaver, corpse poems bring language more fully in line with death; they . . . seek to revivify and reauthorize the dead at the risk of contaminating and killing poetry. To give *voice* to a *corpse* changes both."[40] (It seems that people mostly stopped writing these after the Holocaust, as though it had become too indecorous a fantasy to make dead bodies speak: Celan even included language in the death toll of genocide.)

And then aubade, dawn song. The lovers part at dawn, and so the dawn poem grieves the end to that world of passion: Its lines live in the time of impending separation, at once a complaint against the sun and a pledge of faith. The cleaving fuels the dawn song, and so it looks back in loss, singing in the participles of parting and waiting: a state of suspended animation that is, per Barthes, the definition of loving.[41] Aubade, the dawn

song, comes from the remade self, the self after loss, the self not constituted in the loss but in the embarkation, the wisdom from it. Heartfulness, more capable of sadness; the promise of an emotion yet to be discovered.

Songs, says John Berger, "refer to aftermaths and returns, welcomes and farewells. Or to put it another way: songs are sung to an absence. . . . At the same time (and the phrase 'at the same time' takes on a special meaning here), in the sharing of the song the absence is also shared and so becomes less acute, less solitary, less silent."[42] They "lean forward."[43] The aubade's voice speaks of the impermanence of everything in life. Regret, poignancy, recalling joy, and something more: With that parting dawns individual consciousness. The "separated, or daylit, mind bears the grief or burden of longing for what has been lost. . . . It moves from silence to speech, from the song of the nightingale to the song of the lark, from the rapture of communion to the burden of isolation, and the poem itself becomes a conscious recognition of our separateness."[44]

Waking is the relay into consciousness; it unleashes remembrance, and we return to the loss. Dawn is the time of dew, the earth covered in mythical tears. Dawn is when we mourn not others but ourselves, the ones we were before, the ones in love. Tellingly, and in defiance of elegy, the aubade has no verse form of its own, refusing to mark its own time. Its lyric haven stands as a place where the loss can be undone, but still it is a poem of grief. Poetry of uncoupling, but still, facing toward survival, the ability to survive even in the loss of the beloved world past. Gentle and stoic complaints, but still, a lyric voice that depends on the loss for its self-discovery. Bathed in the resinous light of dawn's leave-taking, proof of passion's loss, but still, insisting that it did exist, did tremble. Giving shape to absence, but still, valuing love over loss. Morning, time of awakening and loss,

awakening to loss. Losing, waiting, leaving, refusing, existing, surviving, consoling their singers for the failure of consolation itself. These songs voice the loss of the cherished promise, their receptacles hold the ardor we've lost and keep it from evanescing. We hear them in our core. Seamus Heaney: We feel them as "foreknowledge of certain things we also seem to be remembering."[45]

These histories in excess trail a time of grieving, and they pose a special problem of knowing. The setting of remembrance was a site of ruination, and these histories in excess make telling a complicated and difficult task. That kind of loss makes history return to us and in us, undesired and incessant. Pasts, hopes sealed off into forbidding crypts: These tellings push against the stagnant instability of that thwarting. Against devastation, against argumentation, against forgiveness, and against the imperative to avenge "wronged" lives, against seeing only the nightmare of these histories as their meaning, these tellings are a seam of freedom from these pasts.

It is the loss that speaks in these tellings, these languages streaming away from the familiar varieties of thought, remaining in the loss's fellowship. Something not being said is speaking. The great act of faith in these tellings, their gift to us, is to turn those tables so that it's not the history's return but our own act of return to break the deadlock. Grief keeps watch over the wounded space, the reserve of knowing that can't, quite, be thought, what is known at the speechless threshold. These words, these swirling dusts of telling with their imperfect evidence, rags of golden air tilting at the eternal ideas of freedom and justice, telling from the verge of the unendurable. Why are we drawn back, if not for our yearning sense of need, the curving back of time existing in an ambivalent correlation with love.

Acknowledgments

One way or another, every book is a collective effort, and it would be impossible to list everyone who has been a part of this one. Although a process wrapped in solitude, this book has also been made possible by the companionship, observations, wisdom, and skepticism of those with whom I have intersected for the past nine or ten years, whether through long periods of friendship and conversation or fleeting asides. Among them I count Luis Camnitzer, Liz Cerejido, Chris Chroniak, Delinda Collier, Mike Dorf, Kate Dumbleton, Jane Farver, Claire Fox, Cola Franzen, Gridthiya Gaweewong, Orlando Hernández, Anne Kofke, Lily Kofke, Alfredo Márquez, Saloni Mathur, Beth Nugent, Dan Paz, Maureen Pskowski, Kay Rosen, Roberto Tejada, Gibran Villalobos, and Micah Weiss. It may surprise some of those who are mentioned here as key interlocutors, but that's what they are: We share the mutual project (one often centered in or arising from the experience of art, though not always) that lies at the heart of this book, which thinks forward to imagine

a better way of being in the world. Writing this book has also coincided with a number of painful losses, and so, in a sense, the process of thinking it through, collecting the pieces, and waiting long enough to understand has been in a strong way analogous to mourning those loved ones.

Probably the most directly formative presence for this project has been the past thirty-plus years of my experience in and of Cuba and of slowly coming to understand the arc that people there have lived—both those who I have known well, and those who I knew only in passing—of hope and disillusionment, of fear, anger, and ruined dreams. Their wisdom, in learning to live in that aftermath, has inspired me through these years, and so, in at least some sense, I am indebted to those aspirations and, equally, their sequelae. They have helped me understand what I do, and do not, know.

My deepest thanks go to the Red Conceptualismos del Sur, whose work exploded the question for me about what the past means, and especially to Miguel López and Ana Longoni, who insisted. Sections of the book were presented in the form of talks at the University of Texas/Austin, the Institute of Fine Arts/NYU, and the Cleveland Institute of Art: my thanks to Andrea Giunta, George Flaherty, Edward Sullivan, and David Hart for those invitations. A residency at the Catwalk Institute in Catskill NY provided crucial space and time to think. Richard Morrison, Editorial Director at Fordham University Press, once again understood what I was trying to do, and supported that. He has my sincere and abiding thanks. Most of all, of course, I am indebted to the artists whose courageous works catalyzed these pages.

In memory of Desiderio Navarro, fierce and beautiful dreamer.

Notes

Introduction: Being Afterward

1. This became the exhibition *Perder la forma humana*, which opened in the Museo Nacional Centro de Arte Reina Sofia, Madrid, in October 2012.

2. Explaining the ethos of that project in Lima, one of its conveners had explained, "Rather than treat them as mere sources of 'the history of art,' we conceived them as living antagonistic forces, capable of intervening in our local memories, our academic apparatuses, and our public debates." Miguel A. López, "South-South Intersections: Southern Conceptualisms Network and the Political Possibilities of Local Histories," in *Speak, Memory* (2010), http://www.tenstakonsthall.se/site/wp-content/uploads/2012/01/Speak_Memory_Laura-Carderera_ed.pdf.

3. Michael Roth, *Memory, Trauma, and History: Essays on Living with the Past* (New York: Columbia University Press, 2012), xxiii.

4. Patrick Duggan, *Trauma-Tragedy: Symptoms of Contemporary Performance* (Manchester: Manchester University Press, 2012), 3–4.

5. Geoffrey Hartman, *The Geoffrey Hartman Reader* (New York: Fordham University Press, 2004), 375.

6. Hito Steyerl, "Missing People: Entanglement, Superposition, and Exhumation as Sites of Indeterminacy," in *Aesthetic Justice: Intersecting Artistic and Moral Perspectives, ed.* Pascal Gielen and Niels van Tomme (Amsterdam: Antennae, 2015), 58–59.

7. For example, Slavoj Žižek exhorts us to "grasp the radical openness of the past itself," which he says "contains hidden, non-realized potentials, and the authentic future is the repetition/ retrieval of *this* past, not of the past as it was, but of those elements in the past which the past itself, in its reality, betrayed, stifled, failed to realize." Slavoj Žižek, *In Defense of Lost Causes* (London: Verso, 2008), 141.

8. Martha Minow, *Between Vengeance and Forgiveness: Facing History after Genocide and Mass Violence* (Boston: Beacon, 1998), 147.

9. Mick Broderick and Antonio Traverso, *Interrogating Trauma: Collective Suffering in Global Arts and Media* (London: Routledge, 2013), 27.

10. Judith Butler, "Afterword: After Loss, What Then?" in *Loss, ed.* David Eng and David Kazanjian (Berkeley: University of California Press, 2003), 472.

11. For an extended discussion of these frameworks, see Claire Hemmings, *Why Stories Matter: The Political Grammar of Feminist Theory* (Durham, NC: Duke University Press, 2011).

1. Lupe at the Mic

1. This chapter was written in July 2010; the postscript was written in July 2018.

During his first address to the nation after the Cuban Revolution's triumph, a white dove landed on Fidel's shoulder. For some believers this signified that he had been anointed by the Afro-Cuban divinity Obbatalá, whose symbol is a dove. The moment became a key icon in the revolutionary image bank.

2. "Blogueros y artistas aprovechan un performance para pedir libertad," *Cubaencuentro*, March 30, 2009, http://www.Cubaencuentro.com/es/cultura/noticias/blogueros-y-artistas-aprovechan-un-performance-para-pedir-libertad-166628.

3. Laura Kipnis, "Aesthetics and Foreign Policy," *Social Text* 15 (Autumn 1986): 89–98.

4. See comment 3 under the article "Blogueros y artistas aprovechan un performance para pedir libertad."

5. Bruguera explained at some further length about her goals: "I try to activate, as a real experience for the spectator, images from the press or mass media that they no longer have emotional empathy for because they happened somewhere else, or a long time ago. I bring those back to life, so that the public [for the work] can have a direct experience, and when it sees a similar image in the press they'll remember it as an experience that they understand and that belongs to them, because they have lived it." See "Nadie está dispuesto al borrón y cuenta nueva," *Cubaencuentro*, April 20, 2009, http://www.cubaencuentro.com/entrevistas/articulos/nadie-esta-dispuesto-al-borron-y-cuenta-nueva-171188.

6. See Yoani Sánchez, "And They Gave Us the Microphones," *Generation Y*, March 30, 2009, https://generacionyen.wordpress.com/2009/03/30/and-they-gave-us-the-microphones/.

7. Jacques Rancière, cited in T. J. Demos, "Moving Images of Globalization," *Grey Room* 37 (Fall 2009): 6–29.

8. Jacques Rancière, "The Emancipated Spectator," http://ranciere.blogspot.com/2008/05/emancipated-spectator.html.

9. Jacques Derrida, *Writing and Difference*, trans. Alan Bass (Chicago: University of Chicago Press, 1978), 244.

10. Sánchez's blog (*Generation Y*) gets more than a million hits every month and thousands of comments on every post. See Daniel Wilkinson, "The New Challenge to Repressive Cuba," *New York Review of Books*, August 19, 2010, 72. As of around 2009, the blog was being translated into fifteen languages.

11. Michel de Certeau, *The Practice of Everyday Life* (Berkeley: University of California Press, 1984), 37–38.

12. de Certeau, *The Practice of Everyday Life*, 38.

13. "Art Performance Sparks Cuban Free Speech Debate," *Washington Times*, April 1, 2009, https://www.washingtontimes.com/news/2009/apr/1/art-performance-sparks-cuban-free-speech-debate/.

14. See Sun Tzu, *The Art of War*, trans. Thomas Cleary (Boston: Shambhala, 1988), xix.

15. Sun Tzu, *The Art of War*, xliv.

16. "Several people, including well known blogger Yoani Sánchez, grabbed the microphone to criticize the government and demand free speech." "Art Performance Sparks Cuban Free Speech Debate"; from the *Miami Herald*, an article with the lede "A Havana art show erupted into a protest of the islanders' lack of freedoms and can be seen on YouTube," http://current.com/items/89933993_artists-work-lets-Cubans-speak-out-in-havana-for-freedom.htm.

17. "Alice Jones: High Rollers and the Fate of Fat Cigars," *Independent*, April 6, 2009, http://www.independent.co.uk/opinion/commentators/alice-jones-high-rollers-and-the-fate-of-fat-cigars-1663413.html.

18. The sequence of events was as follows: The performance took place on March 29, 2009. The declaration by the Comité Organizador de la Bienal was circulated online on March 31. The Prieto interview was published in *La Jornada* on April 2.

19. "The consummation of that 'contestatory' performance," noted one commentator, "prepared by mutual agreement and in a perfect convergence of artist-institution, fulfilled yet another strategy of the Ministry"—to dilute the dissident artistic movement by accepting the performance and using it as a banner of freedom of expression. Comment in "Abel Prieto defiende el 'arte crítico' y cuestiona a Yoani Sánchez," *Cubaencuentro*, April 3, 2009, http://www.Cubaencuentro.com/cultura/noticias/abel-prieto-defiende-el-arte-critico-y-cuestiona-a-yoani-sanchez-167539.

20. "Abel Prieto defiende el 'arte crítico' y cuestiona a Yoani Sánchez."

21. A drastic cabinet reshuffle at the beginning of March 2009 had removed both Carlos Lage and Felipe Pérez Roque from all their positions. In Lage's case those had included executive secretary of the Council of Ministers, membership on the Communist Party's Central Committee and Political Bureau, membership on the Council of State, and parliamentary deputy. Pérez Roque, who had been Fidel Castro's chief of staff for a decade, had gone on to become a prominent member of the Cuban Council of Ministers, the Central Committee of the Communist Party, and the Council of State.

22. One commentator, while agreeing that it takes nerve to speak out in Cuba, also notes that all this nonetheless "collaborates with Raúl Castro's *marketing* [English in the original], in his intention to separate out his 'current government' — 'open-minded and tolerant' — from the 'previous government' of his brother." See "Blogueros y artistas aprovechan un performance para pedir libertad," comment 37.

23. http://www.Cubaencuentro.com/jorge-ferrer/blogs/el-tono-de-la-voz/se-hunde-la-x-bienal-de-la-habana.

24. http://www.lavanguardia.es/premium/publica/publica?COMPID=53676853441&ID_PAGINA=22919&ID_FORMATO=9&turbourl=false.

25. "Nadie está dispuesto al borrón y cuenta nueva."

26. Theodor W. Adorno, "Trying to Understand *Endgame*," *New German Critique* 26 (Spring/Summer 1982), http://www.jstor.org/stable/488027.

27. "Interview: Talking to Cuban Artist Tania Bruguera," *Suffragio*, June 22, 2015, http://suffragio.org/2015/06/22/talking-to-cuban-artist-tania-bruguera/.

2. The Tenuous Moonlight of an Unrequited Past

1. This chapter was written in April 2013.

This chapter's epigraph is from Patricio Pron, *My Father's Ghost Is Climbing in the Rain* (New York: Knopf, 2013), 165. Pron is an Argentinean writer born in 1975. He is part of a generation of writers from the Southern Cone whose work focuses on the "dirty wars" of the 1970s–1980s, during which many in their parents' generation were harassed, murdered, or disappeared by the ruling dictatorships.

2. Dated November 14, 1972, Santiago de Chile. Patricio Guzmán, "What I Owe to Chris Marker," *BFI*, February 10, 2015, http://www.bfi.org.uk/news/what-i-owe-chris-marker. The letter was a plea for help, continuing: "However, WE DON'T HAVE film stock. Due to the US blockade on film imports it can take up to one year to get here. We thought you could help us get hold of the material. . . . I am very sorry for the long letter, and, I ask you to please be absolutely frank in your reply. I completely trust your judgment." Marker gave Guzmán the film stock that he needed. He also brokered a relation for Guzmán with the Cuban Film Institute (ICAIC) and with Alfredo Guevara, which resulted in him being able to spend six years in Havana working on the edit with the help and advice of Julio Garcia Espinosa (arranged by Guevara). The history of Guzmán's film is therefore a kind of map of radical cinema in Latin America at the time. Once he saw the film, though, Marker was apparently not thrilled. Guzmán came to understand it thus: "It has to be said that we were living in very politicized times, and the group that Chris belonged to was comprised of artists and intellectuals from the very radical left. My film wasn't. On the contrary, *The Battle of Chile* is pluralist and not dedicated to any particular militant group; only to the Chilean dream (the struggle of an unarmed people), the utopia of a people in its broadest perspective, which I could see with my eyes and feel with my body in that vibrant Chile with which I identified, and still identify today."

3. Guzmán accounts for this as follows, in 2012: "It was a tremendously powerful oppression, in contrast for instance with Argentina where there has been a much more comprehensive memory work. Argentina lost the Malvinas war and therefore

the army lost its prestige entirely, which helped this process, but
President Cristina Kirchner did a very big job in trying to deal
with the memory problem, which President Michelle Bachelet
didn't do in Chile. She in fact did absolutely nothing apart from
creating a museum, which was ornamental, lacking any analysis
of what happened. Chilean civilians have been responsible
for new history books, but without official assistance of any
kind. Memory has begun to be recuperated by NGOs, honest
journalists and judges, families of the disappeared and victims.
But the state hasn't had a part in it. The government is still living
in a cave." Rob White, "After-Effects: Interview with Patricio
Guzmán," *Film Quarterly*, July 12, 2012, http://www.filmquarterly
.org/2012/07/after-effects-interview-with-patricio-guzman/. Ana
Ros further explains the reasons for the official silence, which
was not confined to the short period of the UP government:
"Concertación [the transitional government] silences this period
and focuses on commemorating its tragic ending. This makes
it impossible to build on the experience of the UP and evaluate
the present from its vantage point. Allende's government is not
the only significant political project excluded from the memory
promoted by the post-dictatorship governments. For similar
reasons, the 1980s student movement was not remembered
after the end of the dictatorship: it is a memory that could
encourage younger generations to not accept their situations as
given and engage in collective struggles. . . . The revolutionary
past of the institutions has been deliberately excluded from the
younger generations' education; it is not meant to inform an
understanding of their possibilities as actors in the present." Ana
Ros, *The Postdictatorship Generation in Argentina, Chile, and
Uruguay: Collective Memory and Cultural Production* (New York:
Palgrave, 2012), 125–26. It's also worth noting that Chile has often
been characterized not only as deeply divided but also as a nation
averse to open conflict, "related to low levels of trust." Alexander
Wilde, "Irruptions of Memory: Expressive Politics in Chile's
Transition to Democracy," *Journal of Latin American Studies* 31,
no. 2 (May 1999): 476.

192 NOTES TO PAGES 37–39

4. Ros, *The Postdictatorship Generation*, 111. Pinochet's statement was made in 1989.

5. The phrase is Guzmán's, from *Nostalgia for the Light.*

6. Fans of symmetry might enjoy the fact that the period from 1973 to 2010 is neatly bookended in Chilean politics, at the beginning by being a laboratory of neoliberalism, where disciples of Milton Friedman worked the kinks out of their free market theories during the dictatorship, and at the end when the billionaire Sebastián Piñera, who made his fortune introducing credit cards to Chile, was elected president.

7. The film does not identify the young people as such, but they are identified in Thomas Miller Klubock, "History and Memory in Neoliberal Chile: Patricio Guzmán's Obstinate Memory and *The Battle of Chile*," *Radical History Review* 85 (Winter 2003): 274.

8. David Scott, *Omens of Adversity: Tragedy, Time, Memory, Justice* (Durham, NC: Duke University Press, 2014), 121.

9. Regarding this hope, Steve Stern calls *Chile: Obstinate Memory* "an elegy told by the elders who lived the dream and its collapse, and who bring the experience into dialogue with the generation coming of age in the 1990s democratic transition." Steve J. Stern, "Filming the Fractured Soul of Chile: Guzmán's Epic and Elegy of Revolution," *NACLA Report on the Americas*, March/April 2010, 43. Regarding this belief, Ros writes that "the post-dictatorship generation takes over in the face of their parents' limits and looks for active forms of transmission of a past that is also theirs." Ros, *The Postdictatorship Generation*, 152.

10. Cited in Carlene Bauer, "Radical Inquiry," *New York Times Book Review*, July 27, 2014, 21.

11. This is Guzmán's phrasing, in *Nostalgia for the Light.*

12. Filmed interview with Guzmán included in DVD boxed set. Expanding on matters, he says in that conversation that until then he had felt like an exceptional exile because he was making the History of all those other exiles, for which everyone would be grateful: He had a cause.

13. About this structure, Guzmán has said: "The last part of the film ends with the beginning, which was Allende's revolution. It's in the third part where you can see the popular revolution that was developing. The previous parts were the actual facts and tactics—but they don't explain the nature of the revolution itself, which is what's explained in the last part. Thus I find that part the most interesting, even though it's incomplete. Maybe you could say it's like an embryo and today it gives Chileans a very strong message." White, "After-Effects."

14. Wilde, "Irruptions of Memory," 480–81. According to Ros, the constitution "turned Pinochet into a constitutional president and established the terms of a 'protected democracy' that would enable what was considered a peaceful transition. This constitution authorized the armed forces to intervene in political life by designating them as guarantors of the institutional framework; it effectively precluded antiestablishment parties from participating in politics . . . it severely restricted freedom of speech. Finally, it increased the president's authority by giving him the power to dissolve the Lower Chamber of Congress and extending presidential terms to 8 years, with the possibility of reelection. In case he would not be reelected in 1988 . . . Pinochet would remain commander-in-chief for ten years, and then become senator-for-life." Ros, *The Postdictatorship Generation*, 108. Such measures not only represented very real constraints on the possible emergence of independent democratic legislative activity; they also ensured the perpetuation of the values and mindsets that characterized public and political life during the dictatorship.

15. Nelly Richard, *Cultural Residues: Chile in Transition*, trans. Alan West-Durán and Theodore Quester (Minneapolis: University of Minnesota Press, 2004), viii.

16. Patricio Aylwin, first president during the Concertación transition, had been the president of the Christian Democrats, the (CIA-funded) opposition party during Allende's presidency.

17. Richard, *Cultural Residues*, 15.

18. Richard, *Cultural Residues*, 24.

19. Commonly referred to as the Rettig Report, the 1991 document addressed human rights abuses resulting in death or disappearance that occurred in Chile during the years of military rule under Pinochet. Ros, *The Postdictatorship Generation*, 113.

20. Quoted in Dennis West, "Nostalgia for the Light," *Cineaste*, Summer 2011, 51.

21. Juan Carlos Rodríguez, "The Postdictatorial Documentaries of Patricio Guzmán: *Chile, Obstinate Memory*; *The Pinochet Case*; and *Island of Robinson Crusoe*," PhD diss., Duke University, 5, 13. According to Wilde, although an extensive report was commissioned and published documenting human rights violations, that report had little influence on subsequent political discourse, for a variety of reasons. Wilde, "Irruptions of Memory," 482.

22. "One of the main challenges facing contemporary Chilean society, which is in the process of regaining a sense of community based on genuine reconciliation, is to relocate this conflict in the public arena and consciousness. . . . The heart of the problem lies, then, in strategies that privatize pain and demand forgiveness on the part of victims while simultaneously immersing the population in a consumerist and success-based ideology." Walescka Pino-Ojeda and Mariana Ortega Breña, "Latent Image: Chilean Cinema and the Abject," *Latin American Perspectives* 36, no. 5 (September 2009): 135.

23. Richard, *Cultural Residues*, 17.

24. The cultural critic Nelly Richard has been especially vehement in her condemnation of the Transition's anesthetic politics. In Concertación's "banal permissiveness" (*Cultural Residues*, 17), "anything can circulate," she says, "but as information (words drained of emotion or commotion)" (17), not as "an irreducible life experience, tense, nonfestive, in mourning" (13). Concertación "balance[d] the ledgers of the Transition with an economy of the reasonable that must leave out of its utilitarian tallies both the failures and excesses of symbolic imaginaries" (12), "leav[ing] aside from their diligent wording all the wounded substance of remembrance: the psychic density, the

magnitude of the experience, the emotional wake, the scarring of something unforgettable that resists being submissively molded into the perfunctory forms of judicial procedure or inscription on an institutional plaque" (18).

25. The woman is Carmen Vivanco, whose husband, son, brother, and sister-in-law were all disappeared. A long-standing human rights activist who had pushed for information on the disappeared and for truth and justice investigations to hold the state accountable, she is a person whose experience and activities had been intensely focused on a commitment to remembering. "I have my doubts," she says, and Guzmán leaves it at that. While these films are usually read as ideologically crystalline, in fact they are full of these quiet spaces of disbelief. "One legacy of the era of revolution and dictatorship," writes Stern, "is to accept that one lives with doubt." Stern, "Filming the Fractured Soul of Chile."

26. The split in Chilean society persists even still. Among other measures, its wealth disparity was and is one of the sharpest globally.

27. Klubock, "History and Memory in Neoliberal Chile," 276.

28. Richard, *Cultural Residues*, viii.

29. Ros, *The Postdictatorship Generation*, 124.

30. Ros, *The Postdictatorship Generation*, 124.

31. About the children, Ros has written about "the teenagers' dismissive attitude towards projects of radical social change, which for them do not belong to the adult world of politics, but to the dreamy world of childhood. This is not surprising in a context in which collective projects have been substituted by individual self-interest and politics has been reduced to a technical matter: Allende's project cannot be grasped through the neoliberal lens." Ros, *The Postdictatorship Generation*, 141.

32. "The film's powerful evocation of personal tragedy and loss produces a sense of memory that is restricted to the individual and defined by nostalgia, rather than a form of collective memory engaged with current political questions. One wonders: is this a sign of the hegemony of free market

ideology and political consensus in 1990s Chile or a sign that the filmmaker is no longer interested in the questions that animated *Battle of Chile?*" Klubock, "History and Memory in Neoliberal Chile," 276.

33. Guzmán attributes his own political awakening to Allende: "I myself was never a militant. My family wasn't leftwing. We were normal petit bourgeois and for our class group the rise of Allende wasn't an eventful time. I put in these scenes to reflect my own personal experience. A lot of people awoke with Allende's election, having never participated politically. When I was a child and even an adolescent I was never politically active and I felt it was relevant to say so. Allende was the spark. My political conscience actually awoke in the Spain of Franco, when I went to study there. I didn't give a damn that Franco was in power. It was 1965 and Spain was an explosive place because the dictatorship was losing its grip and there was a large popular movement coming up. That's when I began to understand. It was an extraordinary period. The dictatorship had basically died and the Spain of the future was taking form—which was better than what we have now in Spain. Things have regressed. This is a problem with transitions. In 1985 the mass movement in Chile was quite extraordinary and that's what created the refusal of Pinochet, but when the transition actually arrived that movement was suppressed, and I don't think the US wasn't a participant. It was a dangerous time. There was the possibility of another popular uprising, and Chile would have become a modern progressive country." White, "After-Effects."

34. C. S. Lewis, *A Grief Observed*, cited in Meghan O'Rourke, *The Long Goodbye* (New York: Riverhead, 2011), 188.

35. Vicky Saavedra: "That night I got up and went to stroke his foot. . . . I took it out of the bag and looked at it. I remained sitting in the living room for a long time. . . . The next day my husband went to work and I spent all morning with my brother's foot. We were reunited."

36. In fact, at least one critic felt that was much the case: "From a certain point of view, the shots of sunlit motes and astral

vistas are the most sinister images in *Nostalgia for the Light* because, apart from being familiar motifs of natural beauty, they most directly express distraction and the way a field of vision begins to blur, to blank out. Patricio Guzmán's film refuses all easy answers; there is no equivalent to the catharsis of *Chile, Obstinate Memory*, and when *Nostalgia for the Light* focuses near the end on an astronomer named Valentina whose parents were both killed by the junta, but who claims that the coup's barbarous influence is now at an end, her strangely phrased optimism — 'I'm a product with a manufacturing defect which is invisible . . . I realize that my children don't have this defect, nor does my husband and that makes me happy' — is possibly an even sadder expression of the national tragedy than silence and stony faces." White, "After-Effects." About the dust, Guzmán explains: "We found a big astronomical cupola from which the telescope had been removed. It was disused and actually full of rubbish. When I saw that space I actually saw the whole process of the coup d'état in the destruction and the absence of what was supposed to be there. I saw this dustbin place as a metaphor. It was thick with dust. There was lots of powdered glass and at one point we started throwing it in the air when the light that was entering the building was like the light you might see in a cathedral. When we did this it was like you could actually see the Milky Way there. We were captivated by this sight for a whole day." White, "After-Effects."

37. This is O'Rourke's reading of Madeleine L'Engle's use of the term. O'Rourke, *The Long Goodbye*, 289.

38. Judith Butler, in David L. Eng and David Kazanjian, eds., *Loss* (Berkeley: University of California Press, 2003), 467.

39. The observation is from Nelly Richard, cited in Michael J. Lazzara, "Guzmán's Allende," *Chasqui: Revista de Literature Latinoamericana* 38, no. 2 (November 2009): 48.

40. Lazzara, "Guzmán's Allende," 48.

41. "Wanting to forget is a defense. I'd like to forget." Hortensia Allende, in the film *Chile: Obstinate Memory*, 50:20.

42. According to Elizabeth Jelin, there are different scales/ layers at which the meaning and agency of remembering exists: For individuals, "the imprints of trauma play a central role in determining what the person can or cannot remember, silence, forget or work through. At the political level, the process of settling accounts with the past in terms of responsibilities, accountability and institutional justice are overlayered with ethical imperatives and moral demands." She further notes that "while natural catastrophes promote social solidarity, social catastrophes disaggregate and divide the social body." Elizabeth Jelin, State Repression and the Labors of Memory, trans. Judy Rein (Minneapolis: University of Minnesota Press, 2003), 2–3, 27–29. In a related vein, we could wonder about collective memory, about whether it's really possible for such a thing to exist or whether that's more a matter of myths and beliefs, in which memory or remembering does not play the central role. As Paul Ricoeur has observed, collective memory is basically a map of power relations: "Collective memory simply consists of the set of traces left by events that have shaped the course of history of those social groups that, in later times, have the capacity to stage these shared recollections through holidays, rituals and public celebrations." Cited in Jelin, State Repression and the Labors of Memory, 12.

43. Earlier, the first of the two young astronomers had responded to Guzmán's question about the women in the desert as follows: "I don't know what I'd do if a sister, a brother, or one of my parents were lost somewhere in the desert, in this vast expanse. Personally, as an astronomer, I would imagine my father or mother in space, lost in the galaxy somewhere. I would look for them through the telescopes." The cosmic identifications expressed by both of the young astronomers are resonant with various spiritual traditions that stress the unity of matter and spirit, especially Hinduism and Buddhism: The essence of each person is also the essence of all things. In fact, there is a passage in the film in which the point is made that it is the very same calcium in the bones being sought that also exists in the

stars, and that it all comes down to us from the same Big Bang. Again, this is something that some critics have struggled with, "as though light speed or the fact that calcium is the common substance of stars and skeletons really mattered at all when set against the story of how the bones of the coup's victims came to be strewn in the sand. The astronomers' enthusiasm for the enigmas of space requires that they look far away from the desert; one interviewee's somber acknowledgment of the preoccupation of nearby grave hunters and bedraggled Antigones encapsulates the problem because his evident sympathy involves a whimsical displacement. . . . And in such a fashion the matter of the coup's terrorism starts to be downplayed even as it is broached: projected onto a starscape, it starts to turn secret again." White, "After-Effects."

44. Theodor Adorno, "The Essay as Form," *New German Critique* 32 (Spring/Summer 1984): 161.

45. Adorno, "The Essay as Form," 165.

46. Adorno, "The Essay as Form," 161.

47. Adorno, "The Essay as Form," 166.

48. Adorno, "The Essay as Form," 166.

49. Adorno, "The Essay as Form," 164.

50. Adorno, "The Essay as Form," 164.

51. Adorno, "The Essay as Form," 168.

52. Adorno, "The Essay as Form," 164.

53. Butler, in Eng and Kazanjian, *Loss*, 468.

54. Leslie Jamison, *The Empathy Exams* (Minneapolis: Graywolf, 2014), 216.

55. "The suffering of memory is used to give life to death: the obsessive fixity of memory can't stop repeating itself because by vanishing it would duplicate the violence of the first erasure of identity executed by the disappearance. . . . What endures in the memory of the victims' relatives is then a 'life-or-death' matter." Richard, *Cultural Residues*, 25.

56. Butler, in Eng and Kazanjian, *Loss*, 472.

57. And in fact an endorsement of this came from surprising quarters in Chile. Of the disappointments of the Transition

process, Jorge Correa Sutil, a lawyer who was the secretary of the National Commission for Truth and Reconciliation, observed that "Chileans could not handle facing for too long the worst part of our collective history, except at the superficial, political level. . . . Perhaps it is too early to expect such a collective reaction. The time for artists' and psychiatrists' explanations will come." Cited in Pino-Ojeda and Ortega Breña, "Latent Image," 136.

58. Adorno, "The Essay as Form," 168.

59. Winnicott: "Fantasy is more primary than reality, and the enrichment of fantasy with the world's riches depends on the experience of illusion." Quoted in Sarah Pincus, "Ordinary Magic: D. W. Winnicott and the E. Nesbit Tradition in Children's Literature," *English Honors Papers* 15 (2014): 25, http://digitalcommons.conncoll.edu/cgi/viewcontent.cgi?article=1018&context=enghp.

60. "Hasn't philosophy superimposed on listening, beforehand and of necessity, or else substituted for listening, something else that might be more on the order of understanding?" Jean-Luc Nancy, *Listening*, trans. Charlotte Mandel (New York: Fordham University Press, 2007), 1.

61. "A sense (that one listens to)" rather than rushing straight toward the "truth (that one understands)." Nancy, *Listening*, 2.

62. "If 'to hear' is to understand the sense . . . (to understand at least the rough outline of a situation, a context if not a text) . . ." Nancy, *Listening*, 6.

63. Nancy, *Listening*, 57.

64. This corresponds to Todorov's concept of "literal memory," which refers to a remembering in order to preserve and to recover. Advocates of this type of traumatic remembering generally proceed from an idea of the moral duty to remember. This literal remembering is a necessary predecessor to "exemplary memory," a successive step in which the painfully remembered past can be transformed into lessons about moving forward. Ros, *The Postdictatorship Generation*, 7–8. There's a largely parallel construction in Svetlana Boym's pairing of

restorative and reflective nostalgia, with the future sharing with Todorov's "literality" a central imperative to return to a past that probably never even existed in the mythologically remembered form, while the latter, along with Todorov's "exemplarity," looks to the past in order to reflect productively on present experience.

65. Patricia Aufderheide, interview with Patricio Guzmán, *Cineaste* 27, no. 3 (Summer 2002): 25.

66. Roland Barthes, *Mourning Diary*, trans. Richard Howard (New York: Hill and Wang, 2009), 178.

67. Barthes, *Mourning Diary*, 203.

68. Peter Matthiessen, *The Snow Leopard* (New York: Penguin, 1978), xxxvii.

69. Walter Benjamin, "The Work of Art in the Age of Mechanical Reproduction," in *Illuminations: Essays and Reflections*, ed. Hannah Arendt, trans. Harry Zohn (New York: Schocken, 1968), 222–23.

70. Néstor García Canclini, *Art beyond Itself: Anthropology for a Society without a Story Line*, trans. David Frye (Durham, NC: Duke University Press, 2014), 184.

71. Lazzara, "Guzmán's Allende," 49.

72. Randall Jarrell, "An Unread Book," cited in Christina Stead, *The Man Who Loved Children* (New York: Picador, 2001), xl.

3. Something That Opens a Wish and Closes a Door

1. The title of this chapter is a quotation from Herta Müller, *The Fox Was Ever the Hunter*, trans. Philip Boehm (London: Portobello, 2009/2016), 27. Müller is a German-Romanian writer and Nobel laureate whose work often focuses on the effects of the violence, terror, depravity, and habitual betrayals of the Ceauşescu regime. In this book, from which several passages are used here to introduce sections of this chapter, Müller builds a collage-like story about four young people living through the last days of the regime, evoking through its often surreal stories the dynamics that linked loving and betrayal.

2. Giorgio Agamben, *Means without Ends*, trans. Vincenzo Binetti and Cesare Casarino (Minneapolis: University of Minnesota Press, 1996/2000), 82.

3. Ceauşescu was "almost always followed by cameras and his career can be fully traced on television: from his celebrated speech on 21 August 1968 condemning the Warsaw Pact invasion of Czechoslovakia to his final and fatal address of 21 December 1989." Ovidiu Ţichindeleanu, "Ion Grigorescu: A Political Reinvention of the Socialist Man," *Afterall* 41 (Spring/Summer 2016).

4. This section's title is from Müller, *The Fox Was Ever the Hunter*, 34.

5. Robert Kaplan, *Balkan Ghosts: A Journey through History* (New York: Vintage, 1994), 108.

6. Kaplan, *Balkan Ghosts*, 109.

7. Kaplan, *Balkan Ghosts*, 111.

8. Kaplan, *Balkan Ghosts*, 166.

9. Kaplan, *Balkan Ghosts*, 173.

10. Herta Müller, "Romania's Collective Amnesia," *signandsight.com*, January 17, 2007, http://www.signandsight.com/features/1136.html.

11. Eva Hoffman, *Exit into History: A Journey through the New Eastern Europe* (New York: Viking, 1993), 302.

12. This section's title is from Müller, *The Fox Was Ever the Hunter*, 42.

13. Kaplan, *Balkan Ghosts*, 90.

14. Brian Hall, *Stealing from a Deep Place* (New York: Farrar Straus Giroux, 1988), 65.

15. Kaplan, *Balkan Ghosts*, 102.

16. Hall, *Stealing from a Deep Place*, 65.

17. This account from Marius Stan and Vladimir Tismaneanu sums it up: "Another telltale case was Dr. Iulian Mincu, Ceausescu's last personal doctor, whom he entrusted with designing the notorious Rational Nourishment Program, a set of draconian policies imposed in the 1980s to justify starvation in the name of medical progress. Ersatz food (adulterated oil made from unrefined soy, fake cheese fluffed up with flour,

dregs of meat like chicken claws, fake coffee called "Nechezol," and so on) proclaimed superior to natural products. In the meantime, the regime could export food for hard currency. For instance, one ration card for one person in the city of Galați, eastern Romania, from the late 1980s contained: Bread—300gr/ daily; poultry—1 kilo/month; pork or beef—500gr/month, or meat cans from Czechoslovakia or the Soviet Union as replacements; other meat products (salami, sausages, usually made of soy)—800gr/month; salted cheese—500gr/each trimester; butter—100gr/month; oil—750ml/month; sugar—1kilo/ month; corn flour—1 kilo/month; flour—1 kilo/each semester; eggs—8 to 12/month; and a supplement for hard workers, meaning 300 more grams monthly for diverse products." Marius Stan and Vladimir Tismaneanu, "When Our President Put His Doctor in Charge of Everything," *Politico*, March 31, 2018, https://www.politico.com/magazine/story/2018/03/31/ trump-ronny-jackson-va-ceausescu-physician-217765.

18. Kaplan, *Balkan Ghosts*, 92.

19. Maria Todorova, "The Balkans: From Discovery to Invention," *Slavic Review* 53, no. 2 (Summer 1994): 453.

20. Katherine Verdery and Gail Kligman, "Romania after Ceaușescu: Post-Communist Communism?" in *Eastern Europe in Revolution*, ed. Ivo Banac (Ithaca, NY: Cornell University Press, 1992), 119. On December 23, Radio Budapest had reported seventy to eighty thousand dead and three hundred thousand wounded. These numbers were believed because it was felt that Ceaușescu was indeed capable of that. Bodies had been hastily excavated in Timisoara after the massacre of December 17, and in their haste some bodies of those who had died from other causes were identified as victims of the massacre. Even though the photos in some cases were clearly of bodies that had decomposed for some time already, they were believed, since such horrors were to be expected of Romania.

21. Slavoj Žižek, "Giving up the Balkan Ghost," in *The Fragile Absolute; or, Why Is the Christian Legacy Worth Fighting For?* (London: Verso, 2000), 4.

22. Todorova, "The Balkans," 455.

23. Cited in Todorova, "The Balkans," 459.

24. Cited in Todorova, "The Balkans," 476.

25. Todorova, "The Balkans," 477.

26. Kristine Stiles, "Shaved Heads and Marked Bodies," in *On Violence: A Reader*, ed. Bruce B. Lawrence and Aisha Karim (Durham, NC: Duke University Press, 2007), 532–33.

27. Kaplan, *Balkan Ghosts*, 95.

28. Kaplan, *Balkan Ghosts*, 128.

29. Kaplan, *Balkan Ghosts*, 128–29.

30. Kaplan, *Balkan Ghosts*, 129–30.

31. Kaplan, *Balkan Ghosts*, 94.

32. Todorova, "The Balkans," 479.

33. Todorova, "The Balkans," 474–75.

34. Žižek, "Giving up the Balkan Ghost," 8.

35. Christina Stojanova, "Beyond Dracula and Ceauşescu: Phenomenology of Horror in Romanian Cinema," in *Horror International*, ed. Steven Jay Schneider and Tony Williams (Detroit, MI: Wayne State University Press, 2005), 222.

36. Cited in Kaplan, *Balkan Ghosts*, 124.

37. Kaplan, *Balkan Ghosts*, 81.

38. Kaplan, *Balkan Ghosts*, 126.

39. Kaplan, *Balkan Ghosts*, 129.

40. Hoffman, *Exit into History*, 293.

41. Press release for "Golden Flat & Co.," December 23, 2010, http://www.e-flux.com/announcements/36083/golden-flat-co/. All grammatical errors *sic*.

42. Stiles, "Shaved Heads and Marked Bodies."

43. Cited in Peter Siani-Davies, *The Romanian Revolution of December 1989* (Ithaca, NY: Cornell University Press, 2005), 275.

44. This section's title is from Müller, *The Fox Was Ever the Hunter*, 43.

45. Siani-Davies, *The Romanian Revolution of December 1989*, 283.

46. Cited in Siani-Davies, *The Romanian Revolution of December 1989*, 282.

47. Verdery and Kligman give ample suggestion that some sort of internal plot was at least a contributing factor but conclude that "the revolution came from a fortuitous convergence of several elements: superpower interests, events in neighboring countries that permeated Romania's borders via the airwaves. Some sort of conspiracy at the top, and a long-incubated 'movement of rage,' culminated in a genuine popular uprising." Verdery and Kligman, "Romania after Ceauşescu," 121–22.

48. Verdery and Kligman, "Romania after Ceauşescu," 119.

49. For one thing, they could see Hungarian and Yugoslavian TV programs. Verdery and Kligman cite a factory worker who addressed the assembled crowds on December 16 with the following exhortation: "All Europe has given us an example to follow: Poland, Hungary, the USSR, Czechoslovakia, Yugoslavia, Bulgaria! What are we still waiting for?" Verdery and Kligman, "Romania after Ceauşescu," 120.

50. Kaplan, "Romania after Ceauşescu," 182.

51. https://en.wikipedia.org/wiki/Romanian_Revolution.

52. Verdery and Kligman, "Romania after Ceauşescu," 118.

53. Kaplan, *Balkan Ghosts*, 156.

54. Siani-Davies, *The Romanian Revolution of December 1989*, 268.

55. A variant of this is the theory that the plot was in order to take advantage of Gorbachev's weakness and ensure that, as Germany unified, it would ally with the United States and not the USSR. On the other hand, the Brandstatter-Durandin school argues that "Ceauşescu's overthrow was primarily the work of the CIA, with various Western security services and the Hungarians—although still communist at the time, nevertheless working in concert with the West—fulfilling a secondary role. The KGB is said to have participated, but had only a bit part." Richard Andrew Hall, "December 1989–2009: Bullets, Lies, and Videotape," *Archive of the Romanian Revolution of December 1989*, https://romanianrevolutionofdecember1989.com/december-1989-2009-bullets-lies-and-videotape/.

56. Richard Andrew Hall, "The 1989 Romanian Revolution as Geopolitical Parlor Game," *Archive of the Romanian Revolution of December 1989*, https://romanianrevolutionofdecember1989 .com/2010/09/21/the-1989-romanian-revolution-as-geopolitical-parlor-game-brandstatter%E2%80%99s-%E2%80%9Ccheckmate%E2%80%9D-documentary-and-the-latest-wave-in-a-sea-of-revisionism-part-one/.

57. This version is compatible with the many accounts that claimed that the "revolution" occurred in two distinct phases, the first of which was truly revolutionary and the second of which—less than a week later—already something more like a palace coup.

58. One pervasive theory held that they were agents of the internal opposition, maintaining enough of a sense of danger and insecurity for the new government to consolidate its hold.

59. Kaplan, *Balkan Ghosts*, 99.

60. Verdery and Kligman, "Romania after Ceauşescu," 129.

61. Aside from being politically expedient for the new leadership, this may have also been necessary, since during the Ceauşescu years there had been very few individuals outside of those innermost circles who had been allowed to build anything like the political, organizational, or technical skills to actually run things effectively. There was not a lot of change in the Securitate either: Unlike with the Stasi, for example, the lack of any public dismantling of the security apparatus seemed a clear and ominous sign of the lack of meaningful change. Verdery and Kligman, "Romania after Ceauşescu," 128.

62. The NSF retained total control over TV and denied permission for any independent stations, and many of the same people also remained in their old TV jobs: The continued presence of the same old commentators as the source of "information" only served to undermine or discredit the message they purveyed, even despite their protestations that "physically we are the same people, but mentally we are completely different." This was compounded by the fact that, until January 29, Aurel Dragos Munteanu held the dual role of head of the television

service and official spokesman of the NSF. Siani-Davies, *The Romanian Revolution of December 1989*, 234–35.

63. Siani-Davies, *The Romanian Revolution of December 1989*, 232–33.

64. "The chief interest of the new leaders [was] not communism but power. If some of communism's structures remain, it is not because the leaders still want Marxism-Leninism but because those structures were eminently suited to concentrating political power and reproducing it." Verdery and Kligman, "Romania after Ceauşescu," 130.

65. In 1977, miners in the Jiu Valley had struck and rioted, and the Securitate had then infiltrated their ranks, organizations, and unions, to keep anything like that from happening again. In June 1990, Iliescu called in those miners from the north to clear out the students and shut down their demand for a second revolution in which the government would be cleansed of "neo-Communism" (in a perverse twist, apparently some of the miners put flowers on their helmets).

66. Verdery and Kligman, "Romania after Ceauşescu," 125. It was not long before the power structure lost all coherence. "Inside each institutional center—army, police, council of state, and so on—is ongoing contention to consolidate power, as people struggle to edge one another out. Each center of influence—individuals or small groups—works behind the scenes to strengthen its power base with other segments. Because no one's allegiance is certain, coalitions shift. . . . Indeed, we question the coherence and unity of all groups named in one or another interpretation—the 'Army,' the 'Securitate,' the 'Front,' and so on. Such unifying labels are unsuited to describing groups with fuzzy boundaries, internal conflicts and fissures, and constantly changing coalitions." Verdery and Kligman, "Romania after Ceauşescu," 138–39.

67. Hall, "The 1989 Romanian Revolution as Geopolitical Parlor Game." Ceauşescu had overseen an unrelenting process of atomization of Romanian society, "in which fear and distrust became the currency of human relations, obviating all but

the most localized and circumscribed loyalties." Verdery and Kligman, "Romania after Ceauşescu," 118. This meant that any and all alliances formed in the revolution's wake were unstable, unreliable, and constantly shifting as individual interests were continually calculated and recalculated according to the ever-volatile scenario.

68. Eva Kernbauer, "Establishing Belief: Harun Farocki and Andrei Ujica, Videograms of a Revolution," *Grey Room* 41 (Fall 2010): 73.

69. This section's title is from Müller, *The Fox Was Ever the Hunter*, 196.

70. Manuel Correa, "Responding to Harun Farocki—On the Documentary," *e-flux conversations*, May 2015, http://conversations.e-flux.com/t/superconversations-day-5-manuel-correa-responds-to-harun-farocki-on-the-documentary/1627.

71. Jill Godmilow and Ann-Louise Shapiro, "How Real Is the Reality in Documentary Film?" *History and Theory* 36, no. 4 (December 1997): 84.

72. Godmilow and Shapiro, "How Real Is the Reality," 85.

73. Godmilow and Shapiro, "How Real Is the Reality," 90.

74. Godmilow and Shapiro, "How Real Is the Reality," 87.

75. Godmilow and Shapiro, "How Real Is the Reality," 92.

76. Godmilow and Shapiro, "How Real Is the Reality," 94.

77. Godmilow and Shapiro, "How Real Is the Reality," 91.

78. This policy had, consequently, anathematized traditional folkways. In fact, when Ceauşescu was at the height of his power, official indignation about Western "Draculiana" came to a head over the George Hamilton movie *Love at First Bite*, with the state film bureau subsequently producing *The True Life of Dracula*, a nationalist epic "full of force and manhood," according to the press release, as a rejoinder. "This rehabilitation of Dracula as national hero," says Stojanova, "derives from the following history lesson: Vlad Tepes, the historical Impaler of legend, 'was faced with betrayal and rancor in the ranks no less complex than that of a modern Romanian ruler, for example Ceauşescu'—thereby justifying the atrocities committed in the same name by

Ceauşescu." Stojanova, "Beyond Dracula and Ceauşescu," 228, citing Karen Jaehne. More recently, Vlad Tepes has become the hook for a renewed tourism campaign for the "land of Dracula."

79. Adina Bradenau, "'Death' and Documentary: Memory and Film Practice in Postcommunist Romania," *KinoKultura: New Russian Cinema*, 2007, http://www.kinokultura.com/specials/6/bradeanu.shtml.

80. Bradenau, "'Death' and Documentary."

81. Bradenau, "'Death' and Documentary."

82. Harun Farocki, "Written Trailers," http://yaleunion.org/wp-content/uploads/2013/12/Farocki_written_trailers.pdf.

83. Godmilow and Shapiro, "How Real Is the Reality," 95.

84. Kernbauer, "Establishing Belief," 79.

85. "Evidently, from the moment that the studio became the focal point of the revolution and the screen the only place of happening everybody ran to the studio to appear on the screen, at any price or into the street to be caught by cameras sometimes filming each other. The whole street became the extension of the studio, that is, an extension of the non-place of the event or of the virtual place of the event. The street itself became a virtual space. How to manage this paradoxical situation? When all information comes from television, how can the thousands of television viewers be at the same time in front of the screen and in the places of action?" Jean Baudrillard, *The Timisoara Syndrome: The Télékratie and the Revolution* (New York: Columbia University Press, 1993), 64.

86. Nonetheless, the TV was, according to many accounts, considered an almost sacred space during and subsequent to the December events, the "central symbol of the December revolution." During the apparent attack on the TV station during the June 1990 protests, when President Iliescu called upon the people to defend that "sacred space," people did in fact respond, since in the popular view it had been on TV that "Romania's 'fledgling democracy' had been born." Verdery and Kligman, "Romania after Ceauşescu," 133. TV was the space from which the narrative had emanated and taken shape.

87. Kernbauer, "Establishing Belief," 79.

88. Hito Steyerl, "Beginnings," *e-flux conversations*, November 2014, https://www.e-flux.com/journal/59/61140/beginnings/.

89. Frances Guerin, "Dislocations: Videograms of a Revolution and the Search for Images," in *A Companion to German Cinema, ed.* Terri Ginsberg and Andrea Mensch (West Sussex: Wiley-Blackwell, 2012), 491.

90. Kernbauer, "Establishing Belief," 76–77.

91. Andrei Codrescu, "The Romanian Revolution Was Televised," *Far Outliers*, December 6, 2004, https://faroutliers.wordpress.com/2004/12/06/the-romanian-revolution-was-televised/.

92. Guerin, "Dislocations," 499.

93. Guerin, "Dislocations," 499.

94. Guerin, "Dislocations," 501.

95. This section's title is from Müller, *The Fox Was Ever the Hunter*, 234.

96. Rob White, "Interview with Andrei Ujica," *Film Quarterly*, March 9, 2011, https://filmquarterly.org/2011/03/09/interview-with-andrei-ujica/. According to Țichindeleanu, "the film does not expose any differences between Ceaușescu in private and public. No 'dirt' is disclosed, no decay shown; far from appearing mentally degraded, Ceaușescu looks like a pensive person, whose political convictions are his true passion. His autobiography portrays him as the epitome of modernity: the fully transparent subject. Apparently, there was no secret to reveal. He was what he was. This unexpected effect prompted local critics to complain that the film 'humanizes' Ceaușescu. Ujică's film reveals Ceaușescu as a complete work of art, exactly as predicated by his cult of personality." Țichindeleanu, "Ion Grigorescu."

97. According to Ujica, "this is the only act of dissent that comes from within the political apparatus and which takes place in Ceaușescu's presence." White, "Interview with Andrei Ujica."

98. White, "Interview with Andrei Ujica."

99. Among Ceauşescu's treasures was a certificate of honorary citizenship to Disneyland, conferred on him by Mickey Mouse. This was housed, along with numerous other oddities, in the National Historical Museum. Anthony Daniels, *Utopias Elsewhere: Journeys in a Vanishing World—North Korea, Cuba, Albania, Romania, Vietnam* (New York: Crown, 1991), 102.

100. As it happens, the reason why so much footage in *Autobiography* has no sound is that a lot was shot that way in order to save money.

101. This section's title is from Müller, *The Fox Was Ever the Hunter*, 204.

102. White, "Interview with Andrei Ujica."

103. Oscar Wilde, "The Decay of Lying," http://cogweb.ucla .edu/Abstracts/Wilde_1889.html.

104. Friedrich Nietzsche, *Philosophical Writings* (London: Bloomsbury Academic, 1995), 214.

105. Since the events were mostly televised, the turning point—12:08—is clearly inscribed onto the popular memory. It also created a clear dividing line—anyone who went out onto the streets after then didn't count as a revolutionary.

106. Dana Duma, "Are We Still Laughing When Breaking with the Past?" *KinoKultura: New Russian Cinema*, 2007, http:// www.kinokultura.com/specials/6/duma.shtml.

107. Mihai Chirilov, "You Can Run, But You Cannot Hide: New Romanian Cinema," *KinoKultura: New Russian Cinema*, 2007, http://www.kinokultura.com/specials/6/chirilov.shtml.

108. Andrei Cretulescu, "Corneliu Porumboiu, *12:08 East of Bucharest*, and Alexandru Solomon, *The Great Communist Bank Robbery*," *KinoKultura: New Russian Cinema*, 2007, http://www .kinokultura.com/specials/6/bucharest-bankrobbery.shtml.

109. Cited on DVD cover.

110. Cretulescu, "Corneliu Porumboiu."

111. Duma, "Are We Still Laughing."

112. Iulia Blaga, "Radu Muntean, *The Paper Will Be Blue*," *KinoKultura: New Russian Cinema*, 2007, http://www .kinokultura.com/specials/6/paperblue.shtml. At the time

those films were made, there were almost no movie theatres in Romania and even less of an audience for them. 12:08 sold only around 15,500 tickets in Romania—it sold 40,000 in France alone. Duma, "Are We Still Laughing."

113. A. O. Scott, "New Wave on the Black Sea," *New York Times Magazine*, January 20, 2008, http://www.nytimes.com/2008/01/20/magazine/20Romanian-t.html.

114. Anthony Kaufman, "Romania's Cinematic Revolution: Struggling against the Past," *IndieWire*, June 12, 2007, http://www.indiewire.com/article/romanias_cinematic_revolution_struggling_against_the_past.

115. White, "Interview with Andrei Ujica."

116. Tarnmoor, "Serendipity: Summoning Up the Genie," *Tarnmoor*, https://tarnmoor.com/2015/10/13/serendipity-summoning-up-the-genie/.

117. This section's title is from Friedrich Nietzsche, *The Gay Science*, cited in Martin Jay, *The Virtues of Mendacity: On Lying in Politics* (Charlottesville: University of Virginia Press, 2010), 23.

118. Cathy Caruth, *Literature in the Ashes of History* (Baltimore, MD: Johns Hopkins University Press, 2013), xi.

119. Caruth, *Literature in the Ashes of History*, 42.

120. Caruth, *Literature in the Ashes of History*, 43.

121. Herodotus, *The History of Herodotus*, trans. George Rawlinson (London: John Murray, 1862), 121.

122. Baudrillard, *The Timisoara Syndrome*, 62.

123. Baudrillard, *The Timisoara Syndrome*, 66.

124. Baudrillard, *The Timisoara Syndrome*, 68.

125. Baudrillard, *The Timisoara Syndrome*, 68.

126. Cited in Jay, *The Virtues of Mendacity*, 46.

127. Edouard Glissant, "For Opacity," in *Poetics of Relation*, trans. Betsy Wing (Ann Arbor: University of Michigan Press, 1997), 189–90.

128. Glissant, "For Opacity," 192.

129. Glissant, "For Opacity," 57.

130. Glissant, "For Opacity," 38.

131. Friedrich Nietzsche, quoted in Patrick J. Keane, "On Truth and Lie in Nietzsche," *Salmagundi* 29 (Spring 1975): 71.

132. Kenneth Cmiel, *Democratic Eloquence: The Fight over Popular Speech in Nineteenth-Century America* (Berkeley: University of California Press, 1990), 260.

133. Nietzsche, quoted in Keane, "On Truth and Lie in Nietzsche," 76.

134. This section's title is from Gertrude Stein, *The Making of Americans* (Normal, IL: Dalkey Archive, 1995), 295.

135. Steyerl, "Beginnings." My emphasis.

136. Wilde, "The Decay of Lying."

137. Maurice Blanchot, *The Writing of the Disaster* (Lincoln: University of Nebraska Press, 1995), 43.

138. Daniel Mendelsohn, quoted in Adam Phillips, "What Can You Know?" *London Review of Books* 29, no. 8 (April 26, 2007), http://www.lrb.co.uk/v29/n08/adam-phillips/what-can-you-know.

4. Whoever Knows the Truth Lies

1. This chapter was completed on January 10, 2017.

She "had been buried alive after a bombardment, [and was speaking] to an American army psycho-specialist." Miriam Hansen, "Cooperative Auteur Cinema and Oppositional Public Sphere: Alexander Kluge's Contribution to *Germany in Autumn*," *New German Critique* 24/25 (Autumn 1981/Winter 1982): 47.

2. Philip Oltermann, "The Well-Read Terror," *Guardian*, November 14, 2008, https://www.theguardian.com/books/2008/nov/15/red-army-faction-baader-meinhof.

3. Cited in Stephen Brockmann, *A Critical History of German Film* (Rochester, NY: Camden House, 2010), 345.

4. Brockmann, *A Critical History of German Film*, 349.

5. In 1970s West Germany, there were only two TV channels and a few major papers. Ray Furlong, "'Terror' Art Challenges Germans," *BBC News*, February 1, 2005, http://news.bbc.co.uk/2/hi/europe/4227203.stm.

6. Andreas Huyssen, *Twilight Memories: Marking Time in a Culture of Amnesia* (New York: Routledge, 1995), 148–49.

7. Brockmann, *A Critical History of German Film*, 348.

8. Hansen, "Cooperative Auteur Cinema," 55.

9. Robert Storr, *Gerhard Richter: October 18, 1977* (New York: Museum of Modern Art, 2000), 81.

10. Geoff Eley, "Review of *Deutschland im Herbst*," *American Historical Review* 96, no. 4 (October 1991): 1131.

11. Olivia Laing, *The Lonely City* (New York: Picador, 2017), 19.

12. Brockmann, *A Critical History of German Film*, 354.

13. The song is "Here's to You: The Ballad of Sacco and Vanzetti," by Ennio Morricone. The lyrics, in full, read "Here's to you, Nicolo and Bart / Rest forever here in our hearts / The last and final moment is yours / That agony is your triumph."

14. Hansen, "Cooperative Auteur Cinema," 50. "The conventional division of labor between fiction and non-fiction genres, according to Kluge, disregards the 'coexistence of fact and desire in the human mind' or — to externalize the perspective — the painful discrepancy between the schemes of history and the 'stories' of human life. Kluge instead proposes a crossing of radical observation and radical fiction which would leave neither genre intact" (49).

15. This references conventional cinema, meaning that it pretends to have full access to the truth, that it owns and distributes and defines the truth.

16. Brockmann, *A Critical History of German Film*, 349.

17. Marc Silberman, "Introduction to *Germany in Autumn*," *Discourse* 6 (Fall 1983): 51.

18. Jeremy Varon, *Bringing the War Home: The Weather Underground, the Red Army Faction, and Revolutionary Violence in the Sixties and Seventies* (Berkeley: University of California Press, 2004), 13.

19. Thomas Elsaesser, "Antigone Agonistes: Urban Guerrilla or Guerrilla Urbanism? The Red Army Faction, *Germany in Autumn*, and *Death Game*," in *The Place of Politics in German*

Film, ed. Martin Blumenthal-Barby (Bielefeld: Aisthesis Verlag, 2014), 156.

20. Cited in Varon, *Bringing the War Home*, 199.

21. Elsaesser, "Antigone Agonistes," 129.

"By leaving its judiciary, its scientists, technocrats and business circles (i.e., the educational and expert elite) virtually unpurged, it also forfeited the loyalty and respect of the younger generation, who pointed to the silence on the subject of fascism in the schools' history lessons, and tainted past of some of its highest officials. . . . [Additionally] the so-called piggy-back law in the civil service, for instance, which meant that with each new appointment, a politically compromised, but bureaucratically experienced ex-Nazi could be reinstated. It was also common knowledge that the Americans had preferred the Nazis of yesterday to social democrat dissidents and political émigrés, because the former could be trusted as good anti-Communists." Thomas Elsaesser, *Fassbinder's Germany: History Identity Subject* (Amsterdam: Amsterdam University Press, 1996), 29.

22. Peter Wollen, "Leave-Taking," *London Review of Books* 23, no. 7 (April 5, 2001), http://www.lrb.co.uk/v23/n07/peter-wollen/leave-taking.

23. Stefan Aust, *Baader-Meinhof: The Inside Story of the RAF*, trans. Anthea Bell (1985; Oxford: Oxford University Press, 2008), xiii.

24. "Citizens were asked . . . to call familiar telephone numbers, i.e., those usually reserved for the results of the state lottery, to report on anybody whom they considered suspect of subversive activities." Hansen, "Cooperative Auteur Cinema," 44. "This was a practice that would have been familiar to anyone who had lived through the Nazi period." Silberman, "Introduction to *Germany in Autumn*," 49. "New laws prevented RAF members from mounting political defenses and restricted their rights of due process (most provocatively, by throwing their attorneys off their cases for supporting the inmates' hunger strikes, or merely parroting the group's political rhetoric); and [the government] harassed and defamed communities,

like university students, especially open to radical politics (condemnation of alleged 'sympathizers' was a staple of anti-RAF rhetoric). . . . The perceived stakes of defeating the RAF were extraordinarily high." Jeremy Varon, "Stammheim Forever and the Ghosts of Guantánamo: Cultural Memory and the Politics of Incarceration," in *Baader-Meinhof Returns: History and Cultural Memory of German Left-Wing Terrorism*, ed. Gerrit-Jan Berendse and Ingo Cornils (Amsterdam: Rodopi, 2008), 304. "Seven years after they had gone underground, the 'omnipresence of the system' was no longer a myth, but an everyday reality: investigation by scanning, by surveillance, the PIOS computer system, Nadis, Inpol; more money, more offices, better equipment for the police, for Counter Intelligence, for the Border Police; new laws, fortified courtrooms, high-security sections in prisons." Aust, *Baader-Meinhof*, 420. "The legality of the anti-terrorism laws was questioned not only on the left but also by jurists, politicians and civil libertarians." Varon, *Bringing the War Home*, 255. "Hardly any domestic issue [had] generated such controversy and heated discussion in the Federal Republic [as] the legal measures for fighting terrorism." Bernhard Rabert, cited in Varon, *Bringing the War Home*, 270. "Prosecutors asked for, and in late 1974 the Bundestag enacted, special laws, which in addition to imposing broad limits on the writing, publication, and dissemination of politically controversial materials, and laying down narrow guidelines for who could represent the accused on political cases (one lawyer was dismissed merely for calling himself a socialist) gave judges the right to carry on with a trial in the absence of those being tried. Thus, on the grounds that a state of national emergency existed, Germany overtly and covertly curtailed its civil liberties, summoning the ghosts of the law-and-order past." Storr, *Gerhard Richter*, 57.

25. Aust, *Baader-Meinhof*, xvii.

26. Cited in Jillian Becker, *Hitler's Children: The Story of the Baader-Meinhof Terrorist Gang* (Philadelphia: J. B. Lippincott, 1977), 13.

27. Storr, *Gerhard Richter*, 56–57.

28. Berendse and Cornils, *Baader-Meinhof Returns*, 306.

29. Berendse and Cornils, *Baader-Meinhof Returns*, 234.

30. Aust, *Baader-Meinhof*, 424.

"The message they sent was: don't do anything more now on our account. End it or find a meaning in it for yourselves! The staging of their death was a number of things: a last blow struck against the power from which they saw themselves escaping entirely. A glimpse of the old morality—'we are the missile.' But also the assumption of responsibility, perhaps even something like atonement, and the recognition that none of it was in proportion for them anymore." Aust, *Baader-Meinhof*, 433.

31. Varon, *Bringing the War Home*, 229.

32. Aust, *Baader-Meinhof*, xii.

33. Berendse and Cornils, *Baader-Meinhof Returns*, 312.

34. Cited in Aust, *Baader-Meinhof*, xix.

35. Aust, *Baader-Meinhof*, 433.

36. Julian Preece, *Baader-Meinhof and the Novel: Narratives of the Nation/Fantasies of the Revolution, 1970–2010* (New York: Palgrave Macmillan, 2012), 5.

37. Elsaesser, *Fassbinder's Germany*, 102.

38. Charity Scribner, *After the Red Army Faction: Gender, Culture, and Militancy* (New York: Columbia University Press, 2015), 113.

39. Cited in Varon, *Bringing the War Home*, 246.

40. Elsaesser, "Antigone Agonistes," in *Fassbinder's Germany*, 137.

41. Berendse and Cornils, *Baader-Meinhof Returns*, 224.

42. Elsaesser, "Antigone Agonistes," 125.

43. Elsaesser, "Antigone Agonistes," 130.

44. Elsaesser, *Fassbinder's Germany*, 33.

45. Maggie Nelson, *The Art of Cruelty: A Reckoning* (New York: Norton, 2011), 149.

46. Quoted in *The Third Generation*, at 03:13.

47. Katja Nicodemus, "Death Wish: Germany's Enduring Fascination with the Red Army Faction," *Film Comment* 45, no. 5 (September/October 2009): 57–59. "All interpretation of the

events seemed preconceived, all arguments interchangeable, and the post-'68 leftists and alternative types busied themselves with building their careers. Meanwhile, the real-life third generation of the RAF continued to set off bombs, but failed to retain its credibility as a social movement. It was only after the group's official disbandment in 1998 that the subject returned to the big screen."

48. Rainer Usselmann, "18.Oktober 1977: Gerhard Richter's Work of Mourning and Its New Audience," *Art Journal* 61, no. 1 (Spring 2002).

49. Storr, *Gerhard Richter*, 111.

50. Storr, *Gerhard Richter*, 130.

51. Storr, *Gerhard Richter*, 112. For a broader consideration of Richter's work, albeit from a more purely art historical perspective, see Benjamin H. D. Buchloh and Peter Osborne, *Gerhard Richter (October Files)* (Cambridge, MA: MIT Press, 2009).

52. Gertrud Koch, "The Richter-Scale of Blur," *October* 62 (Autumn 1992): 139. Richter "has taken great care not to express any detailed opinion of his own about the events which culminated in Stammheim in October 1977 or about the way in which the work might best be interpreted in the context of its subject matter, preferring to leave his own intentions opaque and so, in a certain way, encouraging speculation while disarming direct criticism." Wollen, "Leave-Taking."

53. Cited in Berendse and Cornils, *Baader-Meinhof Returns*, 44.

54. Cited in Berendse and Cornils, *Baader-Meinhof Returns*, 46. My italics.

55. All quotations cited in Wollen, "Leave-Taking."

56. Wollen, "Leave-Taking."

57. It's worth noting that Richter began working on the paintings toward the end of the *Historikerstreit*, a fierce debate among German intellectuals that questioned the country's actual culpability for Nazi actions and calling for an end to "the past that will not go away." Richter's paintings, then, and the

subsequent reaction to them in West Germany, must be seen at least partly in the context of that revisionist battlefield.

58. Storr, *Gerhard Richter*, 29.

59. Apparently, there was interest at the Frankfurt Museum für Moderner Künst in buying the paintings, but they couldn't raise the funds, in part because the second generation of the RAF had been very active there and specifically because Jürgen Ponto, the head of Dresdner Bank and killed by the RAF in 1977, had been a major patron of the museum. Also, Alfred Herrhausen, the head of Deutsche Bank, was killed just as the paintings were being exhibited in Krefeld. Jean-Christophe Amman, director of the museum in Frankfurt, protested their sale, saying that relocating them would render them "ineffective"—many Germans agreed. Storr, *Gerhard Richter*, 34. In the United States, Hilton Kramer's article on the purchase for the *New York Observer* ran under the headline "MoMA Helps Martyrdom of German Terrorists" and noted that the MoMA benefactor who had presumably paid for the work was "precisely the kind of figure who would have been earmarked for assassination by these terrorists in their heyday." Cited in Storr, *Gerhard Richter*, 34–35.

60. Cited in Storr, *Gerhard Richter*, 35.

61. Storr, *Gerhard Richter*, 64.

62. Storr, *Gerhard Richter*, 95.

63. Jeffrey Alexander, *Trauma, a Social Theory* (Cambridge: Polity, 2012), 11–12.

64. Cathy Caruth, *Listening to Trauma* (Baltimore, MD: Johns Hopkins University Press, 2014), 156.

65. Alexander, *Trauma*, 3.

66. Cited in Alexander, *Trauma*, 9.

67. Nelson, *The Art of Cruelty*, 169.

68. Alexander, *Trauma*, 4.

69. "Often down here I have entered into a sanctuary, a nunnery; had a religious retreat; of great agony once; & always some terror: so afraid one is of loneliness: of seeing to the bottom of the vessel." Virginia Woolf, *The Diary of Virginia Woolf, vol. 3: 1925–30* (New York: Mariner, 1981), 196.

70. Caruth, *Listening to Trauma*, 221–22.

71. Caruth, *Listening to Trauma*, 218.

72. Caruth, *Listening to Trauma*, 219.

Conclusion: The Undersong of Our Histories

1. The phrase "the undersong of our histories" is taken from Peter Davidson, *The Last of the Light: About Twilight* (London: Reaktion, 2015), 10.

2. Maurice Blanchot, *The Writing of the Disaster* (Lincoln: University of Nebraska Press, 1995), 48.

3. Blanchot, *The Writing of the Disaster*, 129.

4. Brandon Kreitler, "On Not Knowing Yourself: What's Adam Phillips Saying about Life Story?" *Los Angeles Review of Books*, August 11, 2017, https://lareviewofbooks.org/article/on-not-knowing-yourself-whats-adam-phillips-saying-about-life-story/.

5. Blanchot, *The Writing of the Disaster*, 101.

6. Timothy Garton Ash, "The Truth about Dictatorship," *New York Review of Books*, February 19, 1998, 35.

7. Berber Bevernage refers to the idea of a "knowing forgetting," resorted to "in situations where nations or groups are held hostage to a burdened past and are in great need of the 'drama of forgiveness.'" And, in fact, willful forgetting was the norm, at least in European political history, from the Treaty of Lothar (851) through much of the twentieth century—this starts to change only in the early 1980s: "Although the need for amnesty often remains, it has become more subtle or conditional, and the language of oblivion has almost completely disappeared from the political vocabulary. A 'cultural turn' in political theory made it mandatory that even in situations where political constraints exclude the viability of retributive justice, the past should not be left behind and the burden of history should be addressed. The need to manage the legacy of violent pasts revealed itself as a major policy issue: . . . 'there seems to be a growing consensus that the past demands something from us in situations of transition.'" Berber Bevernage, *History, Memory,*

and State-Sponsored Violence: Time and Justice (New York: Routledge, 2012), 9.

8. Bevernage, *History, Memory, and State-Sponsored Violence*, 13.

9. Since the South African Truth and Reconciliation Commission, the idea of a truth commission has been at least contemplated, if not pursued, in pretty much every postconflict situation: By now there have been dozens of them across Africa, Latin America, the Caribbean, and Asia.

10. Okwui Enwezor, Carlos Basualdo, Ute Meta Bauer, Susanne Ghez, Sarat Maharaj, Mark Nash, and Octavio Zaya, "Introduction," in *Experiments with Truth* (Ostfildern-Ruit: Hatje Cantz, 2002), 15–16.

11. Walter Benjamin, "The Storyteller," in *Illuminations* (New York: Schocken, 1968), 89.

12. Cathy Caruth, *Listening to Trauma: Conversations with Leaders in the Theory and Treatment of Catastrophic Experience* (Baltimore, MD: Johns Hopkins University Press, 2014), 311.

13. Édouard Glissant, "For Opacity," in *Poetics of Relation* (Ann Arbor: University of Michigan Press, 1997), 192.

14. Eelco Runia, *Moved by the Past: Discontinuity and Historical Mutation* (New York: Columbia University Press, 2014), 12–13.

15. Runia, *Moved by the Past*.

16. Runia, *Moved by the Past*.

17. Caruth, *Listening to Trauma*, 322.

18. Narrator in Chris Marker, dir., *Sans Soleil*, 1983.

19. Andreas Huyssen, "Monumental Seduction," in *Acts of Memory: Cultural Recall in the Present*, ed. Mieke Bal, Jonathan Crewe, and Leo Spitzer (Hanover, NH: University Press of New England, 1999), 198–99.

20. Runia, *Moved by the Past*, 71, 90.

21. Runia, *Moved by the Past*, 83.

22. Runia, *Moved by the Past*, 147.

23. Søren Kierkegaard, "Repetition," in *The Kierkegaard Reader*, ed. Jane Chamberlain and Jonathan Rée (Malden, MA: Blackwell, 2001), 115.

24. Cited in Geoffrey Hartman, *The Geoffrey Hartman Reader* (New York: Fordham University Press, 2004), 426.

25. Gilles Deleuze and Félix Guattari, *Kafka: Toward a Minor Literature* (Minneapolis: University of Minnesota Press, 1986), 21.

26. Bevernage, *History, Memory, and State-Sponsored Violence*, ix. "[There is] a false choice between a living present and a dead and absent past and that . . . often is used by perpetrators of historical injustices to escape accountability." Bevernage, *History, Memory, and State-Sponsored Violence*, 174–75.

27. According to Bevernage, another widespread notion of time and history "perceives history as bringing genuine historical novelty and that believes that this novelty justifies a strict qualitative division of the temporal dimensions of past, present and future." Bevernage denotes this view as "modernist." "For De Man, modernity, in the first place, must be associated with 'radical renewal' or even forgetting: It is an obsession with a *tabula rasa*, with new beginnings. . . . [Baudelaire associated the idea of modernity] with the truly new, the ephemeral newness of the present, on which the modern artist had to focus, disassociating it from the overvaluation of the eternal and the old evident in classical aesthetics . . . modern experience as a continuously recapitulated break with the past." Bevernage, *History, Memory, and State-Sponsored Violence*, 99. "The stress on the atomistic nature of time—resulting from Newton's calculus that conceived of time as a sum of infinitely small but discrete units—conceptually supports the common view that represents the historical process as an endless succession of events" (93). "Because mechanical clocks were the first devices that enabled humankind to mark equal, abstract and discrete units of time with precision, and because they were able to do so independently from the movement of the celestial bodies, it is no coincidence . . . that the notion of abstract uniform time

developed in the same historical period as the mechanical clock" (94).

28. Cited in Bevernage, *History, Memory, and State-Sponsored Violence*, 119.

29. Bevernage, *History, Memory, and State-Sponsored Violence*, 4.

30. Bevernage, *History, Memory, and State-Sponsored Violence*, 5.

31. Blanchot, *The Writing of the Disaster*, 131.

32. Blanchot, *The Writing of the Disaster*, 91.

33. Blanchot, *The Writing of the Disaster*, 95.

34. Peter Matthiessen, *The Snow Leopard* (New York: Penguin, 1978), 40.

35. José Esteban Muñoz, *Cruising Utopia: The Then and There of Queer Futurity* (New York: New York University Press, 2009), 3.

36. Blanchot, *The Writing of the Disaster*, 83.

37. Hartman, *The Geoffrey Hartman Reader*, 378.

38. Diana Fuss, *Dying Modern: A Meditation on Elegy* (Chapel Hill, NC: Duke University Press, 2013), 36.

39. Fuss, *Dying Modern*, 71.

40. Fuss, *Dying Modern*, 44.

41. Fuss, *Dying Modern*, 97.

42. John Berger, *Confabulations* (New York: Penguin, 2016), 99.

43. Berger, *Confabulations*, 95.

44. Edward Hirsch, "The Work of Lyric: Night and Day," *Georgia Review* 57, no. 2 (Summer 2003): 371.

45. Seamus Heaney, "On W. B. Yeats's 'The Man and the Echo,'" *Harvard Review* 4 (Spring 1993): 96.

RACHEL WEISS, a writer and curator, is Professor of Arts Administration and Policy at the School of the Art Institute of Chicago. She is the author of *To and from Utopia in the New Cuban Art*.

CPSIA information can be obtained
at www.ICGtesting.com
Printed in the USA
LVHW112313080221
678782LV00006B/379